C / R / E / A / T / I / V / E

newsletters

& annual reports

designing information

9686.225

Copyright © 1998 by Rockport Publishers Inc.

All rights reserved. No part of this book may be reproduced in any form without written permission of the copyright owners. All images in this book have been reproduced with the knowledge and prior consent of the artists concerned and no responsibility is accepted by producer, publisher, or printer for any infringement of copyright or otherwise, arising from the contents of this publication. Every effort has been made to ensure that credits accurately comply with information supplied.

Excerpts from *The Pages* courtesy of MTV Networks, a division of Viacom International Inc. ©1998 Viacom International Inc. All rights reserved.

First published in the United States of America by:

Rockport Publishers Inc. 33 Commercial Street Gloucester, Massachusetts 01930-5089 Telephone: (978) 282-9590 Facsimile: (978) 283-2742

Distributed to the book trade and art trade in the United States by:

North Light Books, an imprint of F & W Publications 1507 Dana Avenue Cincinnati, Ohio 45207 Telephone: (800) 289-0963

Other Distribution by:

Rockport Publishers Inc. Gloucester, Massachusetts 01930-5089

> ISBN 1-56496-430-2 10 9 8 7 6 5 4 3 2 1

Designer: Tinker Cavanagh TinkerDesign

Cover Images on pages: 23, 24, 31, 47, 58, 59, 70, 71, 97, 117, 140

Printed in China

C / R / E / A / T / I / V / E

newsletters

& annual reports

designing information

GLOUCESTER MASSACHUSETTS

A/ C/ K/ N/ O/ W/ L/ E/ D/ G/ M/ E/ N/ T/ S

Thank you to all the designers, editors, and publishers who allowed us to get inside their heads and catch a few creative thoughts as they zipped by.

A special thank you to Darlene D'razzio. Without her help, phone calls, organizational skills, and creative input, we never would have finished.

-Rita Street and Roberta Street

C/ O/ N/ T/ E/ N/ T/ S

- 6 FOREWORD / RITA STREET AND ROBERTA STREET
- 8 NEWSLETTERS: FAR FROM KIDS' STUFF / JOSHUA CHEN
- 9 ANNUAL REPORTS: JUDGING THE BEST / JULIE BUSSE

10 SECTION I: LEISURE

12 Chapter 1: Arts

The Pages; The NATPE Monthly; Oculus; Christie's Art; CalArts Current; New Pacific Writing

26 Chapter 2: Sports

The Green Sticker Vehicle; Ride Inc. 1996 Annual Report; Compass; Harley-Davidson Inc. 1996 Annual Report

36 Chapter 3: Travel

Princess News; Rancho La Puerta Tidings; Island Escapes

44 Leisure Gallery

Footprints; The Art of Eating; The Southern California Gardener; Passages; South Texas College of Law 1996 Annual Report; Window on Wheeler; Malofilm Communications 1996 Annual Report; Jacor Communications Inc. 1996 Annual Report

48 SECTION II: GOODS AND SERVICES

50 Chapter 4: Equipment

Northrop Grumman Corporation 1996 Annual Report; dateline Nissan; Visions; acuSounder; Adaptec Inc. 1996 Annual Report

64 Chapter 5: Careers

CARN; Conservation; Journal of Property Management; Chicago Volunteer Legal Services 1996 Annual Report

74 Chapter 6: Goods

Portland Brewing Company 1996 Annual Report; The World of Kashi; Operations & Sourcing News; bLink

84 Goods and Services Gallery

Choices; Urban Shopping Centers Inc. 1996 Annual Report; Screen Actor; Contrails; H.J. Heinz Company 1996 Annual Report; The Callaway GrapeVine; Big Blue Box; Novellus 1996 Annual Report; Stant Corporation 1996 Annual Report

92 SECTION III: BUILDING AWARENESS

94 Chapter 7: Sciences

Sydney's Koala Club News; Geron 1996 Annual Report; CalMat 1996 Annual Report

102 Chapter 8: Health

City of Hope 1996 Annual Report; HealthWise; Fitness Matters; Starlight Foundation International 1995-1996 Annual Report; The Shining Star

112 Chapter 9: Religion

Anti-Defamation League Pacific Southwest Region 1996 Annual Report; Living Buddhism

118 Building Awareness Gallery

St. Jude Medical Inc. 1996 Annual Report; Heartport Annual Report; Creative Biomolecules 1996 Annual Report; Ultrafem 1996 Annual Report

122 SECTION IV: NONPROFITS

124 Chapter 10: Environmental Conservation

National Audubon Society 1995 Annual Report; Center for Marine Conservation 1996 Annual Report; National Fish and Wildlife Foundation 1996 Annual Report; Conservation International: The First Decade 1987–1997

135 Nonprofits Gallery

World•Watch; The HomeFront; Sharing News; Environmental Law Institute 1996 Annual Report; Environmental Defense Fund 1996–1997 Annual Report; African Wildlife Foundation 1996 Annual Report

141 INDEX

143 DIRECTORY

F/ O/ R/ E/ W/ O/ R/ D

Information is as valuable as gold. However, information in publications doesn't have to be dull, boring, or downright indecipherable. Desktop publishing has changed all that.

With the advent of design software that includes prepress features, today's artist controls the creative process. No longer tied down by the laborious process of mechanical paste-up, artists can spend their valuable time doing what they do best—building beautiful, fanciful, engaging work that actually sells data to readers.

Along with all this freedom, however, has come a growing stage—a stage that definitely rates form high above content. For *Designing Information*, we've found digital designers who cherish the basics—simplicity and readability—over faddish looks. Of course, a few we've chosen, such as MTV Network's *The Pages*, come pretty close to jumping over the too-wild-to-read cliff. However, even this out-there publication maintains the sometimes delicate balance between form and content.

We've also provided a diversity of examples. Flip through these pages and you'll find sophisticated font usage, wacky illustrations, low-budget paper choices, impressive photography, can't-miss templates, even publications that rely solely on ingenious text layout to create effect.

Whether you're a pro or a newcomer, it is our hope that this book will inspire you to push your talents further while remaining true to the basics of good design.

-Rita Street and Roberta Street

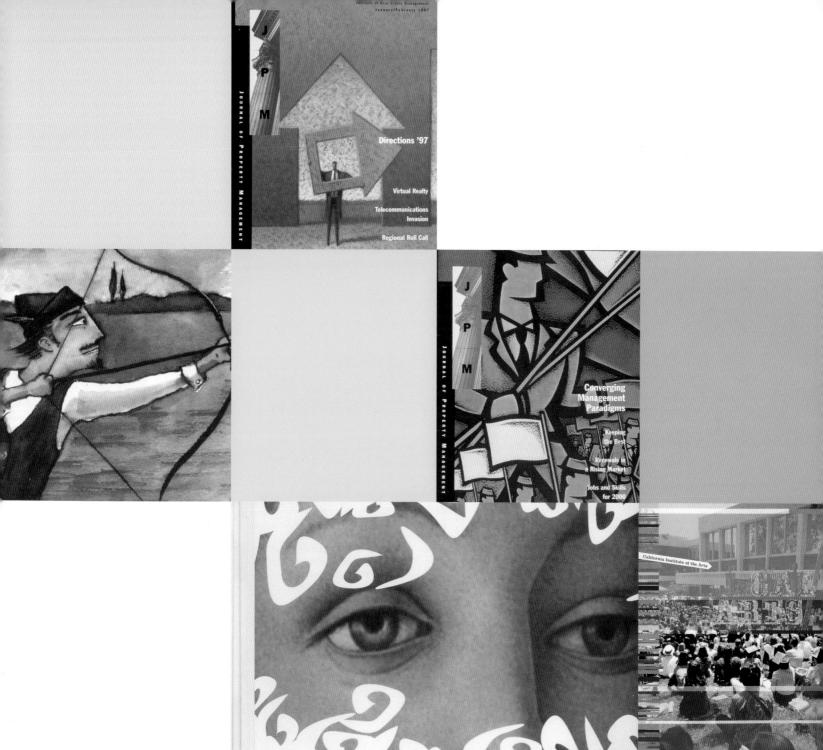

N/E/W/S/L/E/T/T/E/R/S: Far From Kids' Stuff

It was the summer of '79, and I was a bored 12-year-old. It was time to find a new hobby. Write, design, and publish your own newsletter, the school counselor suggested in her "what to do this summer" newsletter.

"O.K.," I thought, ". . . Sure, why not?"

I remember riding my bike down to the local library to find books on newsletter design to get me started. Back then (and it really wasn't that long ago), the only thing I found for inspiration was a tips-and-tricks booklet on typesetting using the typewriter (remember those?). Since the ability to hit Shift-Command-J to justify columns had yet to be invented, you had to type out your text twice in order to do it perfectly: first time, adding slashes (/) at the end of each line, then re-typing the same text but adding extra spaces, based on how many slashes there were. Tedious.

I also remember the challenge and tension of creating a publication that looked as if all the pieces fit together, yet having each article distinguishable enough that the reader knew what to read and where to go. Choices for fonts were limited to typewriter Courier, hand-lettering, and the few Letraset rub-on alphabet sets I could afford to buy on a seventh-grade allowance.

Why this little walk down Nostalgia Lane? I guess it's my way of saying we've come a long way in a short time! Today, newsletters come in all shapes and sizes. They are no longer the newsletters of even ten–fifteen years ago . . . the "ditto-ed" blue pages with that fragrant smell, two-column text set in Times Roman and Helvetica with indistinguishable photographs. Thanks largely to the Macintosh revolution of the '80s, creative newsletter design is alive and well. There is no "typical" newsletter look anymore. Neither do newsletters play second fiddle to glossy pubs. What was previously possible only for magazines with big budgets for typesetting, photography, and art is now possible for the newsletter.

As you read through this book, you'll notice how different designers tackle the same problem issue after issue: getting readers to notice and read their newsletters. You'll also experience how each designer deals with the day-in, day-out challenges of working on a newsletter (do any of these client "quotes" sound familiar?): budgetary concerns ("shouldn't take that long with a computer, right?"); amateur photography ("can you do anything with this Polaroid?"), time/schedule constraints ("can I have this tomorrow morning?"), corporate political games ("my boss hates the color purple"), text versus visual ("what's more important?"); and the meaningless "word count" ("how long does it have to be?").

Just as that little typesetting tips-and-tricks booklet inspired me, it is our hope that this book on creative newsletter design will inspire, stretch, and engage you to be creative in the way you approach your own work.

vorking s the cation to aculty, take on tments.

—Joshua C. Chen

Creative Director, Chen Design Associates

Tides
sice Tanaka has worked in
so and film since 1979, and
works have been seen in
atres, on television, at muses, and in university screems ever since. Her national
siminous include the Museum
Jodern Art, New York, and
1991 and 1993 Whitney
mial. Her international exhions include. Feministrische
nos Unik Kultur, Germany,
son de La Culture, Prance,
oller Muller Museum,
land, The Finnish National

Arte Modern, Lisboa

Musit
Mark Trayle has been performing and composing music
professionally since 1983. He
specializes in electronic music
and has performed his work
around the world. He was the
sound designer on the virtual
reality installation, "Virtual
Brewery Adventure" for
the Sapporo Brewery in Japan,
received three Arts International grants for travel to
European festivals, and in 1988
he received a grant from the
National Endowment for the
Arts and the City of San Diego to

Christopher Barreca has designed 150 productions on Broadway, Off-Broadway, in opera, regional theatre, and dance, as well as film. He restructured the design program at the prestigious Meadows School for the Arts at Southern Methodist University, and he comes to CalArts as the new Head of Design. Among his works include Chronicle of a Desith Foretold by Gabriel Garcia Marquez on Broadway, the premiere of the opera Scourge of the Hyancianhs by Wole Soyinka for the Munchener Biennale,

A/N/N/U/A/L R/E/P/O/R/T/S: Judging the Best

For more than forty years, the annual report has become one of the most important documents produced by a corporation. Once seen as merely a financial report, this document has become the ideal spokesperson, identifying a company's personality, product, and performance.

As director of the Mead Annual Report Show, a competition that has been recognizing the very best in annual report design since 1956, I have had the privilege of being associated with four annual judgings. Each year five nationally recognized annual report designers choose from hundreds of entries submitted, basing their selections on the appropriateness of the design, imagery, and text as it relates to the client.

What is interesting about this process is that five completely different individuals with various influences, experiences, and styles instinctively understand what makes an annual report communicate. Even though each may be swayed by a particular element when casting vote, it is the annual report that executes all the necessary elements effectively that prompts further discussion and recognition. One of the questions that is repeatedly asked after the judging process is over is "why were these particular books chosen?" What makes them special? Invariably the answer is that the books speak honestly and directly to the shareholder, providing adequate information about past performance and future projections paired with groundbreaking design.

Straightforward information, however, is not always enough to set the tone for a company. That is where good design becomes a factor and where trends evolve. Often, companies that produce similar products or offer similar services are acutely aware of their competition and know exactly how they position themselves and communicate to potential investors. Because of the availability of information through the various modes of communication, this can also be seen in the graphic arts community. Those recognized for their work are often the ones setting the style and the standard for the industry.

Yet it is the book that can break away from these influences that transcends time. No matter the economic condition of the country, the newest fashion trend, or the latest electronic capability, the book still must speak to the audience and define the company through effective design. Several companies already have achieved this type of reputation for delivering meaningful messages in association with provocative design year after year—Progressive, Herman Miller, and Northrop Grumman (featured on pages 52–54) are just a few.

Annual reports have become the cornerstone from which companies are branching off into CD-ROMs, Websites, and other forms of communication to create and promote their identity. Creating an annual report that communicates in multiple media gives it longevity; perhaps these will be the annuals that transcend time.

Trends come and go. The true success of a book can be seen when it continues to receive recognition and provoke conversation years after its production. Then a designer knows he or she has done the job well for both the client and the shareholders while maintaining the integrity of good design.

—Julie Busse

Director, Mead Annual Report Show

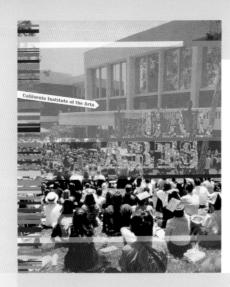

e i s u r e

Rancho La Puerta Tienco

Welcome! from Fitness Director Phyllis Pilarim

Jazz 1996 CD

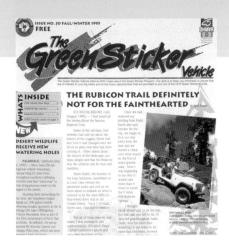

Need to get the word out about your theater company's new season? Own your own arts and crafts shop, but can't reach potential buyers? Just gone public with your chain of sporting goods stores and have to produce your first annual report? This section focuses on design that deals with special needs.

As you peruse these newsletters, you'll see that each has found a unique solution for presenting a sense of "experience." For example,

Whether they highlight the arts, sports, or travel, the publications in this section have one thing in common—each is designed to sell an experience.

take a close look at *The Green Sticker Vehicle*, produced for the Off-Highway Motor Vehicle Recreation Division of California State Parks by California State University, Sacramento. From the jazzy masthead with its green "tire-tracks" to the tipped-in illustrations and pictures—everything about the cover says "go!" Even the contents box, bordered with a wavy line, seems to be set in motion.

In addition, many of the "Leisure" newsletters feature striking redesigns. There are as many reasons for enhancing or redesigning a solid layout as there are publications. However, most leisure-related newsletters do so to recapture a changing audience. For example, each year ReVerb, Los Angeles, reinvents its design for *CalArts Current*—the newsletter for the California Institute of the Arts—as a celebration of the new school year and its new arrivals.

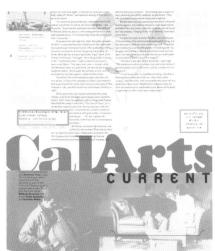

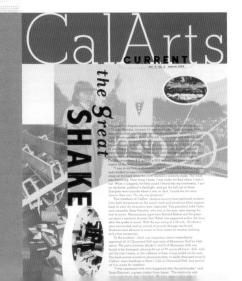

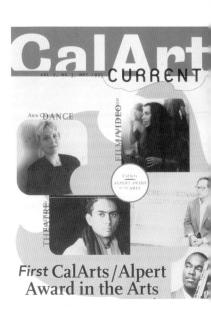

C/ H/ A/ P/ T/ E/ R

A well-made arts publication is a metaphor for the organization or company it presents. A shining example, CalArts Current reflects the independent university it covers: its electric page design, like the school, contains a barely-restrained energy. This "sizzle" echoes the exciting atmosphere of the CalArts campus and its various art disciplines: reading the newsletter is like taking a walk on the campus, or watching a performance.

Powerful synergy between product and publication is a hallmark of

good design—but it is especially critical for arts publications, which often must convey topics or events that might seem less tangible to the reading public than goods or services. The selections presented here are a valuable study in building a metaphor for a particular organization or corporation. Well-made graphics highlight the chosen subject and offer interesting solutions for such inflexible design elements as season calendars or sponsor acknowledgment pages. Notice how fact-based sections get added spice from simple illustrated motifs

or elegant choices of sans serif type.

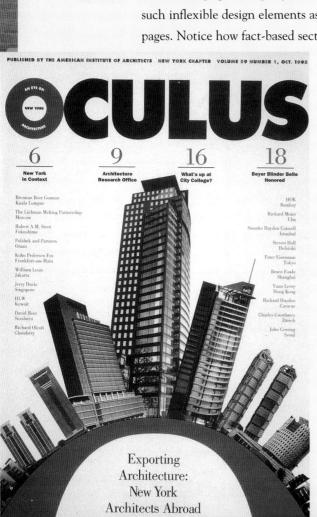

the pages

If you mixed Entertainment Weekly with Spy and added a touch of an underground 'zine, this is what you'd get. Published by MTV Networks' Creative Services department, The Pages covers the worldwide happenings at Nickelodeon, Nick at Nite, TV Land, VH1, M2, and of course, MTV.

INSIDE...is your chance to win a deluxe trip to Puerto Rico or Los Angeles. Don't be a loser — enter now!

TRIM SIZE is 10" x 13 1/2" (25cm x 34 cm)

SIXTEEN-PAGE, TWO-COLOR MONTHLY

Spring Hill Incentive 100 Offset 70 lb. TEXT STOCK

BODY FONTS INCLUDE Gill Sans, Bell Gothic and others

CIRCULATION: 5,000

FEATURE COPY LENGTH: 1,000 words

LAYOUT PROGRAM: QuarkXPress

HARDWARE: Macintosh

EDITOR: Cheryl J. Family DESIGNERS/CONTRIBUTORS: Jason

Chappelle, Noel Claro, Mike Eilperin, Wendy Lefko, Mia

Quagliarello and Ken Saji.

Too Hip

When editor Cheryl Family started *The Pages* she had a definite feel in mind for the publication. Remembers Family, "Well, you can imagine that it was a challenge to come up with a design that could compete graphically with what our channels had on and off the air. So I decided to give *The Pages* an underground look, sort of grassroots and, for lack of a better term, disenfranchised. It's definitely of the people, by the people, and for the people."

Size Wise

The unusual size of this newsletter is meant to cut through the clutter on employees' desks so that they will pick it up and give it a few minutes of their time. The original format was actually larger than the current 10° x $13~1/2^{\circ}$, but readers found it difficult to handle on their subway rides to work. "It was just too big," she says, "and tended to invade other people's space." Family also made the layout more reader-friendly. Originally, type ran vertically as well as horizontally; again, this caused a bit of a snag for cramped commuters.

Templates? What Templates?

Family refers to *The Pages* as "down and dirty," and everything about its design certainly fits this dynamic description. There is no real template for the layout. Each page stands on its own, and often resembles a grunge band handbill. "I like to think of it as incredibly well-thought-out chaos." However, as the newsletter grows, small concessions to typical design set-ups will ultimately creep in to save time and provide some sort of organization.

Experimental Graphics

In keeping with the underground feel, designers experiment with background colors, tints, and duotones. However, Family admits that this doesn't always work to the benefit of design. Sometimes the freewheeling approach makes for some muddy spreads. Yet, more often than not, the serendipity inherent in trying the unexpected pays off in striking new looks.

The Pages designers also play around a great deal with fonts. In fact, as far as they're concerned, too much is never enough. This, along with wacky head-line treatments, makes for a highly energetic layout.

Say No to Non-Exclusives

Press photos rarely appear in this publication. The editorial staff owns one little Olympus camera that gets passed around from staffer to staffer, from event to event. Says Family, "Because of our vantage point at rehearsals or just around the office, we get some great off-beat photos of celebrities." These candid treasures aren't treated specially—they're developed at the local one-hour photo, scanned, and masterfully slapped on the page.

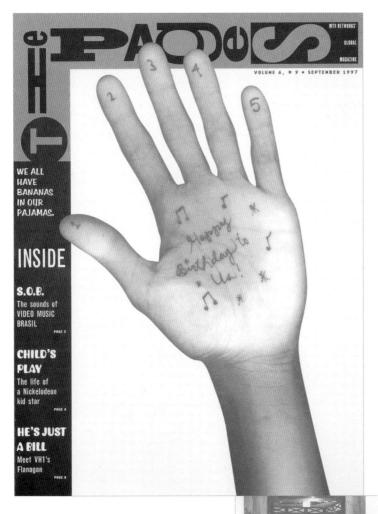

THE OUTPOST INDEX

- Overheard at the candy bin:
 "Um...Could we get a guard over here?! This isn't all you can eat, you know!"
- In a popular 88 movie, a disembodied voice from beyond whispers, "If you build it, they will come." But, as a wiser disembodied voice would say. "If you build it and offer fee food, they will come in droves, scam passes from each other little papal indulgences, and then eat everything in sight." On June 25, The Outpost, The Lodge's satellite location on the concourse level of 151 Broadway, opened for business with a free food kick-off for PERKS.

Our correspondents in London, Disseddorf and Atlanta gave us an ear- and eyeful this month. Jayiya Epega, Assistant/Coordinator, StudioFacilities, MTV Europe, gave us the skinny on her department's retreat to Porrugal falong with photographic evidence). Frailein Carol Cate, Manager, Programming/Viewer Services, Nickeldoson Germany, worte to us at the summer's start, gefulily announcing the office's access to company-wide e-mail. And finally, Sal Dalvi, Account Manager, Allilians Sales and Marketing, Southeastern Region, let THEAT with the count of the 1996 Summer Olympics.

The TREAT In mesously south of the Issue for release.

On the cusp of the 1996 Summer Olympics.

RE TRIAT

On Jon LATTY Group's floating-friedmen spartness and for Couns of Laps, Principal, single gind Play McDowle.

Indicate Vice President/Clarf Francial College, and Asiley

Group's Clark College College College College College

Annual College College College College College

Annual College College College

Annual College College College

Annual College College

Annual College College

Annual College College

Annual College

A

HUMAN RESOUR NEWS RESOURCES

you satisfied until the next issue of THE HaRd FACTS slides into THE PAGES.

THE SPECIALIST

THE SPECIALIST

All members of the Aetru Health Managed Care Flan should note a change in policy on specialist referrals. Referral authorization for research of certain chronic illustrate size of the specialist referrals in the second size of the specialist referral chronic applies to specialists out as lifergies and immunology, cardiology, endeconlogy, interchain disease, pulmonary medicine, enceclogy/mematology, neurology and rheumanology. Also be aware that this looky applicable to specialists with the Aetra network for those teeing specialists out-of-network, fact that of the specialists out-of-network, fact that continues to determine medical necessity every 90 days. That's nothing to sneeze st.

NETWORKING ON THE NETWORK

NETWORKING ON THE NETWORK
Exploring your options, but can't plick up a capy of the latest job postings? (Or maybe you're just tago) iden lews. MTV Networks Job Postings can now be accessed on ermail. Follow these easy steps and — whatdpak troop — the postings are asy pood as yours:

1. Go into ermail and select. "COMPOSE."

2. For "TO," select. ATTVN JOB POSTINGS from the global address list.

3. For "SUBLECT" yee you DO POSTINGS from the global address list.

3. For "SUBLECT" yee you DO POSTINGS from the global address list.

3. For "SUBLECT" yee you DO POSTINGS from the global address list.

3. For "SUBLECT" yee you DO POSTINGS from the global address list.

4. Click on "SEND."

"You'll not only receive the listings within minutes, you'll also get instructions on how to post for your dream job once you've found it. You have a rew chance each week to pervise the postings—— as with the hard copy, they softlings are mailable on-line beginning servey Tuesday. 2 Preguntat Call feet Kalinsky, Manager, Satfling Resources, at (212) 238–7893.

THE PAGES 7 AUGUST 1996

spens as your money in one pace.

Wondering what is do with the label this weekend Ludy for you, they can be charp dises at
Discovery Zone, MTNN employees can purchase
tokenes for a permy sto 6% to be used at any
Discovery Zone in the world. Adults and
children owo years of age and younger are
admitted for free interested? Send a check or
money order purples to Discovery Zone to
Jojo Barnes, Employee Events (address above).

The NATPE Monthly

NATPE is the acronym for the National Association of Television Program Executives. To keep members up-to-date on events and workshops produced by NATPE throughout the year, the Creative Services department developed The NATPE Monthly.

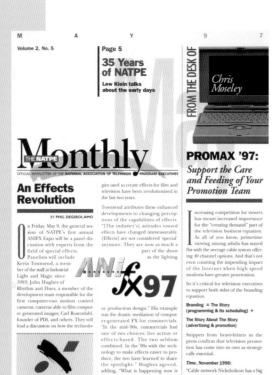

TRIM SIZE is 7 7/8" x 11" (20 cm x 28 cm) with gatefold SIX-PAGE, FOUR-COLOR MONTHLY (free to members)

Topkote Dull Book, 100 lb (150 gsm) Text Stock

New Baskerville BODY FONT CIRCULATION: 15,000

FEATURE COPY LENGTH: 750 words

LAYOUT PROGRAM: QuarkXPress
HARDWARE: Macintosh

EDITOR: Beth Braen, NATPE vice-president of creative services. DESIGN: Ross Waldorf and Ken Camner of Dog Ear Design based in Los Angeles, California.

To Color or Not to Color?

When editor Beth Braen met with Dog Ear Design to discuss a new layout for *The NATPE Monthly*, she brought a lot of newsletters with her. "I showed them examples of what I wanted and what I didn't want. Mainly I explained that whatever we came up with, it had to be colorful and yet have a lot of white space."

Artists Ken Camner and Ross Waldorf took this statement literally. When they built their template, they decided to alternate colored backgrounds with large areas of white. For example, if the statistics column, "Bytes From Baseline," has a pastel green background, then the adjacent "Washington Update" will lie on top of white (opposite page, top). This allows the reader's eye to relax and easily define areas of interest.

Carefully Woven

Camner and Waldorf create texture in their work by placing elements with contrasting attributes next to each other. Notice how the soft edges of the U.S. flag illustration placed next to the hard edges of the word "Washington" create energy in the "Washington Update" headline.

Once Is Never Enough

No one wants to start the day with an angry call from a member upset over a misspelled name. To avoid embarrassing copy mishaps, Braen hires top-notch freelancers, writers she knows will provide lively copy that has been fact-checked. After designers lay out a story, Braen reads it several times, then sends it to her staff for double and triple copyediting passes. Before *The NATPE Monthly* goes to press, it gets a last look from the NATPE president. "No one knows our membership better than Bruce Johanson. He's definitely been known to catch a few caption errors—the ones that we can't see after the third or fourth reading," says Braen.

Word Power

Type can be used to activate an otherwise quiet area. Camner and Waldorf suggest running type vertically on occasion or, like an illustration, allowing it to cross the borders of an adjacent feature.

Here a Font, There a Font...

The Dog Ear artists use more than twenty different faces in *The NATPE Monthly*, a choice they actually warn against. Says Waldorf, "If you're just getting started, try not to use too many fonts. It's typically a dangerous choice because it can make your layout look cluttered. Because *The NATPE Monthly* requires so many little headlines and breakouts, we decided to forego this rule of thumb. However, we're very careful to place fonts that complement each other side-by-side."

Up in the Sky

Direct Broadcast Satellite (DBS), is raining down hundreds of digital quality channels onto an ever-increasing number of American homes. By aggressive astimates, Paul Kagan Associates projects 10 million DBS subscribers by 2003 (a growth of over 100% from today) with an annual subscription revenue of \$6.9 ful-(an impressive rise of 263%, with a 41% mark-up in subscription rates). The US cable industry, on the office hand, looks to increase its subscriber revenue from \$23.9 bil today to \$47.5 bil in 2003 (with a 98% growth). The race continues.

Europe Wired

elevision for a long time. But cable access is on the rise in a big way. According to PKA, there are currently 39.3 mil basic cable subscribers in Westen Europe and 12.6 mil in Eastern Europe. By 2005. compare and 12 or mill in Lastern Europe. By 2005, those numbers are projected to increase to 59 million and 30 mill, respectively. That would mean increase of 40% and 121% in penetration of TV households (to 45.7% and 32.8%), and overall increases in annu-revenue of 138% and 362% to \$13.6 bit and \$1.8 bil). Interestingly, with cable rate increases of 55%

day cheer through TV movies and specials And everyone's getting in on the act, with no less than 20 projects in the works. Angela Lansbury returns to TV with the CBS musical comedy Mrs. Santa Claus. The Family Channel offers Christmas in Toyland With Michelle Kwan, an Ice Capades presentation. Sally Field makes her directorial. debut in the ABC family drama The Christmas Tree. Fox revives that ghoulish "60s sitcom family, once again for The Munsters" Scary Little Christmas telepic. NBC presents its perennial variety favorite Christmas in Washington. And PBS will be showing Elma Saves Christmas starring Sesame Street's little red monster.

Baseline is the definitive online source for selection and film information. Subscribers may access the Baseline databases may the Internet on through a direct dial-up service. To find our more about Baseline products and how to subscribe, call I-800-CHAPLIN or e-mail info@pkbaseline.com.

A survey indicates that the No. 1 gift adults will receive this Christmas will be abdominal exercise gadgets. Says Steve Tatham, "That means 1997 is going to be a busy year for garage sales."

Web TV, a television set-top system that allows consumers to surf the Web via their TVs, has been classified as a weapon by the U.S. nt, reported the New York Times. The reason for the classification is the powerful computer-security technology Web TV employs.

The Election Impact on FCC's Policy Agenda

ith President Clinton's re-election, you can expect the administration to rere-election, you can expect the administration to re-nominate the FCC's current Common Carrier Bureau Chief, Regina Keeney, to the Commission's vacant Republican seat as soon as the 105th Congress convenes in January. President Clinton also has the option to nominate a new Democratic Commissioner if the administration decides to replace the highly esteemed Commissioner Jim Quello, who currently is serving in an expired term.

"If" is the operative word, because no one inside the Beltway is quite sure how the Republican-led 105th Congress will react to the FCC nominees from the new Senate Commerce Committee Chairman John McCain (R-AZ) favors a Republican other than Kinney, he

NATPEView The Online Virtual Marketplace

This month marks the launch of NATPE's

This month marks the launch of NATPE's that mortestical collection for the NATPE's business ro-business web site is designed to give trelevation indepting professional information on member companies and their product (programming) in a very lost is early to update and carabital 24 hours a day 355 days a year. "As the moditional program selling season in being spread out over the Collecting years." It is notificated programma years. It is not to the collection of mortesting. The online exhibition has a search engine that allows cares to consentences enthaliation has an ascerd engine that allows cares to consentences enthaliation has a search engine that allows cares to consentences enthaliation.

search engine that allows users to cross-reference information based on a company's name, the type of company or program type.

Zentropy is Television on the Internet.

Taking the burden of Internet communications off you

> Original content creation Online marketing & promotion Online commerce Technology

Call us 213,525,2545
See us @ www.zentropy.com and at NATPE 197
Zentropy is the cificial internet services provider to NATPE

THE **NATPE** MONTHLY

Executive Editor – Beth Braen
Editor – Todd Barasch
Copy Editor – Gary M. Johnson
Graphic Design – Dog Ear Design
//Print Production – Koehler & Co./ D.I.S.C.

Monthly

1-800-NATPE-GO

Prime Time

CONTINUED FROM THE COVER

You have mixed emotions."

Law & Order.

crash? Stay tuned.

http://www.natpe.org

VATPE BOARD OF DIRECTORS Then Carsey-Werner's *Townies* meets Witt-Thomas's *Pearl*, whose exec producer Don Reo faces another of his creations, John Laroquette. "It's kind of like watching your mother-in-law drive off a cliff in your new car," said Reo. Star Trek: Voyager travels to 9, facing a comedic onslaught including three high-profile newcomers: Bochco/Tarses' Public Morals, C-W's Men Behaving Badly and WB's Jamie Foxx. Then at 10, Universal faces itself when promising rookie EZ Streets meets grizzled veteran Will the season's changes click or As a freelancer specializing in television As a prevancer specializing in television, Harvey Solomon writes articles, scripts, proposals and speeches. His phone and fax number is 213-938-5845.

PAID

Broadcasters At Risk?

TV Spots Preventing
Handgun Violence

TV

IMPORTANT EVENTS AND HAPPENINGS

June

PROMAX'97

Oculus

Published by the American Institute of Architects New York Chapter, Oculus gives architects and enthusiasts an inside look at design trends, commissions, and new or unusual commercial buildings, homes, and neighborhoods.

New York
In Contact

Research Office

Re

TRIM SIZE is 7 1/2" x 11" (19 cm x 28 cm)

TWENTY-FOUR-PAGE, TWO-COLORplus spot-color issued ten times per year

Finch Opaque 70 lb (105 gsm) TEXT STOCK

Bodoni Book BODY FONT CIRCULATION: 5,000

FEATURE COPY LENGTH: 2.000 words

LAYOUT PROGRAM: QuarkXPress

HARDWARE: Macintosh

EDITOR: Jayne Merkel. DESIGN: Michael Gericke and Edward Chiquitucto of Pentagram Design Inc.

Design Metaphors

When Pentagram designers Michael Gericke and Edward Chiquitucto began work on *Oculus* they played around with the shape of the letter O. Taking a cue from the flag subtitle, "An Eye on Architecture in New York," they thought of O as a metaphor for the eye of the viewer or the eye of a camera focusing in on a building. For this issue, they used the O shape as both a frame and a border for a photo of Bausch & Lomb headquarters. By setting up a pattern and then breaking it with a strong shape, their design forces the viewer to zoom in on the highlighted image.

Power Covers

Great covers make or break a publication, especially one like *Oculus* that competes with high-budget consumer glossies on New York newsstands. Here's another example of eye-catching design. This rendering of the Karet Office Tower in Indonesia (left) looks like a spear stabbing at the heavens. Pentagram designers heightened this by allowing the image to cut into the flag. "After a publication has established a memorable identity," says Gericke, "designers can obscure the masthead with an image. It gives the cover more interest and engages the reader."

Smaller Can Be Better

Editor Jayne Merkel thought that making *Oculus* slightly smaller than a typical magazine would create interest. She also thought that it would make it easier for architects to fit the pub in their typically stuffed briefcases. "Besides," says Merkel, "The thinner look reminds you of tall buildings."

Balancing Text and Image

Oculus is made up of four thin columns, like skyscrapers standing together. Images appear in the outer column and are no wider than its borders. The exception to this are horizontal images sized to take up exactly two column widths (opposite page, top). Says Merkel, "In Oculus, images support the text, not the other way around."

To Color or Not to Color

Young designers often are afraid to create in black-and-white. If they don't use all the colors in the rainbow they worry the reader will feel cheated. In this sophisticated example, lack of color is an asset. Because the photos are so exceptional and the layout is so buttoned down, readers don't notice that *Oculus* is a black-and-white publication. In fact, color would detract from its mission—to inform through text.

Simple Shapes

Like many great architects, Pentagram artists know that it doesn't take much to really liven up a design. Here are two fun examples of simple shapes creating energy in a spread. The first uses circular shapes to form a familiar image. The other uses text to create a triangular shape that pulls the reader's eye across the page. Note how the use of large drop caps creates energy within the copy. Without these, the heavy title might be overwhelming.

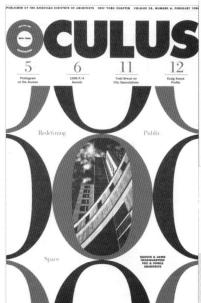

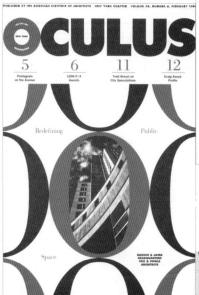

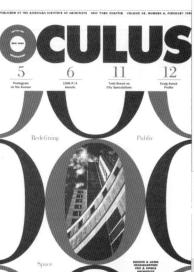

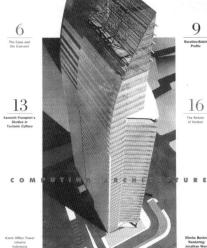

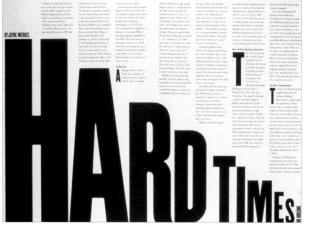

Christie's Art

Published by Christie's—one of the world's most prestigious auction houses—to inform and educate the new collector.

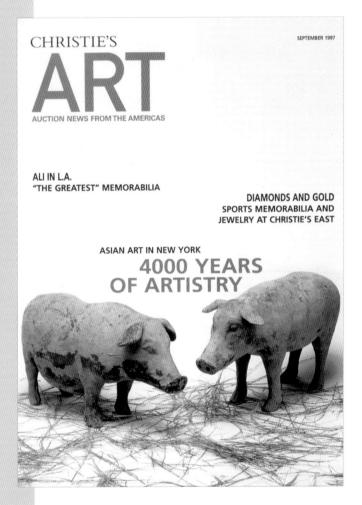

TRIM SIZE is 9" x 12" (23 cm x 30 cm)

TWENTY-FOUR-PAGE, TWO-COLOR, issued nine times per year

76 lb (115 gsm) matte TEXT STOCK

BODY FONTS INCLUDE Christie's Bembo and Frutiger

CIRCULATION: 50,000

FEATURE COPY LENGTH: 500 words

LAYOUT PROGRAM: QuarkXPress

HARDWARE: Macintosh

SENIOR EDITOR: Marissa Wilcox. Director of Creative

Services, Skip Pollard; SENIOR ART DIRECTOR: Lynda

Havell; DESIGN: Martin Schott.

Lighten Up

Christie's is famous for its auction catalogs. The functionality of these publications requires that each offering be photographed in even, museum-style light. Photographs are cropped similarly and laid out in a scholarly fashion.

When Skip Pollard began the recent redesign of *Christie's Art*, he moved away from the catalog format. Working with his creative staff and Meredith Ethertington-Smith of Christie's London office, he developed a playful look that appeals more to the publication's target audience.

Photos now float in text and, as Pollard points out, actually are treated with a bit of whimsy. "Our first issue," says Pollard, "features a shot of seventeenth-century terra cotta pigs. They are well-lit, but instead of placing them on a pedestal, we placed them in hay."

Rich Design

The Christie's Art template is not set in stone. The choice between two or three columns depends entirely on the look and focus of a particular spread—definitely a more magazine-like choice. However, the overriding rule is to keep the focus on art, rather than copy or headlines.

Notice how the "4000 Years of Artistry" headline (opposite page, middle)—although immediately legible—seems to recede into the background while bringing the images to the fore. Also, in keeping with the mission of the publication, photographers style the property as it might be for an upscale retail store window (a symbol of accessibility), but the historic nature of the elements lends a touch of aristocracy to the design.

What Was That Date?

Placing the monthly calendar of events on the center spread makes it more user-friendly—and easier to tack up on a bulletin board.

Drawing Them In and Keeping Them There "In keeping with our goal to educate new collectors, our first issue [after the redesign] included a history of rugs and carpets (oposite page, middle). Although this sounds rather staid, it proved to be a fascinating topic," explains

Adding an element of intrigue, the publication's designer used a simple trick. The two featured carpets are arranged so that an entire pattern is apparent but only a small portion of either rug is seen in full. As the reader begins to picture the entire rug, he or she is brought into the page. The placement also hints at movement, as if the images themselves are flying past the text on some mysterious journey of their own.

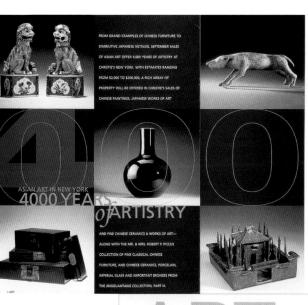

CHINESE CERAMICS AND WORKS OF ART

in September 19, Christic Community of the Christic September 19, Christian September 19,

Direction point via territorica, de continue del discourse des discourse des de la continue de un de la continue de la continue de un de la continue del la continue de la continue del la continue de la continue de la continue del la continue

the legacouse first III, where is Kinney Sone point (III) III. The presence of the III III. The IIII. The III. The III. The III. The III. The III. The III. The IIII. The III. The III. The III. The III. The III. The III. The IIII. The III. The III. The III. The III. The III. The III. The IIII. The III. The II

signs of a place of facilities are all administrations (see a sign) of 25 on 0.0 killing interest. (2010) 2020 The convent continues and facilities for the signs of a continue of 25 ones or humanities from 6 of a continue of 25 ones or the continues of 25 ones or the continues of 25 ones or the continues of 25 ones or 15 ones or 15 ones of 25 ones or 15 ones or

see an object of a symbol of the Stakes and Child and were long Stakes in you to get the Stakes and Child and some long signaling in common generality of foliam and beared group Stakes is that in some long and otherwise day, more some that covering were used to inferred day may not seen and the sold and should be staked got such a signal was a malligate for stakes. Some long the day are the some longhing the probability of the stakes of the stakes of the bootstakes that it was not support days and the part little of the stakes of the his consequent their three VIII is and the four long to Children.

Addition of the second of the

In the day pleases that despite of Egish engine in institutes are Kannesse.

From the Kannesse.

From the time world, I steer, and Enterpose is upper, and fight proachly woulder institution. All the power offices, which would be instituted, before a first power office. That will 50th (minimum bosine of the days a collection of the institution of the ins

When being on along supplied in golds with in a supplied in such as the condition of their relative in their golds in the content of the condition of their relative in the golds in their anterpretation and in the condition of their their condition for their conditions of their conditions and their termination will be such as the driver to whether a product group, they be their are never than 1.5 is can also all intercent on plant or their conditions are often as the condition of their conditions of their conditions.

Larger than 6' x 9' is a carpet; smaller is a rug'l

Charter control control or an author and allow haloes and a control or an easy of a control or an easy of a great set and a control of a control of

compete and several following.

The September 5 counting allow haldows a bounded as and outlier contractional range and large research repulsar golds or sealing a contraction of the process of the proc

obbined styling one at Christich has Newsoper had been become to an energy of drosen mehr at Charles 21 km of France also and the December C. Empress and Oriental expensation. For more interestation on any of their major at most in a Christic reproduction of any of their major at most in a Christic reproduction of any or a southern and place in coll.

on Associate Copyel Event on the consumption field district the first term of the construction of the cons

CALENDAR of upcoming Sales

SALE	DATE/LOCATION	ON VIEW
From the Pennsylvania German Folk Art and Decorative Arts	Saturday, 6 at 10 am	
Collection of Mr. and Mrs. Paul Flack On the Premises, Holicong, Pennsylvania	and at approximately 1 pm on premises	September 4-5
The Nineteenth Century	Thursday, 11 at 10 am & 2 pm at Park	September 6-10
Antique and Fine Jewelry	Thursday, 11 at 10 am & 2 pm at East	September 6-10
Japanese Works of Art	Wednesday, 17 at 10 am at Park	September 13-16
The Mr. and Mrs. Robert P. Piccus Collection of Fine Classical Chinese Furniture	Thursday, 18 at 10 am at Park	September 4-17
The Jingguantang Collection, Part III	Thursday, 18 at 11:30 am at Park	September 13-17
Fine Chinese Ceramics and Works of Art	Thursday, 18 at 2:30 pm at Park	September 13-12
Fine Chinese Paintings and Calligraphy	Friday, 19 at 10 am at Park	September 13-16
Finest and Rarest Wines		
including the Collection of Belle and Barney Rhodes	Friday, 19 at 2 pm and Saturday, 20 at 10 am & 2 pm	

SALE	DATE/LOCATION	ON VIEW
Sports Memorabilia	Saturday, 20 at 10 am & 2 pm at East	September 13-
Fine Jewels	Tuesday, 23 at 6 pm at Los Angeles	September 6-9
Asian Decorative Arts	Wednesday, 24 at 1 pm at East	September 21-
The Henry Stern Collection of Antique Glass Paperweights	Wednesday, 24 at 10 am at Park	September 20-
French and Continental Furniture	Wednesday, 24 at 2 pm and Thursday, 25 at 10 am & 2 pm at Park	September 20-
Fine European and Oriental Carpets	Tuesday, 30 at 10 am at Park	September 27-
Furniture and Decorative Arts	Tuesday, 30 at 10 am & 2 pm at East	September 26-
Spink America United States and Worldwide Stamps and Covers	Tuesday, 30 at 2 pm at Park	September 26
Shinkar subgest to sharige. Mode off 212-271-4486 for contributions		1

CalArts Current

CalArts Current, a nine-year-old publication, celebrates the independent personality of the California Institute of the Arts.

Headquartered in Valencia (just outside Los Angeles), the school and newsletter's shared goal is to nurture the progressive and creative spirit of its student body.

EIGHT-PAGE, TWO-COLOR TABLOID issued three times per school year GLOSSY TEXT STOCK

Elegans BODY FONT

CIRCULATION: 20,000

FEATURE COPY LENGTH: 750 words

LAYOUT PROGRAM: QuarkXPress

HARDWARE: Macintosh

PRODUCED BY ReVerb, Los Angeles, a studio employing

California Institute of the Arts alumni Somi Kim and

James W. Moore. Published by CalArts Office of

Public Affairs: Anita Bonnell, DIRECTOR; Chris

Meeks, EDITOR AND WRITER; PHOTOGRAPHY by

Steven A. Gunther and Rachel Slowinski.

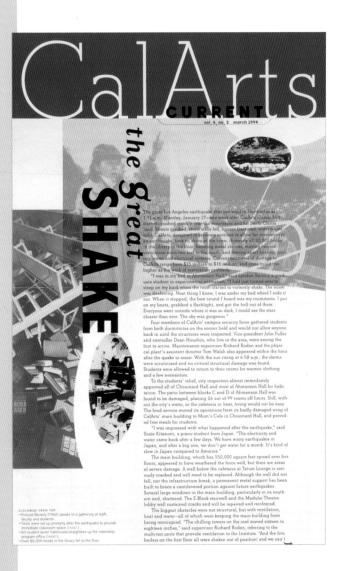

Stay Flexible

"We still use an adaptation of the Current's original template designed by Caryn Aono (CalArts director and design program faculty) simply because it is so flexible. Each page has six columns that can be divided in half plus twenty-four vertical modules," says Somi Kim.

In March of 1994, design took a back seat to a pressing editorial issue—the Northridge earthquake (left). Devastated by the temblor, parts of the main campus had to be shut down. However, classes continued at satellite locations. Says editor Chris Meeks, "Editorial became very dense at that time; we had to get out a lot of important information concerning class schedules, locations, and the progress of rebuilding. Since 1994 we have tried to return to our original concept for editorial—'keep it short and sweet.'"

Don't Overdo

The design of the *Current* is flamboyant and free-spirited, like the institute itself. But sometimes, as Meeks attests, design does not support readability. "I encourage the ReVerb team to experiment, but I also insist that each issue be easy to read. Illustrations laid behind text sometimes make copy illegible. Or it may not be clear where an article begins and ends. In these cases, I simply offer notes and we come to a creative compromise."

Creating the Look

Each fall, ReVerb creates a new flag for *CalArts Current*. Although the overall design remains similar in tone, the "new" look allows incoming students to feel that they have some ownership in the publication. This fresh approach also conveys a vital message to the arts community (and nearby entertainment industry); that the Institute is constantly evolving.

"We've always loved the calligraphic shapes of the ornamental swooshes on certificates and diplomas," Kim says, "so James and I simplified that inspiration into the single decorative element that you see in the flag."

Moore and Kim carried the motif through spring 1996, using swooping shapes created in Adobe Illustrator as backgrounds and frames for photo collages. Although the tabloid-size *Current* runs on medium-quality glossy paper, its creative team stays within budget by printing just two colors. Hues are screened back, combined, or manipulated to look like a full-color palette.

CalArts Course Catalog

"When I start laying out a spread I tend to focus on one area first. The most important element of this spread was the calendar, so I started with that. Then I tried to lay out the rest of the pictures and copy on diagonal lines, so that the readers' eye would move easily between the pages. Whenever I got stuck, I just start moving things—as if the elements were puzzle pieces—until the design felt right."

—James W. Moore

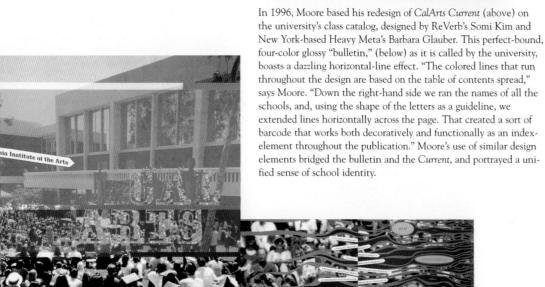

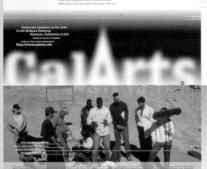

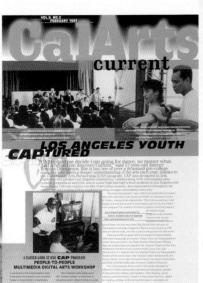

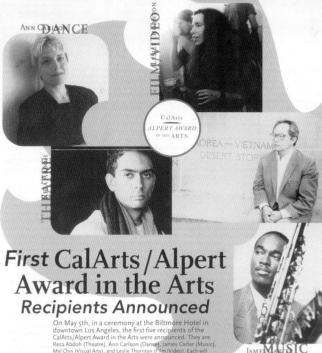

New Pacific Writing

New Pacific Writing supports the growth of Mānoa: A Pacific Journal of International Writing, published by the University of Hawai'i. It provides snippets of text from stories featured in upcoming editions, as well as news about the Journal and its activities.

TRIM SIZE is 8 1/2" x 11" (22 cm x 28 cm)
FOUR-PAGE, TWO-COLOR QUARTERLY
Evergreen 70 lb (100 gsm) TEXT STOCK
GOUDY BODY FONT
CIRCULATION: 1,000
FEATURE COPY LENGTH: 250–500 words
LAYOUT PROGRAM: QUARKYPress

EDITORS: Frank Stewart and Pat Matsueda.

DESIGN: Rowen Tabusa.

HARDWARE: Macintosh

Creating a Feel

Designer Rowen Tabusa brings the feeling of the Pacific region to his design through hand-crafted imagery. For the background of the flag he scanned a piece of apa cloth—the vibrantly patterned material created by Hawai'ians with dyes made from native plants. Borders are also created out of various apa patterns. In addition, Tabusa drew a logo for Mānoa, the parent publication of New Pacific Writing, which is acknowledged on the back cover of each issue. This stylized view of an island-scape is reminiscent of a wood-cut.

Say More with Words

Because this publication is for readers and writers, designer Rowen Tabusa works to make the copy, rather than the images, stand out. Unlike most newsletters that pack in the text, this copy is double-spaced for easy reading.

Be Friendly

"Manoa can look somewhat imposing with its thick, book-like spine and small type," says editor Frank Stewart. "The goal of the newsletter is to draw readers into the journal; to interest them in upcoming issues by being friendly, accessible, and newsy." Tabusa's use of ample white space and simple graphics supports this mission. Like its home island, the layout is open and inviting.

C/ H/ A/ P/ T/ E/ R

S

Perspectives

Member loyalty gets focus in '97

What could be more exciting than whizzing down a slope of powder on a brand new Ride snowboard? Probably the choice to invest in the company. However, even in the realm of sports, excitement isn't necessarily something a typical stockholder wants. For VSA Partners, the Chicago-based design firm chosen to create snowboard manufacturer Ride's 1996 annual report, the number-one concern was to convey, through visuals, that a manufacturer producing trendy new sports equipment has established a reputation worth banking on.

VSA's striking design, which combines the look of

views of highly skilled craftsmen and executives in business attire, evolved from Wall Street research.

hip-hop, the beauty of the wintry outdoors, and

Excitement isn't necessarily something

your typical stockholder wants.

By doing their homework and checking out the company's perceived strengths and weaknesses in the investment community, they knew what they needed to show (and not show) to attract attention and build confidence.

As you peruse our feature on Ride and the other projects in this chapter, you'll see that good design doesn't just pop out of the air. If a design truly meets a client's

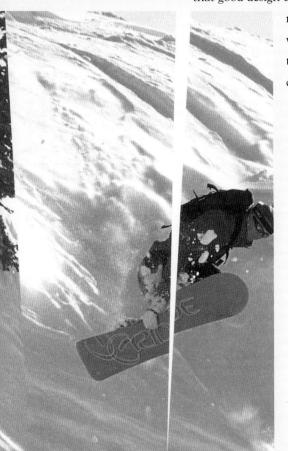

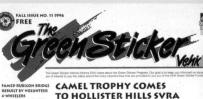

The Green Sticker Vehicle

The potential audience of The Green Sticker Vehicle is the 350,000 registered off-highway vehicle (OHV) owners and potential users in California. Chief among its missions is to educate the public on the location of approximately one hundred riding areas and the more than one hundred thousand miles of managed recreation trails and roads in California.

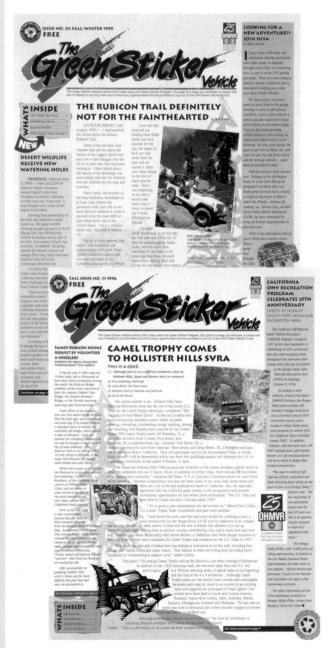

TWENTY-PAGE, SIX-COLOR, TABLOID ISSUED BIANNUALLY

Vision Matte 45 lb (70 gsm) TEXT STOCK

Weidemann BODY FONT

CIRCULATION: 40,000

FEATURE COPY LENGTH: 750

LAYOUT PROGRAMS: Adobe PageMaker and Macromedia

FreeHand

HARDWARE: Macintosh

EDITOR: Priscilla Davis and Clifford R. Glidden, deputy director of the Off-Highway Motor Vehicle Recreation

Division, a division of California State Parks.

DESIGN: Jim Molina of University Media Services,

CSU Sacramento.

Stick to the Basics

It may sound simplistic, but when sitting down to rough out a flag and template, it pays to think about the mission of the publication. The *Green Sticker Vehicle* is dedicated to green issues: environmental management, volunteerism (such as building trails), and outdoor recreation that treads "lightly on public and private lands." Therefore, Molina uses green in both theme and look. The words "green sticker" included in the flag designate the actual sticker required to operate an OHV on restricted lands. These words overlay green brushstrokes that resemble tire tracks—the kind made by tires that have a minimal environmental impact. Together, these elements convey a sense of adventure and responsibility. He also used green as a base color in graphics, page-number icons, and for some screened backgrounds and headlines.

Strong Composition

Molina's basic grid comprises five columns. For an interesting spread in the Fall 1996 issue (opposite page, bottom), Molina created definition between articles by shading one story background green and another white. In the story with the green, he gives each column its own free-standing background with white space between each. This choice follows the outdoors theme in two interesting ways: in one respect, the columns resemble trees leading up to green hills; in another, they look like tracks racing up a hill. Images placed loosely along diagonals run from the top of the left-hand page to the bottom of the right-hand page, and from the top of the right-hand page to the bottom of the left. It's a good basic composition choice, pleasing to the reader's eye.

Design They'll Read

Ever wonder if your newsletter actually is read and not thrown away? Editor Davis says, "We know people like the *Green Sticker* and save their copies because, for example, they mail in photocopies of coupon offers rather than cut up their newsletters."

Keep It Active

Every page in *Green Sticker* is active. The tilting of picture and text boxes is especially appropriate since this publication is all about going up and down hills. Even the contents box features squiggly lines around its ragged border (opposite page, middle)—like the lines denoting movement of characters in comic strips.

Custom Graphics

All the illustrations in *Green Sticker* are custom made to fit the expectations of the readership. "Our audience is quite specific when it comes to vehicle type so we need to have all of them represented," Molina says. "All of our illustrations are designed and or redrawn in [Macromedia] FreeHand. Most are one color, but some are colorized for impact."

Molina adds that creating a balance between intriguing illustrations and color photos can be complex. "Remember," he says, "the point is to draw the reader to the article, not wow them with graphics."

agaiii.

that the team is comprised grammers, laborers, other fields in that each

THE PRESTIGIOUS CALIFORNIA OHMVR COMMISSION 1995 AWARD WINNERS

CALIFORNIA OFF ROAD VEHICLE ASSOCIATION (CORVA)

In addition to the 1,850 ki

NEW OHMVR OFF ROAD PALS PROGRAM

Superior

CASTROVILLE GIRLS TRAVEL TO SAN BERNARDINO TO BECOME "OFF-ROAD PALS"

The Next Level: Ride Inc.

1996 Annual Report

The theme of this report is spelled out in its title, The Next Level. Ride began as a snowboard manufacturer run by young outdoors enthusiasts. With the market for snowboards choked by competition, the company needed to express progressive business philosophies that make it stand out from the pack: the foresight to bring on "experienced leadership"; "the ability to maintain the interest of distributors" through new products; and "the technical and manufacturing capability to raise the bar."

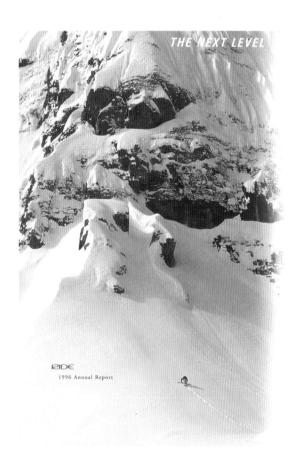

TRIM SIZE is 6.5" x 9.75" (17 cm x 25 cm)

NINETY-TWO-PAGE, FOUR-COLOR ANNUAL

Simpson Starwhite Vicksburg and Fox River Rubicon $\ensuremath{\mathsf{STOCK}}$

BODY FONTS INCLUDE Universe Condensed, Garamond

CIRCULATION: 40,000

LAYOUT PROGRAM: QuarkXPress

HARDWARE: Macintosh

COPYWRITER: Ken Schmidt. DESIGN: Curt Schreiber, Jeff

Breazeale. All are staff members at VSA Partners Inc.

The Big Picture

The biggest challenge facing any annual report designer is what to include. "There's always so much to cover that ideally you'd want to have three hundred pages," says VSA partner Ken Schmidt. "However, no one wants to read three hundred pages of data—no matter how pretty you make your layout. So you have to take a helicopter view of the whole story. Sort of get above it all and look down."

Defining the Big Picture

VSA met with financial analysts to better understand Ride's perceived strengths and weaknesses. Overall they learned that Wall Street confidence in the snowboarding industry is waning. To combat this concern, Ride and VSA focus on three themes: Leadership Through Innovation; Brand Building for Competitive Edge; and Broadening the Revenue Base.

Through images and graphics, these areas (each of which is a section in the book) create a balance between the stability of Ride's manufacturing prowess and the edginess of so-called Xtreme sports. Some images convey the handcrafted quality of Ride products. Others show the courageous, sometimes otherworldly, appeal of Ride logos.

Mix It Up

Here (opposite page, middle right) artist Curt Schreiber frames the eyes of a Mona Lisa-like board logo with swirls of white. In other areas of the book the designers make the wild world of snowboarding look sophisticated. Here, one of the company's cutting-edge logos looks serious and businesslike inside a fanciful border.

Sometimes You Just Know It's Right Image boxes with jagged edges frame photos show snowboard enthusiasts at play (opposite page, top). Often, portions of the same image overlay each other. On one hand, this is reminiscent of rocky crags and the wintry outdoors, even refractions in icicles. On the other, it feels like the careful

planning that goes on in a boardroom—ideas that jump to the fore are

carefully examined and reexamined.

Keeping a Balance

The Next Level opens with a double gate-fold (opposite page, bottom). The inside four-page spread shows the company's product line cleverly laid out with lots of white space. Although the arrangement of the boards in a sunburst shape brings an element of fun to the spread, the large amount of white space combined with images of the manufacturing and distribution process brings balance. This doesn't feel like a new over-the-top sport; it feels like it has a heritage akin to alpine exploration or climbing. Note how the colored banner in the middle ties all the elements together.

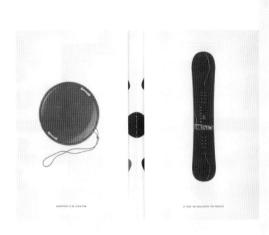

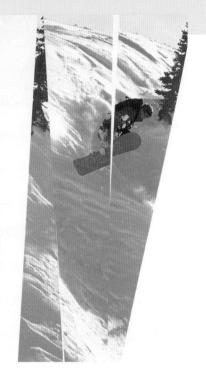

Ride, Inc. 8160 304th Avenue SE Preston, Washington 98050 206.222.6015

I. LEADERSHIP THROU

for technological leadersh and improve margins by:

that delivers tangible.

zierkelable censumar bauelitz

No.

COMPETITIVE EDGE faximize our competitiveness and gain market share profitably by:

Narrawing our broad facus

a fell-line expeller.

with resolvers and consumer

Increasing our visible presence so the mountain

reseace so the mean

III. BROADENING OUR REVENUE BASE

Create improved levels of lineacial performance and customer serisfaction by:

> build sacre-store apparel and accessories nates

> erd eccessories ribation channels beyond

Extending our reach into serling goods nickes beyond our core haziness through

service seppers.

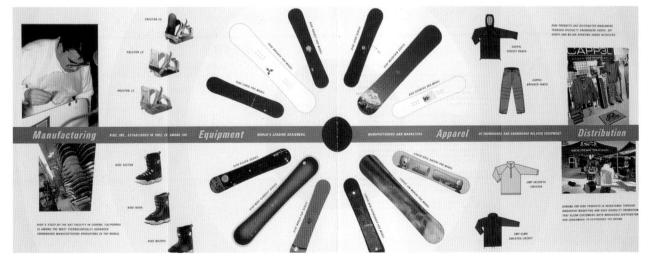

Compass

Recreational Equipment Inc., better known as REI, has been providing customers with "quality outdoor gear and clothing" since 1938. The company's appropriately named house organ, Compass, has served as a guide for employees since 1982. Its mission is to provide information pertaining to corporate strategies, store openings, and new products, as well as employee activities such as company-backed expeditions.

FOUR-PAGE TABLOID QUARTERLY

Sandpiper Mushroom 80 lb (120 gsm) TEXT STOCK

BODY FONTS INCLUDE Helvetica and Baskerville

CIRCULATION: 4,500, free to employees

FEATURE COPY LENGTH: 500 words

LAYOUT PROGRAM: QuarkXPress

HARDWARE: Macintosh

EDITOR: Cheryl Mikkelborg, corporate communications administrator for REI. DESIGN: Janis Olson of Janis

Olson Design. Both are based in Seattle, Washington.

Less Is More

When Compass first hit the presses it was filled to the brim with information; even employee anniversaries and awards were included. After a reexamination of purpose, management decided to cut production back from monthly to quarterly and to focus on the big picture. Now Compass includes only pressing corporate topics and the most interesting employee stories. This makes designer Janis Olson's job easier and more rewarding. She fits everything in and still has white space left open so that readers can actually see her work.

Every Little Bit Counts

Design conception should take every element into consideration. Since REI is all about getting involved in outdoor activities, the design had to reflect a back-to-nature feel. Olson used muted, earthy tones for her colors, woodcut clip art, and, of course, recycled paper. "It's these subtle underpinnings," says Olson, "that make your work feel and look appropriate."

Keeping It Together

When Olson began work on Compass two years ago, she gave the publication a mini-redesign. The earlier version had an adventurous feel but was so graphics-heavy it was hard to read. Olson's current design uses fewer graphics but runs them at an increased size. In addition, she is careful about her use of colored type. The best time to use colored type, believes Olson, is when it can be a linking element between copy and artwork. In this spread the chart on "Member Loyalty" is screened in green and surrounded by a green border. The adjacent story is set in green type.

Spend the Money

Everyone has to stick to a budget, but there are some areas where designers shouldn't skimp. One of these areas, Olson believes, is clip art. "Young designers often start out with the clip art included in their computer purchase package. This is cheap art so it ends up looking cheap. For Compass we purchased an expensive package. However, it's like money in the bank because it's the only package I use. If you try to combine clip art libraries your design begins to look messy. Think of your clip art as a unifying factor."

A Little Trick

You don't always have to use clip art to create a dynamic illustration. To set off a photograph of a climbing harness (opposite page, middle right), Olson created a border of triangles and diamonds in QuarkXPress by reshaping polygon boxes and filling them with color.

P. 3 WHAT MAKES REI **MEMBERS** LOYAL?

P. 4 **PRO-DEALS GET MORE ATTRACTIVE**

PERSPECTIVES

Wally Smith

Member loyalty gets focus in '97

Grant sees REI member-led expedition to summit!

REI HELPS "HEINVENT GOVERNMENT"

Harley-Davidson Inc.

1996 Annual Report

Chicago-based VSA Partners has a long-term relationship with its client Harley-Davidson. This is the sixth annual report the design firm has created for the motorcycle manufacturer.

Trim Size is 7" x 11" (18 cm x 28 cm) Seventy-four pages, plus pull-out poster, four-color

ANNUAL

Fox River Coronado 80 lb. (120 gsm) Text, Simpson Silverado

80 lb. (120 gsm) TEXT STOCKS

Cheltenham BODY FONT

CIRCULATION: 170,000

LAYOUT PROGRAM: QuarkXPress

HARDWARE: Macintosh

COPYWRITER: Ken Schmidt. DESIGN: Curt Schreiber, Ken Fox, Fletcher Martin. All are staff members at

VSA Partners.

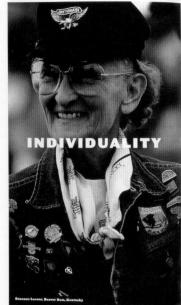

Bringing Worlds Together

A Harley owner could be anyone—the accountant next door, a local politician, even a grandmother. Part of the strength the company's brand lies in this universal appeal. However, not every investor connects with Harley culture. As VSA partner Ken Schmidt puts it, "Sometimes there's a bit of a disconnect between Wall Street investors and customers with Harley tattoos."

Bringing these two worlds together is a design challenge. For the 1996 annual VSA focused on the company's intangible assets—the qualities that make a Harley a Harley, and that make Harley riders so unique. VSA divided these qualities into categories and gave each category a striking one-word title like "Heritage" or "Freedom." These categories, combined to form the cover image, become section headings inside the book.

Each heading is explained through words and pictures that focus on people stories. The National Geographic-style layout lends credibility to what some might consider an alternative lifestyle. For example, this unusual shot of a H.O.G. (Harley cycles are dubbed "hogs," and local Harley Owner Groups use the H.O.G. acronym) owner with his son in Graceland (opposite page, top left) sheds light on the real personality of most Harley owners. This picture says Harley is about more than the open road; it's about real ideals, such as family.

Know Your Product

VSA has one rule for team members working on the Harley account—they must own Harleys. Otherwise, the partners believe, they won't know the product well enough to create a convincing design.

Not Quite Right? Do It Again!

There is an intentionally gritty feel to this design. The type is, as Schreiber explains, "no-nonsense. There's nothing fancy or new-wave here." Just like the product, "it's down and dirty."

The report, like a Harley, is also well-made. VSA designers seldom follow a grid or template for their annuals. Instead, they spend hours laboring over the creative balance of each page. This intensive work gives the overall product a handcrafted feel.

Keep the Reader on the Road

To create a feeling of movement between pages, VSA relies on a painted-background motif. These earthy tones of orange and ocher used to frame images or as background for text were actually painted on canvas and then scanned into the computer for layout.

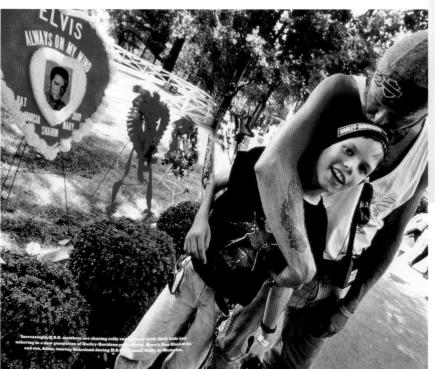

Can history be a corporate asset? Just ask our customers, dealers and employees, who treasure our colorful past, glorious achievements and mystique. That's why every motorcycle we design and build pays rightful homage to its forebears. It's not just nostalgia; it's heritage. And it's unique to Harley-Davidson.

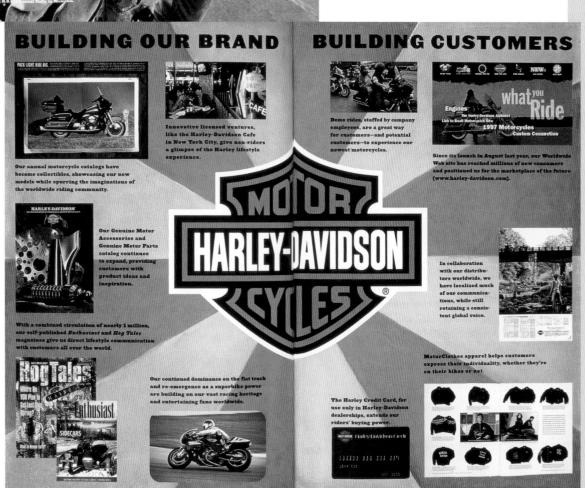

C/ H/ A/ P/ T/ E/ R

Rancho La Puerta Tionne

Summertime!—the great outdoors at Rancho La Puerta. Our early morning hikes get us going as we greet the dawn on Mount Kuchumaa. Views and cool breezes join us in Oaktree Gym, our beautiful open-sided exercise pavilion.

Cool pool waters host the expanded water-exercise program: including waterworks classes, water circuit, and the popular Aqua Plus class (treading water with buoyancy cuffs on your ankles in a small deep-water pool). Two Water Weeks will delight those of you who love water and outdoors combined. Bring a straw hat, long-sleeved shirt, and lots of sunscreen

Research in osteoporosis prevention now shows that flexibility and strength exercises keep bones strong. Yoga fits the bill on both counts! Summer specialty programs include ever-popular yoga of both Iyengar and Ashtanga styles. Also this summer, various experts in Body Conditioning teach a classic, incredible effective alignment and strength method with profound results.

For a month mid-lune to mid-luly we

have two "Watsu" experts delighting us with the way they combine shiatsu massage techniques and relaxed floating in warm water. Watsu will open you up to a whole new experience! (Appointments are limited and there will be a fee.)

Week helps you learn (or refine) the Zen approach to being present in our lives. Dance Week and Aikido Principles Week complete our offerings.

I know you'll benefit from the greater depth of tuition and experience each of Ranch is a time of learning and growth expanding horizons, and shared age-old knowledge in each ancient discipline, from Aikido to Yoga-an adventurous time for

I look forward to seeing you soon. Have a very happy summer! —Pbyllis

Welcome!

from Fitness Director Phyllis Pilgrim

IN THIS ISSUE ...

Summer Theme Weeks and Special

New Gyms and Health Centers Olive Oil Production at the Ranch: Notes from a Harvest

Murals With an Ancient Power Bill's Cocina Recipes A Different Kind

of Showe A Tribute to Chris Draver

SUMMER 1996 . NEWS FROM MOUNT KUCHUMAA . SUMMER . 1996

"Vacation." It's such a magical word. We wait for it. We save for it. We even spend a great deal of time dreaming about it.

Marketing professionals at travel agencies, airlines, cruise lines, and resorts are well

aware of this compulsion. That's why they put a lot of faith and dollars into getting the word out about their services. One of the most powerful and personal ways many have found

Designers sell an experience. Each has put the focus on visually defining one important element—the look of a great escape.

to tout their wares is to lay them out in the form of a newsletter.

Deborah Szekely, founder and owner of one of the world's oldest and finest spas, Rancho La Puerta, has produced a newsletter for her customers for fifty years. As you might expect, the design for this pub has changed many times. The latest incarnation celebrates the beauty of the spa's Tecate, Mexico, setting and its elegant amenities through the viewpoint of a guest. This almost homegrown touch reminds customers of the treasure they have found, or are about to find, in the sunny rolling countryside south of the U.S.–Mexico border.

In our "Travel" section, whether designers are selling an experience through unique design interpretations or branding their company's style and attitude for their own employees in house organs, each has put the focus on visually defining one important element—the look of a great escape.

Princess News

Since eighty percent of all Princess Cruises employees are shipboard, few can keep as up-to-date on corporate activities and initiatives as their shore-based counterparts. Princess News bridges the gap in ship-to-ship and ship-to-shore communication thus providing all employees with a steady stream of corporate news and features.

The Action of the Control of the Con

SIXTEEN-PAGE, TABLOID QUARTERLY featuring FOUR-COLOR PROCESS AND TWO SPOT COLORS

Northwest Gloss Book 70 lb (105 gsm) TEXT STOCK

Garamond BODY FONT CIRCULATION: 12,000

FEATURE COPY LENGTH: 1,000 words LAYOUT PROGRAM: QuarkXPress

HARDWARE: Macintosh

EDITOR: Julie Benson. DESIGN: Lisa Juarez. Both work at Princess Cruises corporate office in Los Angeles,

California.

It's the Little Things

Designer Lisa Juarez adds little touches to each issue of *Princess News*, touches that lighten its sophisticated, corporate feel. For example, page number placements float from top to bottom as if cresting or descending waves. Some page numbers are set in colored boxes. Others are framed by a colored diamond or oval, but all are followed by a small trail of bubbles.

Dealing with Photos

Photo-collage pages can be a design nightmare. Juarez keeps such pages clean by using her four-column grid as a guide for placement. Small images are "anchored" to a single, large image placed slightly above center. Also notice how she creates variety by cutting out a few of the more active images and feathering their edges. These soft-edged photos pop off the page when surrounded by photos in hard-edged frames. This gives the page depth.

Editorial Departments

Shipboard employees receive a lot of mail from friends, family members, and their corporation. To keep *Princess News* from getting overlooked or misplaced, the design team chose a tabloid format.

Editor Julie Benson reports that employees look forward to the publication's regular departments. Says Benson, "Our staff members transfer from ship-to-ship, so most of our employees know each other. One spread, called 'News from the Ships,' which focuses on fun news, is extremely popular because it helps them stay in touch."

"Repeating departments make newsletters interesting to readers," adds Juarez. "So I give those sections a different look from the rest of the book. 'News from the Ships' typically has a background color, different drop caps and body face. That way people can flip right to it.""

Flags

Even though newsletter flags are typically simple, creating them can be excruciatingly complicated. That's because the flag has to convey both the name and the feel of a publication in a small space. Therefore, it pays to model a flag on the client's corporate logo—this avoids the woes of starting from scratch with the added benefit of enhancing a brand.

For *Princess News*, Juarez started with a modified Bauer Bodoni all caps and spread the word "Princess" across the entire width of the page. She included the two spot colors from the company's logo plus the logo of its parent company, a quartered flag, and Princess's graphic logo, a stylized sea witch. Moving the sea witch from her position above the company title and placing her on the same horizontal plane as the flag makes it appear that the wind is blowing her hair and furling the flag. This creates movement, important for a flag that deals with news from the sea.

CAPTAIN'S CIRCLE COUPLES TAKE 43RD CRUISE

Onboard a recent Star Princess cruise, two couples both having 43 cruises and 397 days travelled, were honored at an onboard cocktail party. Pictured (left to right) are Cruise Director Billy Hygate, Ruth and Morton Grossman, Captain Robert Baker, Monica Guardino, Social Hostess Linda Stocum and Sal Guardino.

EOPLE RINCESS

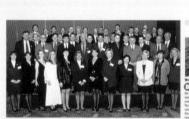

... 1

Rancho La Puerta Tidings

In operation since 1940, Rancho La Puerta is one of the oldest and finest spas in the Americas. Its newsletter is as old as the spa and has seen many incarnations. Founder and owner Deborah Szekely produced early versions on a mimeograph machine. Tidings' mission is to form an emotional bond between former guests and the spa. It reminds them of the spiritual experience they had and how much they would like to return. Rancho La Puerta is located in Tecate, Mexico.

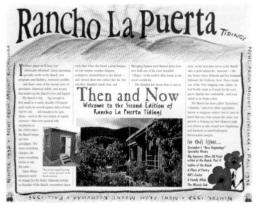

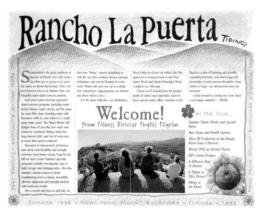

FOUR-PAGE, FOUR-COLOR TABLOID PUBLISHED THREE TIMES A YEAR

Evergreen Natural Matte, 70 lb (105 gsm) BOOK STOCK

BODY FONTS INCLUDE Garamond and Gill Sans

CIRCULATION: 30,000

FEATURE COPY LENGTH: 500 words

LAYOUT PROGRAM: QuarkXPress

HARDWARE: Macintosh

EDITOR: Peter Jensen. DESIGN: Laurie Mansfield Dietter.

Both are San Diego, California-based freelancers.

Image Placement

When designer Laurie Mansfield Dietter lays out the center spread, she works like a painter. "I choose one dominant image as my base. This picture, typically a vista or beauty shot of one of the buildings on the complex, is always the biggest on the layout. I decide where to place additional images by zooming in and out. I step back and see how the spread looks as a free-standing image; then go back in and work on detail," explains Dietter.

Creating a Theme

"Obviously we don't have the room to take a standard magazine approach with a big headline, one nice big photo complemented by several others, captions, and lots of white space," says editor Peter Jensen. "We have to include up to ten different items in our center spread. But we tie this organized chaos together with a design theme."

Both Dietter and Jensen make numerous trips to the spa in order to develop themes. For the first issue of *Tidings*, Jensen wanted to report on the rock-art-style murals that grace two of the spa's new gyms (opposite page, top). Dietter picked up on this and used her own sketches of cave paintings from the area as her motif. Note how Dietter's illustrations ramble across the page—a technique that keeps the reader's eye in motion.

That Friendly Touch

The use of hand-drawn illustrations, borders, and backgrounds combine to give the design of *Tidings* a very down-home feel. "There's nothing wrong with looking personal," says Jensen. "In fact, I think that's the mark of a good newsletter. It should look like it was created by a micro-publisher rather than a slick advertising firm. Of course, you may win a lot of design awards for an overtly professional look, but you won't always reach your client's customers."

Creating a Feel

"If I was an artist or a botanist staying at Rancho La Puerta," says Deitter, "I would keep a journal or field notes of what I saw. This quick-sketch feeling is something I try to bring to the newsletter." For the Winter 1997 issue, Deitter brought back samples of local fauna, spread them out on her kitchen table, and sketched them (opposite page, middle and bottom). These whimsical yet detailed illustrations reconnect former guests with the garden beauty found everywhere at the spa.

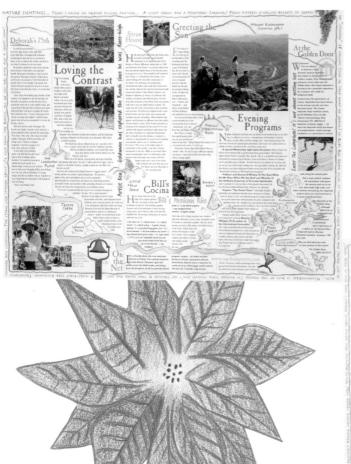

Island Escapes

The mission of parent publication Islands magazine is to describe the feel of island destinations to readers. The publication's subscriber base, however, needed particulars such as how to get to an exotic locale, where to stay upon arrival, and how much a trip costs. Such details, the publishers concluded, would require a change in Islands' highly successful format. The solution? Produce a newsletter.

TRIM SIZE is 8 1/2" x 11" (22 cm x 28 cm)

EIGHT-TO-SIXTEEN-PAGE, TWO-COLOR MONTHLY

Crane Scott Opaque Vellum Book 70 lb (105 gsm) Text Stock

Adobe Garamond BODY FONT; sidebars in Futura Bold

CIRCULATION: 5,000

FEATURE COPY LENGTH: 2,500-3,000 words

LAYOUT PROGRAM: QuarkXPress

HARDWARE: Macintosh

EDITOR: Tony Gibbs. DESIGN: Patty Kelley. Both are members of the Islands Publishing Co. staff based in Santa Barbara,

California.

Island-hopping

Every traveler needs a good map and every issue of *Island Escapes* includes one—even though its creation is often an adventure in itself. "Source material is always a problem," says editor Tony Gibbs, who travels to most every destination covered in the newsletter. "Islands that are or were under British possession are well-charted, but islands in other territories often have no official maps." In these cases, Gibbs has to find less conventional forms of reference, such as illustrations from T-shirts or cocktail napkins, to supplement the work of his photographer.

Back home, Gibbs turns over his research to designer Patty Kelley and a freelance artist who combine these varied pieces of information to create a finely detailed pencil illustration. Once this contour map is complete, Kelley scans it and imports it into Adobe Illustrator to create the island's network of roads, trails, and landmarks.

Design You Can Rely On

For the inexperienced, travel to an obscure island can be downright scary. So, not only does the copy for *Island Escapes* have to be up-to-the-minute, the design has to instill a sense of trust, a feeling that everything found within the publication will prove true upon arrival.

To maintain subscriber confidence, Kelley sticks to her three-column template for each issue. Travel data fills the outside sidebar, which measures 2" (5 cm) in width. The center column, 4" (10 cm) wide, carries the feature story; the inside column, which measures 1" (3 cm) wide is set aside for captions and breakouts such as additional photos and copy boxes. The inside and outside columns use bold sans serif type that create a solid frame for the demure serif body copy in-between. The result is a sophisticated, almost scholarly look to the layout.

How Big Is My Photo?

"In most newsletters," says Kelley, "it makes sense to vary the size of photos to create variety. Because the images in *Island Escapes* are informational rather than decorative and deal with specific places such as a hotel or restaurant, it makes sense to keep them all the same size. That way, they carry equal weight in terms of importance for the reader."

Pretty Colors

Kelley works with an illustrator to create clip art for each issue. These pieces represent some unique aspect of the featured island. For instance, the issue on Catalina—the island famous for its roaming herds of buffalo—featured a bison. After the artwork is complete, Kelley digitizes it and imports it into QuarkXPress, where she screens it back behind black text. "I always choose very deep or rich colors," says Kelley, "so I screen my images back to 20 percent or even 15 percent so that you can still read the body text that overprints the illustration. If you're working with a lighter color, of course, you'll be able to go with a much higher percentage."

***** ** E A T

A few minutes later, the signs of human development become visible, most of them clustered toward the east end, in the heights around the harbor of Avalon. And then you pick out the details of Catalina's most famous landmark, the magnificent cylindrical Casino. Bustling Avalon, larger of the island's two towns, holds nearly all the tourist facilities – restaurants, hotels, shops, tental apartments and homes, tour companies, and water sports operations – as well as most of the island's permanent population. In spite of regular influxes of tourists, the town has managed to retain a distinctive personality of its own, especially noticeable in the off-season months; it's a good-humored

Most of the island is benignly controlled by a nonprofit foundation.

cross between amusement park and frontier village.

Residents know they depend on visitors for their economic survival — but they also recognize that the visitors will keep coming only if the island remains worth visiting. And though there are differences of opinion about how much development is permissible and what form it should take, most islanders love Catalina essentially the way it is.

Outside Avalon and the small village of Two Harbors, more than 80 percent of Caralina retains the sometimes stark, always dramatic beauty of natural California, the way Catalina reasons one sometimes war a ways unamate scans in the state of the state o water between it and the mainland made development simply impractical.

After some 4,000 years of habitation by Native Americans, Santa Catalina was

"discovered" and claimed by the Spanish in the 16th century. A land grant from the last

The Bois Johi accommodation are orther connected bumplows for individual room in a block, price-sense has building slightly removed from the restaurate. The rooms are small and the furnishing rational, but the create and the state of the state of the state of the state of the building state of the state of the state of the state of the building state of the building state of the state of the state of the building state of the state of state st

choice

Year's unliably to find to move excludely resound until me than this 1 is now excludiment, that is more in a large form of the production of the section of the section of the section of the section of the production of the production of antiques is used to the production of antiques is place for solid just the excellance place for solid just one on lossings one what will solice proor destinate, which year and is another by exhectic taped music. On think in a deligibility of the content of the production of antiques place for solid just destination of the production of the production of the section. The section place was the section of the section of the other place is seen and admiring — their law having policy and for the section. The other places is set of the version of the other places in a section of the section of the other places in the section of the section of the other places in the section of the section of the other places in the section of the section of the other places in the section of the section of the other places in the section of the

Currency is the French franc, which runs abou 5F = US\$1.00. On Terre de-Haut, most

Footprints

Footprints is published by Adventure 16, a Southern California-based outfitter devoted to equipping, training, and guiding outdoor enthusiasts.

TRIM SIZE is 11"x 12" (28 cm x 30 cm)

SIXTEEN-PAGE QUARTERLY
CIRCULATION: 75,000
EDITOR: Peter Jensen. DESIGN: Marjorie Taylor.
Both are freelancers based in San Diego, California.

Everything about *Footprints* says "outdoors," from the action photos to the intriguing woodcut-style banners and icons. *Footprints* runs on newsprint, which isn't as friendly to color as a glossy or matte-finish paper. However, Adventure 16 designers make the most of this format by using color sparingly. Overuse of color would seem dull. Here, colored icons and rules mixed with a few background screens add just the right amount of spice to already stunning outdoor images.

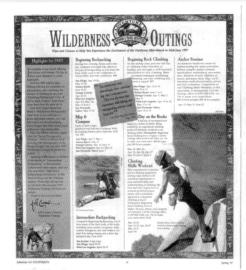

The Art of Eating InTuscany The Sargiovene Grape Bread Without Salt A Pot Like a Blottle The Veneration of Olive Ol Intustion of Chinom surveine Florence and Seria, HIRE AND THERE TOU all see old grapewine growing up that or allow trees, the success via against the arms and the surveine surveine growing up that or allow trees, the success via against the arms and the surveine and the surveine s

The Art of Eating

Edward Behr's publication The Art of Eating proves that every meal can be an exquisite experience.

TRIM SIZE is 8 1/2" X 11" (22 cm x 28 cm) TWENTY-PAGE QUARTERLY Sabon BODY FONT CIRCULATION: 2,500

EDITOR AND WRITER: Edward Behr. DESIGN: Keith Chamberlin of Saint Johnsbury, Vermont, and Edward Behr of Peacham, Vermont.

The Los Angeles Times calls The Art of Eating "thoughtful and graceful." Both these adjectives certainly apply to Edward Behr's design. This publication embodies the art of simplicity, proving that elegant design is just as appealing as cutting-edge design. Behr's clean, two-column layout emphasizes well-written copy. Sophisticated black-and-white photography creates interest. Notice the subtle use of dingbats—as essential to this publication as the proper presentation of a gourmet meal.

and it comes into balance with the bre nearly every Tuscan bakery also sell called pane pugliese (though it is no the bread in Puglia), but that is the bre Most of the unsalted Tuscan bread merely average; occasionally it wa than that.

The crust of a Tuscan loaf is crist more dried than caramelized. The made lighter by the flour dust that from sticking to its protective cloths as of the fragile dough is rarely slashed be the oven, and the loaves don't swell a are somewhat flat. The flavor is much when the bread comes out of the oven a few hours later. At Tuscan baker behind the counter grabs a loaf for reflexively squeezes to make it crack left hand, right hand, very fast: craprove freshness.

Tuscans often eat bread with olive frequently they sprinkle salt on top, toasted, the combination is called fet or bruschetta, according to the ps. Fettunta can be breakfast. Rubbing the

The Southern California Gardener

The informative Southern California Gardener comes to readers three-hole punched so that they can save seasonal tips, advice, and reminiscences on gardening along the Pacific Coast from year to year.

TRIM SIZE is 8 1/2" x 11" (22 cm x 28 cm)

TWENTY-EIGHT-PAGE BIMONTHLY

Centaur BODY FONT CIRCULATION: 8,000

EDITOR: Lili Singer, who, along with CO-PUBLISHER: Phyllis Benenson, is based in Van Nuvs, California. ART DIRECTOR: Siobhan Stofka, Siobhan Stofka Design, located in Los Angeles.

Color illustrations make this handy notebook a real piece of art. Covers for The Southern California Gardener are especially striking, setting the tone for

each issue. The two-column layout allows for text to flow smoothly throughout, even in the more complicated "Planting Guide" section where information on annuals, perennials, and edibles is separated by two-point rules.

Passages

Magellan's World is a club for travelers, the benefits of which include a subscription to Passages. Features include travel, health, adventures, discoveries, and new products.

TRIM SIZE is 8 1/2"x 11" (22 cm x 28 cm) EIGHT-PAGE QUARTERLY Adobe Garamond BODY FONT CIRCULATION: 5.000

EDITOR: William Callahan of Magellan's World. DESIGN: Dean Puccinelli of Balint & Reinecke. Both are based in Santa Barbara, California.

Old World maps, icons, and treatments serve as pleasing backgrounds for this businesslike publication. The three-column format and relatively small (tenpoint) Garamond type allow designer Dean Puccinelli to include more text than most newsletters. However, notice that he is careful to keep the leading open for

easy reading. Photos run relatively small but still pack punch as they are well-cropped and sharp.

South Texas College of Law 1996 Annual Report

The only private law school in Houston, Texas, South Texas

College of Law has trained lawyers to hold positions of leadership since 1923.

TRIM SIZE is 10 1/2" x 8" (27 cm x 20 cm)

FORTY-EIGHT-PAGE ANNUAL

BODY FONTS INCLUDE Adobe Garamond, Gill Sans, and Triplex

CIRCULATION: 10,000

DESIGN: Geer Design, artist Mark Geer based in Houston, Texas.

This annual report details the college's initiative to bring together technology and the practice of law. By using the Internet as a massive resource, virtually creating an on-line courtroom, students can jump-start their careers into the twenty-first century. Futurism combined with the sophistication of the legal profession are portrayed through Mark Geer's vibrant design.

The cover is a good example of this symbiosis. It features an embossed image of a wall plate for a telephone jack, in this context representing modem outlet. Inked on top are tiny orange arrows running in opposite directions in horizontal columns, this arrangement evokes the power of information exchange. Throughout the report, digitally-enhanced photos reproduced with fluorescent inks show how the study and practice of law will benefit from existing and emerging technologies.

Window on Wheeler

TRIM SIZE is 11" x 8 1/2" (28 cm x 22 cm)

FORTY-FOUR-PAGE ANNUAL

Galliard Body Font, horizontally scaled to 90 percent

CIRCULATION: 5,000

EDITOR: Laurie Flynn. DESIGN: Keating & Associates/Hess Design with the Wheeler School Art Department. The Wheeler School is located in Providence, Rhode Island. Keating & Associates/Hess Design is based in South Natick, Massachusetts.

The most impressive element of *Window on Wheeler* is the courageous design decision to allow student work to stand on its own. This gate-fold, featuring three pages from the oeuvres of young Wheeler artists, is proof that kids can do anything, even self-portraiture, just as well as adults—that in fact, the sky is the limit. The layout of these images is held together by a repetitive frame with a thin (half-point) rule. This is featured throughout and represents Wheeler's "Window."

Note the pleasing compositions of photos from page to page. On the left-hand page, images are arranged along diagonals. On the center page, images follow a more circular path and are placed near the outlines of the frame. The right-hand page puts the weight of images on the top and bottom of the page. This change in rhythm attracts attention and draws the eye from page to page.

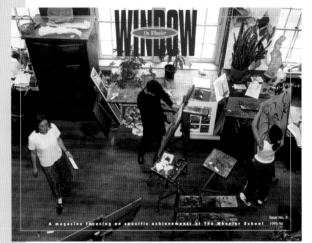

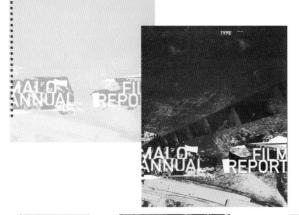

Malofilm Communications 1996 Annual Report

Malofilm Communications is involved in all aspects of the entertainment industry. From live action, multimedia, and animation production to acquisitions and distribution, they do it all.

TRIM SIZE is 9" x 11" (23 cm x 28 cm)
THIRTY-SIX-PAGE ANNUAL
Trad Gothic BODY FONT
CIRCULATION: 6,100
DESIGN: Belanger Legault Communications Design Ltd. based in Montreal,
Quebec, Canada.

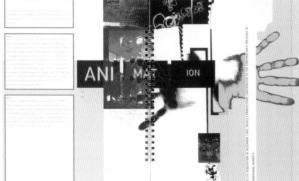

With major acquisitions and numerous projects in the production pipeline, Malofilm is a company on the move. Belanger Legault Communications' design captures both this progressive feel and the excitement of the moving image with a jazzy layout. The "in production" look comes, in part, from the irregular and rough treatment of images, as if they were pieces of film rescued from the cutting-room floor. Also note that negative images are used often. The six-column layout is played with, sometimes becoming one wide column, sometimes running horizontally instead of vertically. This effect gives the look of film running through a projector.

Jacor Communications Inc. 1996 Annual Report

From the annual: "Including announced pending acquisitions, Jacor owns, operates, represents or provides programming for approximately 130 radio stations in 28 broadcast areas. . . . In addition, Jacor's E.F.M. subsidiary syndicates programming, including Rush Limbaugh and Dr. Dean Edell, to approximately 800 stations throughout the country."

TRIM SIZE is 6 1/2" x 11" (17 cm x 28 cm)
FIFTY-PAGE ANNUAL
BODY FONTS include Garamond and News Gothic
CIRCULATION: 15,000
DESIGN: Petrick Design of Chicago, Illinois.

Titled *Imagine*, Jacor's annual report comes in a black sleeve with a small cut-out window that frames the word "enigaml" printed on the report within. When the report is removed from the sleeve, the reader finds a ten-page vellum fold-out. "enigaml" becomes "Imagine" and a string of

vellum fold-out. "enigaml" becomes "Imagine" and a string of very interesting lyrics are revealed across the accordion-like pages. Text from news reports are mingled with phrases from popular songs, creating an almost improvisational poem—and exactly what listeners hear when they flip through a radio dial.

Underneath the text is a stream of screened-back colors forming the image of a recycling radio wave. This intriguing fold-out leads the reader into a clean, concise, two-color report.

Gard is destinating to facility and our compared by a some size of the compared by the compared to facility and process and the second sequences, which to extend sequences, which considered series and it is floating as series of the compared to the compa

S/E/C/T/I/O/N log drains

goods & services

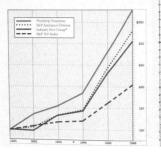

ory, and we reduced our debt by \$1 billion

Notificated Outf (upon 19 A) Dillion.

Your management team is excited about the future of Northrop Grumman. We are in a growth mode. Many of our programs are at the beginning of their production life cycles. Our products are performing well in service, and have throw praise from our customes. We were successful in winning many new programs in 1996 and we are off to a good start in 1997 capturing new and follow-on business in our primary markets.

We continue to take the actions necessary to streamline our operations, eliminate excess facilities and equipment, and strengthen the company's position to compete in the defense and commercial aerospace and information systems market-places of the twenty-first century.

Over the past three years, we have successfully brought together four separate enterprises—Northrop, Grumman, Vought Airerit, and Weatinghouse's deferse and electronics business—for form a seamlest sem. Our business imperative of "Perform, Win, and Grow" is intrinsic to the management philosophy of all our operating elements, and we continue to employ the fundamental principles of integrated product and process teams throughout the competitive rechnology, transagement, and financial advantages secured to employ the product of the process teams through future.

With the acquisition of the defense and electronics business of Westinghouse Electric Corporation last March, we have ransformed the company from a producer of military air-planes to a defense electronics firm with a stable military air-craft business and expanding commercial sensitructures and marine, space, and information systems businesses;

believed it. An

could come alone and build a small car

at an affordable price that would rival the imports

in quality.

Saturn Turns Ten

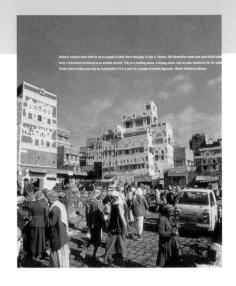

No matter the social status, no matter the purpose, excuse, or inclination, nothing can stop us from shopping. We buy goods that support our daily needs, that display our social

status, that entertain and comfort us. Many even spend a great deal of their workday buying goods and equipment for their workplaces.

Nothing can stop us from shopping. We buy goods that support our daily needs, that display our social status, that entertain and comfort us.

With an ever-increasing sea of choices, it is often hard for companies providing goods or needed services to rise above this melee of buying. Nowadays it is not enough to have the best product or to create something truly useful and worthwhile. For customers to even know it exists, a product must be marketed in constantly evolving ways.

Branding a product—to create for it an identity that is immediately recognizable as the most hip, the most exclusive, the most reliable, or the most unusual—is all important. One of the best ways to develop or enhance a brand is through the design of a strong newsletter or annual report. As opposed to a Website, the value of printed material is the ability to immediately convey substantiality. Great design can build this by portraying not only the product but the feel of the product. As you will see in the pages that follow, design and illustration combine to explain how a manufacturer feels about a product and what it can do. Design shows that a grease-stained aircraft hangar is actually high art, that a piece of computer hardware is really a playful tool, and that box of cereal can remind us of the victories of life.

Design, in other words . . . sells.

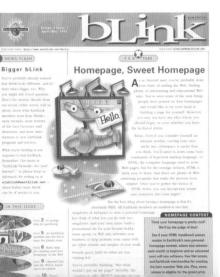

e q u i p m e n t

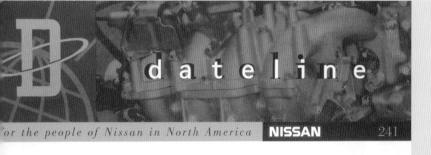

C/ H/ A/ P/ T/ E/ R

Infiniti Indy Power Takes Five Top 20 Finishes

To sports enthusiasts and automotive manufacturers around the world, the Indianapolis 500 represents his year a large crowd, including a group of Infiniti dealers, DOMs, and service writers were on hand to witness the Infiniti Indy engine make its successful debut at the Indy 500 – only 15 months after the project officially began. After 200 laps around the historic 2.5-mile Indianapolis Motor Speedway, five of the tog 20 finishers were powered by the Infiniti Q45-based, 4.0-liter, 32 valve V8 racing engine.

A total of six Infiniti Indy-powered cars qualified for the event, piloted by an experienced drivers list that included Mike Groff, Roberto Guerrero, Lyn St. James, Johnny Unser, Dr. Jack Miller and Dennis Vitolo.

For only the second time in its 81-year history, the start of the race was delayed for two days due to rain – with the event

Running as high a ninth place at one L, point in the race, Infiniti Indy drives Lyn St. James' #90. Hemelgarn Racing Infiniti Dallara receives attention in the nit.

Go with your gut. That's the slogan of Cahan & Associates, a San Francisco-based design firm that created the quirky and highly successful 1996 annual report for Adaptec, a manufacturer that specializes in computer products that move digital information at high speeds. In this case, the client wanted to brand a new identity. Of course, Adaptec wanted to show that it builds products that "move

the data that moves the world." Also needed was something a bit beyond the ordinary. Users were to think of the products as more than just pieces of equipment—as tools for enhancing, creating,

and furthering any type of digital endeavor.

You know you've got a great design concept when the parts come together with relative ease—your favorite choice is often the right choice. The designers highlighted in this chapter adhere to this simple yet elusive law of design.

The solution? Create a publication *simple yet elusive law of design*. that anyone can identify with—a child's primer with all its bold colors, feisty characters, and simplistic text.

When interviewing Bill Cahan about this ingenious choice, he explained that when the idea came up, every one of his designers immediately knew it was right because . . . it felt right. Because it felt right, all the elements of the design process fit perfectly, as if the project itself appreciated the idea. (Hint: you know you've got a great design concept when the parts come together with relative ease.) Cahan added that one of the most rewarding aspects of production was the confidence to work from the gut, that the favorite choice is often the right choice.

In our this chapter, all the designers have adhere to this simple yet elusive law of design. We hope you enjoy their unexpected approaches.

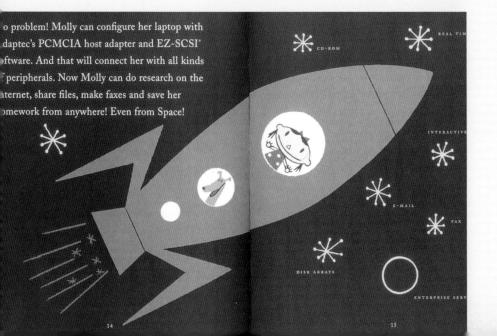

Northrop Grumman Corporation

1996 Annual Report

For thirty years, Northrop produced high-quality annual reports featuring black-and-white photographs. In 1996, the company focused on its move from aircraft prime contractor to defense electronics manufacturer. To maintain its dignified manner, present aerospace equipment as art, and portray a new feeling of diversification, Northrop Grumman relied on the talents of Douglas Oliver and his Santa Monica-based design studio.

Trim Size is $8"\ x\ 11"$ (20 cm x 28 cm)

EIGHTY-EIGHT-PAGE, SIX-COLOR ANNUAL

Confetti Black, COVER STOCK; Proterra Shale, Stucco,
Oyster 70 lb (105 gsm)Text Stock; Duotones printed on
Mead Signature Gloss 100 lb (150 gsm) Text Stock

Bembo BODY FONT

CIRCULATION: 87,000

LAYOUT PROGRAM: QuarkXPress

HARDWARE: Macintosh

DESIGN: Douglas Oliver, Douglas Oliver Design Office,

Santa Monica, California.

Just Let It Happen

Cover design is the most important aspect of any quality annual report. However, the process of creating a great cover often is attributed more to serendipity than technique. Designer Douglas Oliver found this cover while touring a naval facility for Northrop in Annapolis. He was intrigued by the many computer printouts tacked to walls and strewn across desktops. When he spied a sonar test on unique circular graph paper, he knew he had his art.

Box It Up

To help portray the new, diversified nature of Northrop Grumman's business, Oliver decided to compartmentalize. He treated each section as a standalone, mirroring the way the company began approaching its many new sectors. One of the most powerful departments in this annual report is a twelve-page photo essay of black-and-white images, each showcasing a piece of equipment in dramatic light. Oliver explains that the showcase serves several purposes: first, it provides a sophisticated feel, akin to fine art; second, the use of black-and-white rather than color gives the report the air of a documentary film, which, as Oliver points out, lends credibility—a sense that everything included rings true; and third, the gallery does not feel overdone to stockholders. Black-and-white, although usually as expensive to produce as color, seems a fiscally responsible choice.

About Those Charts

Oliver created reader-friendly charts. For instance, a graph on page two (opposite page, top) shows how dramatically an investment of US\$100 in Northrop Grumman common stock rose in five years. "When a company has something this powerful to say, they want to put it up front," explains Oliver. However, he is quick to add that charts have to be straightforward. "I've never been excited by gimmicks in charts or ones that are too involved. You can use design to cleverly disguise poor numbers, but, in the long run, you're really not hiding anything. I think it's better to create charts that deliver a simple message quickly."

Paper

One of the first elements that both designer and client agreed upon was the choice of paper. "We wanted a textbook feel to the book. We also decided early on that, budget-wise, it was not compelling to sprinkle the entire book with photos. An uncoated stock meant we could enhance the sophisticated feel by adding colored line art." Each compartment boasts a different shade of paper, but each choice comes from the same family.

Shareholder Value

AT NORTHROF GRUMMAN, a principal business objective is to achieve superior growth in shareholder value. In 1993, we initiated a shareholder value measurement process based upon cash flow return on investment principles. This process is surgeral to our strategy formation and execution, and guides cally business operations. Success requires that we maintain excellent relationships with customers, suppliers, employes, and other stakeholders.

The adjacent chart portrays the measurement of shareholders value creation. Performance to the right of the vertical centice line indicates success at earning cost of capital—the minimum level of return necessary to compensate shareholders for investing their money in the company. A position above the horizontal centerine indicates effective uses cultilation. Our goal as to continue to perform at the highest level in the blue quadrant while growing revenues.

Shareholder value is the primary components in determining incentive compensation for Northrop Grumman officers and key managers. Ongoing employee educational programs ensure that a unified focus on value creation permease the entire company. As a result, employees are devising and executing such value-building actions a disposing of excess assets, speeding cycle times, and eliminating unnecessary activities.

The comparative returns clust below clearly shows the success of our efforts in solute creation persular control and the Standard and the Standard

value creation as compared to our industry peer groups and the Standard and

fig. 1 - SHARPHOLDER
VALUE CREATION

1996 WAS A VERY SUCCESSFUL AND EVENTFUL YEA We achieved record sales of \$8.1 billion and record op million. The company's business backlog stood at \$12. end figure in our history, and we reduced our debt by

Fellow Shareholders

Northrop Grumman. We our programs are at the be cycles. Our products are p drawn praise from our cus winning many new progra good start in 1997 capturing new and follow our primary markets.

We continue to take the actions necessary to streamline our operations, eliminate excess facilities and equipment, and strengthen the company's position to compete in the defense and commercial aerospace and information systems marketplaces of the twenty-first century.

.....

Over the past three years, we have successfully brought Over the past three years, we have successfully brought together four separate enterprises—Northrop, Grunman, Vought Aircraft, and Westinghouse's defense and electronics business—to form a seamless team. Our business imperative of "Perform, Win, and Grow" is intrinsic to the management philosophy of all our operating elements, and we continue to employ the fundamental principles of integrated product and process teams throughout the company to achieve the competitive technology, management, and financial advantages necessary to ensure a bright future.

With the acquisition of the defense and electronics business With the acquisition of the defense and electronics business of Westinghouse Electric Corporation last March, we have transformed the company from a producer of military airplanes to a defense electronics firm with a stable military airraff business and expanding conumercial aerostructures and marine once and information systems businesses.

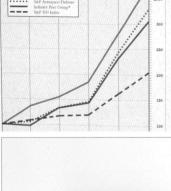

Northrop Grumman Corporation

not reasons } 35.

Described by U.S. Air Force officials as "absolutely outstanding," the first live warhead GAM test from B-3 aircraft in October 1996 destroyed sixteen targets with sixteen weapons. Air Force Chief of Saff General Romald R. Fugleman said that B-2s with GATS/GAM allow the service to begin "to Change our thinking from how many aircraft it takes to deterry one target to how many targets we can destroy with one aircraft." The operational capability of the B-2 is being enhanced by block upgrades to currently fielded and flight test aircraft at the company's Palmdale, California, facility.

Military Airlitt Global air mobility is integral to the changing defense environment, as is the capability to deliver manpower and equipment to remote locations quickly and effectively. Given shrinking force structures, few segments of the military aircraft market are considered growth areas. One exception is the Defense Department's procurement of strategic airlift, and the G-17 Globernaster III military transport is the cornerstone of future U.S. air mobility.

As the largest subcontractor to McDonnell Douglas on the C-17, Northop Grumman is poised to perform on the multiyear procurement of 80 additional aircraft, bringing total C-17 procurement to 120. The company also is actively participating in several cost-saving initiatives for the aircraft, including a redesigned nacelle system and development of a new graphite, composite horizontal stabilizer that will replace the previous aluminum structure. The new stabilizer results in a reduced number of parts, shorter assembly time, plus a 20 percent weight reduction and a 50 percent decrease in acquisition costs.

1996 [ноятикот свимман]

Commercial Aerostructures With commercial aircraft orders resurging, CAD expects to increase 1997 sales of its Boeing integrated airframes by more than 50 percent compared.

increase 1997 sales of its floeing integrated airframes by more than 50 percent compared to 1996. In addition to aerostructures, the company produces integrated wing systems, complete nacelles, acountic structures, engine cowls, and thrust reverses.

Boeing for the production of commercial aerostructures, Northrop Grumman was awarded a contract in Februsary 1997 to produce aircraft doors for the 737, 757, and 767 jetliners and to increase current door production on the 747 program. This new business, which extends into the next century, has potential revenue of more than \$400 million, depending on the number of aircraft delivered. It also will position the company as a "Tier I" integrator with the capability to produce integrated doors that are ready for installation on aircraft.

To maintain a competitive edge in the commercial aircraft markerplace, preferred supplier continually reduce costs and improve quality. In October 1996, Northrop Gramman delivered to Boeing the first 747 Nostge panel completed under the accurate finelega assembly program. Developed by Boeing and

Developed by Boeing and Northrop Grumman, this assembly system applie digital computerized methods to the production of fuelage panels, resulting in reduced rework and shorter cycle times. A primary program goal is to ensure that assemblies virtually "map together" the first time without the need for large, expensive, major assembly tools. This capability presents the leading edge of aircraft assembly technology and will be extremely immorrant as 742 production rares double from important as 742 production rares double from

A Little Character, Please

"We only use five typefaces here and have a tendency to focus on the ones with a low x-height and tall ascenders in the lowercase. Faces with this configuration just look more classic, more elegant. Bembo is the face we chose for Northrop because it has a complete family of old-style figures and a goodlooking companion italic. The choice of your type is a major one, and that's why we work with so few. Within a face there are a whole family of options that can be used together to create a typographic system for your book. This should create a set of visual cues for the reader that lures him through," says Oliver.

To Keep It Simple, You Need a Lot of Patience

Oliver wanted to depict the width and depth of the company at a glance. To achieve this he created a chart (below) that boasts all the intrigue of a periodic table. Early concepts for this spread included a mock-futuristic battle-field on which each of the many combat systems would be shown in action. As Oliver explains, this became an abyss of work and didn't seem to meet the mission statement. Instead, he decided to stick with detailed silhouettes that literally jump off the page. Although this may appear to be one of the easier spreads to put together, its layout kept changing until print time—proving that achieving simplicity can be a complicated process.

TRIM SIZE is 14" x 8 1/2" (36 cm x 22 cm)

FOUR-PAGE, TWO-COLOR, BIWEEKLY

Evergreen 70 lb (105 gsm) TEXT STOCK

Times Roman BODY FONT

CIRCULATION: 3,200

FEATURE COPY LENGTH: 450 words

LAYOUT PROGRAM: QuarkXPress

HARDWARE: Macintosh

EDITOR: Kristin Gallagher, located in Tustin, California.

DESIGN: Randy Nickel, Nickel Advertising Design,

located in Dana Point, California. Internal

Communications, Nissan, Rick Christopher, based at the

national headquarters in Gardena, California.

Pick a Template, Any Template-Then Stick with It

Five years ago designer Randy Nickel was hired to redesign dateline Nissan. Working in conjunction with freelance editor, Kristin Gallagher, Nickel's goal was to create diversity from issue-to-issue through graphic elements, as opposed to constantly redoing his template. Says Nickels, "I've learned that you can really push too hard to create a new look. You have to listen to that old phrase—keep it simple, stupid. If you keep the layout consistent, same type from issue to issue, you allow your graphics to make a difference." And that, after all, is what they're there for.

Different Is Good

dateline Nissan's template is three columns, plus two very thin outside columns used for wacky trivia and oddball quotes. Gallagher explains that originally these quotes had something to do with Nissan or at least with cars and were included to keep reader interest. The response from employees was overwhelming-most workers state that the quotes are the first item they read when they pick up the publication. Says Gallagher, "Our selection of quotes just got more funky and off-the-wall. Now they have nothing to do with articles; they're just there to keep people entertained."

Notice (page 57) that these outside columns are also used for photo bleeds.

dateline Nissan

dateline Nissan keeps employees up-to-date on internal events, activities, and initiatives.

Nissan Foundation Celebrates Year-Five

True to its heritage, the Nissan Foundation commemorated its fifth anniversary by rewarding five non-profit organizations with grants totaling \$250,000. The grants, which far exceeded the organizations' requests,

were presented at an

awards ceremony held

Recipients of the anniversary grants included The Accelerated School, the Youth Intervention Program, A Place Called Home, Puente Learning Cente and Para Los Niños. The five organizations were selected to recei Foundation grants based on their innovative programs that are proving to ositive results in the South Central Los Angeles Co

"Thanks to the Nissan Foundation's support, our Crisis Nursery has cessfully prevented abuse and neglect in over 99 percent of participa during its first three-and-a-half year of service," says Miki Jordan, executive director and CEO of Para Los Niños. "The Crisis Nursery keep its doors open to families during times of crisis to ensure the safety

The Nissan Foundation was established in 1992 as a five-ye ment following the civil unrest in South Central Los

Infiniti Indy Power Takes Five Top 20 Finishes

To sports enthusiasts and around the world, the Indianapolis 500 repre

his year a large crowd, including a group of Infiniti dealers. DOMs, and service writers were on hand to witness the Infiniti Indy engine make its successful debut at the Indy 500 – only 12 months after the project officially began. After 200 laps around the historic 25-mile Indianapolis Motor Speedway, five of the Notes Speedway. The Committee of the Infinity (45-based), 4-biter. valve V8 racing engine.

A total of six Infiniti Indy-powered cars qualified for the ev

A total of St. Iffillin Indy-powered car squanteo to the even ploted by an experienced drivers list that included Mike Groff, Roberto Guerrero, Lyn St. James, Johnny Unser, Dr. Jack Miller and Dennis Vitolo.

For only the second time in its 81-year history, the start of the race was delayed for two days due to rain — with the event

dateline Nissan

sew things myself, such that
afe household product
used to unclog drains a
vely as the chemicals we buy
2s. One boy showed me how
sood and vinegar unclogad
i. It's not only safe for the
mnent, but economical.
SBBEC Science Fair is an
event sponsored by local
ate and community
as
in the position of the event,
has been held in the South
or the past six years,
the fifth
rutive year. Mary Williams,
t area planner for Dissan,
d the event. Nisan and par-

Since the budget is fairly tight, Nickel creates most of the illustrations himself. Although he doesn't think of himself as an illustrator, his kooky creations are refreshing. Take a look at this fun picture of a rather nerdy young fellow surrounded by zipping atoms. This graphic accompanies an article about a science fair judged by a Nissan employee. Part of the appeal comes from the fact that it's a rough, simple sketch. However, refining it a tad in the computer with the additions of tinted highlights and a colored background makes it jump off the page.

Steal from the Big Guys

Nickel wanted the newsletter to look like a magazine, at least, at first glance. So, he set up his flag as a grid. The D for "dateline"—with its ring that represents employees coming together—always butts up against a frame with a changing background. Behind the lowercase word "dateline" is a new image every issue.

Table of Contents: Don't Box Them In

Tired of seeing tables of contents in a box? Here's a fun alternative. Nickel runs his "Inside this Issue" along the bottom of the page with icons representing the various stories (opposite page, bottom).

Inside This Issue

Tuned into Jazz

The Elmo Close

Women
buy more
athletic
shoes per
year than
men do,
but men
spend 34%
more per
pair.

succe Kanri ope Sacramen PDC-wide NMC's P The Gent took place of 1996 a NML's Sa Japan. In NMC trai Genba Ka PDC supe operations parts distr Genba shop floor philosoph boost PD as well as

IQS Rankings Strengthen Brand Image There is plenty of excitement around Nissan about the 1997 J.D. Power and Associates Initial Quality Study (IQS) results, and rightly so. The findings of this independent research group make a powerful statement to consumers about the quality of Infiniti and Nissan vehicles — a statement that can translate directly into increased sales.

0 n S

Visions is a publication for Saturn owners, employees, retailers, and their families.

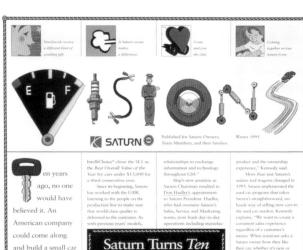

Saturn Turns Ten

at an affordable

price that would

rival the imports

TRIM SIZE is 11" x 17" (28 cm x 43 cm)

EIGHT-PAGE QUARTERLY; FOUR-COLOR outside,

TWO-COLOR inside

Sabon BODY FONT

CIRCULATION: one million+

LAYOUT PROGRAM: QuarkXPress

HARDWARE: Macintosh

EDITOR: Juanita Kukla. DESIGN: Hal Riney & Partners,

San Francisco, California.

Preview Features

The cover of Visions (left) lets readers know what's inside by placing, just above the flag, a brief description and portions of graphics from feature articles. This design technique subtly suggests: "We've got a whopper newsletter here, and some of the things to look for are . . ."

Designer Drop Caps

Susan Holmgren of Saturn's Corporate/Manufacturing Communications says an artist was commissioned to design "a whole alphabet with a Saturn look." The Visions flag spells the newsletter name with letters from this parts-toolsgauges, etc. creation. The drop caps that head each article keep the look a Saturn look, a consistent look.

A Little Fun with Art

Artists are commissioned to design graphics for Visions. Their assignment is to keep the upbeat look of Saturn's brochures, to come up with work that is, as Holmgren describes, "cartoony, playful." This fun look follows the idea that Saturn customers shouldn't be just satisfied, they should be enthusiastic.

Note the graphic that takes up one-third of the back page of Winter 1995 Visions (opposite page, top). The expressions of members of a rowing crew present the idea that their work—say, they're really working together as builders or sellers of Saturn or they're really out for a spin in a Saturn—is just plain fun. They row with tools of the Saturn trade rather than oars.

Another large graphic shows cheerful-looking figures who appear to be on an assembly line. They are a retailer and a worker who team up by raising high a giant wrench. Thus the Saturn spirit is kept in place here and throughout Visions.

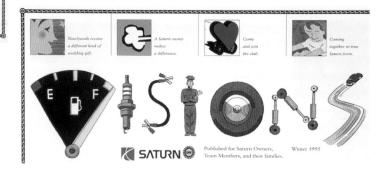

Retailers Help Build Cars

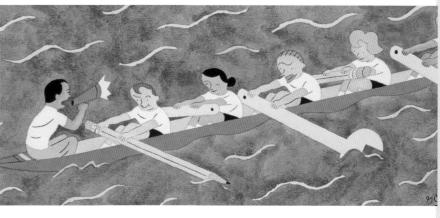

a reputation for knowing a cool thing when you drive one, chances

acuSounder

Acuson corporation is a leading manufacturer and service provider of high-performance medical diagnostic ultrasound systems and digital image management products. The Human Resources department publishes acuSounder to keep its worldwide base of employees in touch. Its mission is to provide general news about the company, focusing on the people involved.

ACUSON

The terrifically

Selected

TRANSDUCE

REFURBSHMENT

THAN SPACE

AND SELECTION

AND SELE

TRIM SIZE is 8 1/2" x 11" (22 cm x 28 cm)
EIGHT-PAGE, TWO-COLOR PUBLICATION PRINTED

11 TIMES YEARLY

Simpson Coronado 80 lb (120 gsm) Text stock

BODY FONTS INCLUDE Garamond 3, Frutiger

CIRCULATION: 2,500

FEATURE COPY LENGTH: 500 words LAYOUT PROGRAM: QuarkXPress

HARDWARE: Macintosh

EDITOR: Mary Thorsby, freelance. ART DIRECTOR: Joshua Chen of Chen Design Associates. DESIGNERS: Joshua Chen and Gary Blum. PUBLISHER: the Human Resources department of Acuson Corporation. All are based in the San Francisco Bay area of California.

It Doesn't Take Much

Designer Joshua Chen's work on the current redesign of *acuSounder* began with a slight change to the flag. Formerly *acuSounder* was spelled out entirely in lower case. The client decided that the S should be a cap, yet Chen felt this would appear intrusive. He developed a compromise by dropping the cap as if it were a lowercase descender. This pleased the client and gave the flag a sophisticated punch.

Don't Give It All Away

Next, Chen addressed the cover as a whole. The former template placed the cover story on the actual cover, making the design cramped and unattractive. Chen worked with editor Mary Thorsby to create a magazine-type feel. Chen encouraged Thorsby to write the opening more as a teaser so that only a paragraph appears on the cover. Laid out with an interesting image, this entices the reader to turn the page and get into the body of the newsletter.

Show Some Teeth

As explained above, the goal of *acuSounder* is to provide general news about the company. Although elements of the design are clean and straightforward (note the subtle use of rules that create a slightly technical feel), the overall impression is one of abundance and content. Acuson employees enjoy many aspects of their work. Chen uses cropped images of people to focus attention on the faces of Acuson employees. Note how many images he uses of people and how each is cropped to focus on their best asset—a smile.

Build It Up

Chen likes maps because they are filled with texture—one of his favorite design elements. Says Chen, "Texture brings so much more to the page. I create texture by building up layers which give a sense of perspective; layers allow elements in the foreground to play off elements in the background."

The April '97 cover (opposite page, top left) is a great example of texture. Notice how the placement of elements make them appear to float one on top of the other. The map seems to recede into the background, while the headline (which looks like the rumpled, slightly burned edges of a treasure map) appears to float on the same level as the copy. This illusion is created in part by the use of a feathered border on the map and by the use of light-colored borders around the two pictures. The reader's eye is further tricked by the ingenious use of carefully chosen images. See how the photograph of Kanji characters follows the curve of the map, thus the map seems to recede into the distance. The photo of the pottery vessel follows this curve as well; however, it follows in a subtle manner. Combining these elements enhances the sense of depth.

Ask anyone in Acuson's North America service group to describe 1996, and they'll sum up the year in two wordschallenge and success. While the group had plenty to celebrate as they gathered on Soutsdafe, Ariz, Last month, they upon a significant amount of time discussing how they can make even greater

cussing how they can make even great intributions to Acuson's bottom line.

"I don't think anyone needs to be reminded what a year it's been," conference host Ray Cales acknowledged at the kackeoff session. "The all of our Accion, it's been a supertransition. Without all of you, Aciono would not have been able to overcome the challenges we faced last year. You Ji make a difference,

Cales, who was recently named North America Service Manager, mixted several Austine resourtives to share a few thoughts with the group. The speakers complimented the Service team on successfully meeting all the challenges associated with introducing the Sequous and Aupen products law year while maintaining an exceptionally high level of service on Asson's other products.

area of selling service contract

nuggest concern," says CE Lowell Morgan, who covers th Washington, D.C. and southern Maryland areas. "We have out of competitors out there, so it was good for us to hear

Chaney, Directors of Sales for General Imaging and Cardiology, respectively, shared good news about to product sales, noting that

helped strengthen Acuson's leadership position in the ultrasound market. In fact, several customers who were planning to purchase other systems changed their minds when they learned about Sequoia.

The group heard updates from several other Mountain View leaders, including a few words from Remort Access Product Support Engineer Weinsh Kunkel and Ultraceard Help Desk Manager Michael Hardini alcost low their trains are helping to solve customer problems via the trippione and remore access, thereby reducing the number of times CEs most travel to customer strit, taked from early only for the product of the former strit. Under their new or these groups in future acknowledge.

Western Bar-B-Que Round Up

What better way to kick off several days of brainstorming than with a good ole' western Bar-B-Que

May 97 4

Ion Van Creveld (HQ: far right) moseys u

Tim Chaney (HQ and Dee Lillis (New Jorsey).

acuson

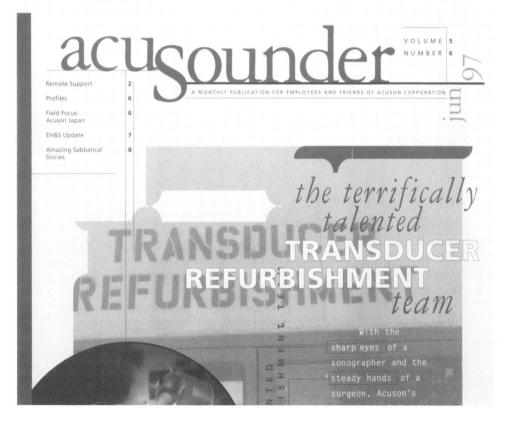

ABC&D-All About Being

Connected to Data:

1996 Annual Report

From the annual: "Adaptec makes products that move information faster, so people can work, build, and create more productively . . . Adaptec moves the data that moves the world."

TRIM SIZE is 8 3/4" x 10 1/4" (23 cm x 28 cm)
58-PAGE, FOUR-COLOR ANNUAL
Cougar Vellum Text Stock
Caslon Body Font
CIRCULATION: 65,000
LAYOUT PROGRAM: QuarkXPress
HARDWARE: Macintosh
EDITORS: Lindsay Beaman and Kevin Roberson. ART
DIRECTOR: Bill Cahan of Cahan & Associates, located in
San Francisco, California. DESIGN: Kevin Roberson,

Understand Your Client and You'll Find a Theme

also of Cahan & Associates.

When owner/designer Bill Cahan and his associates sat down to brainstorm the design of Adaptec's 1996 annual, they knew two things—the technology that Adaptec works with to build products is becoming more and more complex and that Adaptec products allow customers to move data quickly. "We tossed out a lot of ideas," says Cahan, "but most of them were pretty esoteric. What we wanted to say was that although the systems behind Adaptec products are complex, the message is simple—Adaptec moves the data that moves the world."

Half-joking, someone suggested turning the annual into a children's book. Of course, this brilliantly simple concept stuck. Based on the look of children's primer books, Adaptec's report explains the complex functions of UltraSCSI PCI cards and PCMCIA host adapters in language we can all understand—the phraseology of "Dick and Jane." In classic beginning-reader fashion, the story of Adaptec follows the antics of Molly, Wally, and dog Data. Wally has a hard time scanning big photo files and backing up his hard drive. Molly, on the other hand, can "multitask" with the help of Adaptec tools! And Data, "being a smarter than average dog"—an adaptation of the slogan used by U.S. cartoon icon Yogi Bear—uses Adaptec host adapters and network interface cards to "beat the bandwidth bottleneck."

Go Traditional... If You Can Find a Printer

Once this jolly design concept was given the go-ahead, "everything," said designer Kevin Roberson, "pretty much fell into place." The book was quickly broken down into three chapters—"Chapter One: A Small Office," "Chapter Two: The Enterprise," and "Chapter Three: The Mobile User"—each with a little moral ending. The tricky thing about pulling off it was finding the right illustrator. Roberson decided to go with Richard McQuire, a fine artist with little experience in designing for annuals but possessing a unique style.

Roberson explained to McQuire that he wanted the characters to be primitive, drawn with heavy lines and block colors. To achieve this, McQuire built his images the old-fashioned way with rubyliths (an acetate film that serves as a mask for particular areas) for color separation by hand rather than computer. "It actually was very ironic. We wanted to hearken back to traditional techniques for over-printing, so our illustrator created four different layouts—one for each color—and all to talk about technology. The really funny thing about it was that our printer didn't know what to do with our rubyliths. Since everything is digital now they had to set up a whole system for taking our color to film," says Roberson.

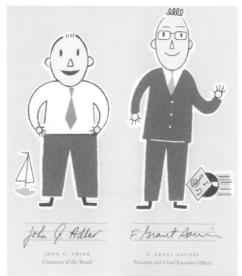

Having Fun

Cahan is particularly proud that Adaptec management received so much positive response from the book. When CNBC produced a four-minute segment on Adaptec, part of the story was dedicated to the captivating design of the annual report. "The response was huge," says Cahan, "which proved to us that it pays off to go with your instincts, even if that means going out on a limb with something significantly different." All the free publicity of course pleased Chairman John G. Adler and President/C.E.O. F. Grant Saviers, whose atypical portraits appear here.

Those Little Extras

This report is bound exactly like a children's book, hardcover and all. Endsheets are decorated with rockets, teddy bears, and pictures of Data the dog. The front endsheet has a graphic for a "this book belongs to . . ." bookplate.

See Wally hard at work.

He tries to scan big photo files.

He tries to move video files to his backup drives.

Poor Wally. Wally thinks his new processor makes him work faster. He does not know that the data link between his PC, peripherals, and the network is more critical.

C/ H/ A/ P/ T/ E/ R

5

c a r e e r s

CONSERVATION

Publications that cover the how-to's of a business or industry are typically rather dry. These poor war horses, which have to pack an overwhelming amount of facts into a page count that is limited by budgetary concerns, are often downright unreadable.

For our section on "Career" publications, we have searched for exceptions to this rule. The following diverse selection of newsletters/journals and annual reports share one design element in common—an eye for white space.

Nothing is more tiring for the reader or, in fact, more overwhelming than lack of white space.

Publications that persist in cram-

ming both copy and illustrations up to the trim find that no one actually reads their stories. Although there is a great deal of information conveyed in the Getty Conservation Institute's newsletter, Conservation, its out-of-the-

INVESTOR RELATIONS

Accessing international analysts

One investor conference company makes it easier for corporations to get the attention of busy investors and financial watchers

Reaching analysts online just got easier - thanks to one enterprising investor conference company.

New York City-based The Wall Street Forum

New York City-based The Wall Street Forum (www.wallstreetforum.com) is the first conference outfit to make broadcasting presentations to investors online possible.

At the first conference uploaded on the Internet, 85 analysts from Europe, Canada and around the county logged in, says Gerald Scott, CEO of the Forum That's on top of the more than 750 who attended the January conference physically. At the second conference in March, the number of virtual attenders more than doubled to about 200.

The service has been a boon to lesser-known com-

The service has been a boon to lesser-known com panies, like Wallace Computer Service, that traditionally have had a tougher time getting analysts to listen to their investment story.

"If you're McDonald's, or some company with a big

name, it's fairly easy to get investor interest — people are willing to take a look at your numbers," says Brad willing to take a look at your numbers," says Brad Samson, director of IR and public relations at Lisle, Ill-based Wallace, "But when you're more of an industrial business-to-business company like we are, even though we're almost 5 billion in size, people may not take the time to find out about you."

The challenge for smaller companies, Samson adds, is to get big investors to give you a hearing. Unless they're specifically interested in a company, analysts and institutional investors won't take the time to the size when the same properties are the professors.

analysis and institutional investors won't take the time to physically attend the conferences.

"To me, one of the best parts of the Internet feed opportunity is that people who might be slightly interested in you, can dial in just like you flip to a movie on HBO that you're not sure you're going to like and you don't want to spend the money to rent," Samson

How it works

The Forum usually draws about 100 companies to The Forum usually draws about tou companies to present at the conference. Most companies have capitalizations of more than \$100 million. The number of analysts attending: about 800 on average.

The cost to a company making a presentation at the conference is \$3,300. The Internet link-up is an

extra service Samson believes will give the Forum as

earta service samson believes will give the Forum an edge over the competition (i.e., brokerage firms and larger conference outfits).

Each presentation lasts 30 minutes followed by a 15-minute Q&A session. Analysts attending the conference via the Internet actually see and hear exactly what conference attendees do. Viewers need

exactly what conference attendees do. Viewers need basic computer equipment: 4,486 system with 3 RAM speakers, Web access and a modern of at least 14.4 bps Once analysts choose a session to attend, they're given an electronic form on which they provide their names, firm, city and state. The form also provides space to list questions directed at a speaker. The form

can be e-mailed at any point during a presentation, and Forum staff simply voice any questions listed. On the left two-thirds of their PC screens, they view the same slide show the company uses at the onference. To make this work, The Forum collect the slides a few weeks before the conference and loads

them online.

The right third of the screen shows a live digital photograph of the CEOs or CFOs who are presenting.

To ensure that things go smoothly on the technical side, The Wall Street Forum keeps a demo presentation

up on its Web site so analysts can test their software and make sure it's working before the actual confer-ence. The Forum also makes it possible for analysts to

CARN: Corporate

Annual Report Newsletter

For corporations producing annual reports, CARN is a godsend. Dedicated to examining every aspect of annual report production, this Lawrence Ragan Communications publication provides insight for executives, designers, and editors on new trends in editorial themes, cutting-edge layout, and financials representation.

TRIM SIZE is 8 1/2" x 11" (22 cm x 28 cm) SIXTEEN-PAGE, THREE-COLOR MONTHLY 60 lb (90 gsm) White Offset STOCK Minion BODY FONT CIRCULATION: 800 FEATURE COPY LENGTH: 1,000 words LAYOUT PROGRAM: Adobe PageMaker HARDWARE: PC EDITOR IN CHIEF: Cecile Sorra. ART DIRECTOR: Lucy O'Sullivan. Both are staff members of CARN, a division of

Tips, Trends and Tactics

ARs set course in sea of change

Reports are launching pads for firms undergoing 'reinvention'

annual reports lean heavy on the financials and light on everything else. But this year the insurance giant's AR took a decided turn.

insurance giants AR took a decided turn.

Instead of its usual plain cover, Actas's
1996 cover bears a black-and-white close-up
of a young boy wrapped in a parent's protective arms. And the company added a slogan
to its typically drab title. "Actna Annual
Report": To Manage Best What Matters Most:
Astras 1996 Annual Report".

tha 1996 Annual Report."

The AR serves as a prime example of how mpanies, faced with a fundamental turn in companies, faced with a fundamental turn in their business, look to their report to commu-nicate their new image and direction. For Actna, change comes from a shift to managed healthcare from general insurance. Reports play a key role not only in com-

municating such change but in convincing stakeholders that the changes are the right

It's a tricky job. How does the report co municate all the messages? Who should it speak to? How should it be different from pre-

speak to Fiths should the distriction from par-vious years?

To get answers, CARN editors spoke with communication experts and with AR produc-ers from Connecticut-based Aetina and Suncor Energy, an Alberta-based oil and gas company also in the midst of a "reinvention

annual report has a real opportunity to be a flag in the sand, to speak to várious audiences and to unify all the different perspectives," says loyce Oberdorf, Aetna's vice president of cor-porate communications. "This opportunity is

The first hurdle: Who to target? Becar

of the new market the company wanted to command. "Part of the strategy [in the AR] a very small marketing section and a huge MD&A and notes section."

Inside

Graphically Speaking... p. 4 A review of early 1996 ARs finds few companies really care about the report's look. Will the bulk of ARs to

INTERACTIVE INVESTOR RELATIONS

ences promise greater exposure..... Can a CD-ROM tell your changing IR story?.....p. 9 IR site profile: P&G.....p. 10

Electronic AR Profile....p. 11

Suncor Energy

Little Things

When designer Lucy O'Sullivan set out to redesign CARN, she knew it wouldn't take much to update this already classic newsletter. To help readers find their way through the publication she added an additional color and expanded the depth of the border at the top of each page so that it could carry the title of each section. To accommodate more copy without unsightly line breaks, O'Sullivan broadened columns by a few points. She also moved the table of contents from the inside to the front.

Lawrence Ragan Communications Inc. in Chicago, Illinois.

Come Together

Lawrence Ragan produces sixteen publications per year, the majority of which are top sellers. However, Interactive Investor Relations, a sister publication of CARN, did not live up to the company's expectations. "Instead of scrapping the newsletter," explains editor Cecile Sorra, "we decided to include it as an insert in CARN." "Interactive Investor Relations," which covers online interactive investor relation packages (such as annual reports), complements the content of CARN. It is bound into the middle of the newsletter and is set apart by a very business-oriented look. For this publication, O'Sullivan sticks to two columns and simple pull quotes to spice up the copy. She also adds a one-point rule to frame each page and a different but related pastel color for the headline and illustration backgrounds.

The overall advantage? Reader appreciation. Subscribers feel they are getting more editorial bang for their buck.

Charting It Out

No designer likes to create charts, but if you set up a template and stick with it, it won't be such a nightmare. The annual report "report card" that appears on the back of each issue (opposite page, top right) gives readers a quick and easy reference for what works in an annual report and what doesn't. However, cutting copy to fit is a tedious task for Sorra, who edits directly in Adobe PageMaker on O'Sullivan's template.

Says Sorra, "The 'Report Card' is definitely my biggest challenge because I have to justify, in just two sentences, why an annual has received a particular grade on a particular aspect of design or editorial. And those two sentences have to be absolutely straightforward; otherwise readers will question my grade."

Size Matters

O'Sullivan has the production of CARN down to a science. Her three-column template is so streamlined that her biggest concern each month is how she's going to size photos. Typically O'Sullivan begins her production work by creating a rough layout. She carefully measures her art and then sizes it for scanning; that way she can confidently work on copy layout while art is being digitized. Note that she likes to keep her images about the same size. Of course, this avoids complaints from competing companies that the newsletter covers, but it also gives the design a uniform, almost museum-catalog look and feel—definitely a sophisticated (and time-saving) option.

THE SYNCHAY INVESTOR RELATIONS

Accessing international analysts

One investor conference company makes it easier for corporations to get the attention of busy investors and financial watchers

Reaching analysts online just got easier — thanks to one enterprising investor conference company.

New York City-based The Wall Sturvete Forum (www.sulstreetforum.com) is the first conference outfit to make broadcasting presentations to investors online possible.

At the first conference uploaded on the Internet, 85 analysts from Europe, Canada and around the country logged in, says Gerald Scott, CEO of the Forum. That's on top of the more than 750 who attended the January conference physically. At the second conference in March, the number of virtual attenders more than doubled to about 200.

The service has been a boon to lesser-known companies, like Wallace Computer Service, that traditionally have had a tougher time getting analysts to histen to their investment story.

"If you're McDonald's, or some company with a big name, it's fairly easy to get investor interest — people are willing to take a look at your numbers, "says Bread Samson, director of IR and public relations at Liske, Illiadusiness-to-business company like we are, ever though we're almost 15 liblion in size, people may not take the time to find out about you.

The challenge for smaller companies, Samson adds, is to get big investors to give you a hearing. Unless they're specifically interested in a company, analysts and institutional investors won't take the time to find out about you, can dial in just like you flip to a movie on HBO that you're not sure you're going to like and you don't want to spend the money to remt. 'Samson says.

How it works

How it works

The forum usually draws about 100 companies to present at the conference. Most companies have capitalizations of more than \$100 million. The number of analysts attending; about 800 on average.

The cost to a company making a presentation at the conference is \$3,300. The Internet links up is an estra service Samson believes will give the Forum an edge over the competition (i.e., brokerage firms and larger conference outfish).

Each presentation lasts 30 minutes followed by a 15-minute Q&A session. Analysts attending the conference with the internet actually see and hear executly what conference attendees do. Viewers need basic computer equipment: A 486 system with 3 RAM, speakers, Web access and a modern of at least 14.4 bps.

Once analysts choose a session to attend, they're given an electronic form on which they provide their names, firm, city and state. The form also provides space to list questions directed at a speaker. The form can be e-mailed at any point during a presentation, and Forum staff singly voice any questions listed.

On the left two-thirds of their PC screens, they view the same slide show the company uses at the conference. To make this work, The Forum collects the sildes a few weeks before the conference and loads them online.

The right third of the screen shows a live digital.

them online.

The right third of the screen shows a live digital photograph of the CEOs or CFOs who are presenting. To ensure that things go smoothly on the technical side, The Wall Stere Forum keeps a demo presentation up on its Web site so analysts can test their software and make sure it's working before the actual conference. The Forum also makes it possible for analysts to

Report Card

Company	Nordson Corp. 26601 Clemens Rd. Westlake, OH 44145-1119 (Indiatris) mtr.)	Molex Inc. 2232 Wellington Ct. List, II. 60532 (connector mfr.)	Fair, Isaac & Company, Inc. 120 N. Redwood Dr San Rafael, CA 94903 (Brancial software developers)	Tredegar Indus- tries 1100 Boulders Parkway Richmond, VA 23225 (plastic/akuminism products).	Genentech, Inc. 450 Pt. San Branc Blvd. 5: San Francisco, CA 54000-4990 (hielachnology)
Appearance Refers to the immediate visual impression.	B- There's no innovation, almost boring. But it's simple, straightforward. While not an attention- getter, info is clearly segmented and easy to obtain.	C- Wouldhasebeen an "A" — striking pics, well- conceived flow. But AR's binding fell apart! Don't underestimate the im- port of a good printer.	C AR actually looks a little sifly with all the shots of grinning managers. Book's drablook doesn't convey co.'s bright po- sition in industry.	B Pics effective in showing what co. produces. But some pages get a little busy, diluting overall communication of AR's design.	A: Cover is fun, showing CD-ROM of latest ap- proved drug stuffed is blue jeans pocket. Plays on theme, "Genes At Work."
Readability Grades the final effect of the combination of design and content. (For example, can the reader tind and digest material quickly?)	B AR is adopt at providing product overview and break-outs of key strat- egies and performance. But pics are staid and not communicative.	A Like the completeness of financial highlights. Into is readily segmented in logical, geographic or- der, tying together AR's global theme.	C Italicized headlines get lost on page. Purple and blue print is light and serves no readability purpose. Good infogets lost.	A: There are lots of charts throughout that daringly track oo.'s performance at a glance. Most dem- onstrate an impressive business operation.	B+ Because of technical na ture of co. AR is packet with info. Some page suffer from overfoad but others provide good snapshots.
Chairman's Letter Does it explain last year and tell what the company aims to do in the next year(s)?	B Bit windy. Has candid explanations of year's performance, but leaves out definitive strategy for '97. Ex: How will ac- quisitions boost co.'s strength in market?	A Letter is translated into 5 languages, Impressive 'cuzit makes sense to do thematically and strate- gically. Good perspec- tive and detail that doesn't bog down prose.	A- Phew! A 6-pager, Prob- ably could have cut it back by 1/3. But we appliand the effort to educate reader on co.'s service — and market.	C Succinct.That's normally good, but letter should claborate a little more. Ex: "We see many threats." What are the threats! How will co. deal with them?	C Too many technica terms. Surely it cas translate in lay terms Also, strategies are it reverse order: improvi finances should list first
Text Does it deal efficiently with important assues?	A Presents balanced look at ups and downs (and whys) in geographic regions. Highlights work-force while imparting key business strategy.	B+ Well-scripted blend of marketing and perspec- tive. But would have liked to see more detail on strategy for some of the co.'s trouble spots.	B+ AR makes sure readers know what services co- provides and demand for them. But we still need some discussion of co's performance.	C This report relies a lot on the graphs to tell the story. But reader doesn't know how sales of some divisions may have in- flated some numbers.	B- Lawausts seem to plagu company, targely be cause of patent issue Text mentions all o them. But reader is let to guess at impact.
Discussion of Financials Does the report weasel, hide behind ponderous locutions, or otherwise make a reader struggle to decipher what is really happening?	B It's all here, but it doesn't provide some insportant details. Ex: Co.'s trying to reduce negative im- pact of inflation by rais- ing productivity, but doesn't say how it will do that.	B+ Readable prose, but info needs to be segmented, not lumiped under gen- eral subheds. Also need more info on how over- budget start-up plant was and how co. is responding.	C+ Financial section does better job than middle of book of breaking out info sections. But if s a tough read. Can barely make out info if s trying to impart.	B Finally have some expla- nations for the graphs in the middle of the book. It's a largely complete picture that should have appeared in earlier pages.	B+ This discussion i straightforward, givin reader a better idea o co.'schallengesthan an other part of the book.
Stock On the basis of this report alone, would we buy the stock?	Yes While there are some holes in the report's disclosure, it provides sufficient evidence that co. is healthy and will continue to be so.	Yes AR is convincing in its message and outline of co.'s growth around the world. There's a good amount of perspective.	Yes If you can muddle through the test, you'll find that co. is possed for rapid growth.	No Get the sense that co. is hiding some serious info because much of the real story doesn't appear until financial discus- sion.	No Not convinced that ce has clear strategy to pur out of the many prob lems if has. AR needs do better job of pullin relevant into together.

CARN innes its decision to buy stock is a company on the annual report's efectiveness in commun-tering a firm's unessage and direction, not necessarily on its bealthy, or not-so-bashin numbers.

Technology trends for the IR professional

Graphically Speaking

Part I of II

Who cares?

Which companies appear to care about the report and its design? Our take on the first batch of 1996 ARs

By lack Summerford Contributing Editor

This column really began more than 15 years ago, when I placed my name on every season, when I placed my name on every season every the season

they succeeded in relaying the message visually.

Stack B consisted of reports from companies that also cared but — because of a lack of resources or imagination or trust in a good design firm, or all three — just didn't pull it off. It's called mediocrity.

Stack C was the stack from graphic hell. the Land of Nobody Cares. You know the kind, the IO Ks wrapp, or similar types, the kind that if it did have photography or all bustation, it was of the poorest quality. And, the typography. we won't discuss the typography.

And, the typography ... we won't discuss the typography.

The third stack was the tallest. I mean it was really the tallest. If my memory is accurate, this stack of reports represented of two-thirds of all the reports in my

"study."

The size and status of a company seemed to have no bearing on whether a particular report ended up in the tall stack, or the shorter stack for that matter. Some of Wall Street's flinest were included in Stack C. Their numbers may have been great, but they were graphically hankrupt.

Graphically Speaking

So, the final result was something like

this:

- Stack A (those companies that cared about
the design of their report, tried and succeeded): about 10 percent

- Stack B (those that cared but failed): about

Admittedly, all this grading and judg-ing is subjective. But that doesn't mean we can't have standards of excellence. In addi-tion to satistying the obvious requirements of good communication, such as readabil-ity, logical numerical display, and maybe a good photograph of the CEO, there are two main elements essential to a well-designed

annual report.

First and most important, the report should have an idea. A concept. A theme. This is the vehicle that carries the

This is the vehicle that carries the company's messes. Second, that vehicle needs good fuel, be ingredients of that fiel are copy, types-raphy, photography and/or illustration, chars and graphs, paper stock and chars and graphs, paper stock and quality, but also meed to be appropriate to the idea or message. That's about it. Two very broad steps to great annual reports. Those are the electronic annual reports annual reports covers. That is how I determine if a report ends up in Stack N.

Grab the easy chair

Grab the easy chair

Now that brings us to the new crop. The 1997 crop of 1996 reports. What will the harvest reflect!

Unfortunately, as we go to press with this issue, our timing is just slightly off. In about a week and a half we should help that the properties of the properties

Conservation

The Getty Conservation Institute publishes Conservation to keep trained professionals informed about its work. The publication is also designed for anyone who appreciates the work of preserving cultural heritage. Conservation covers the preservation of not only fine art and architecture but also sites of archaeological importance such as the 3.6-million-year-old hominid footprints, preserved in volcanic ash, discovered by Mary Leakey in the late 1970s.

CONSERVATION

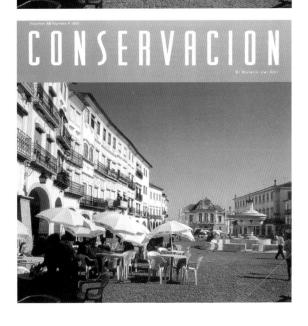

TRIM SIZE is 11 5/8" (29 cm) square

TWENTY-FOUR-PAGE, TWO-COLOR PUBLICATION PRINTED THREE TIMES YEARLY

Evergreen 70 lb (105 gsm) BOOK STOCK

Ehrhardt BODY FONT CIRCULATION: 8,500

LAYOUT PROGRAM: QuarkXPress

HARDWARE: Macintosh

EDITOR: Jeffrey Levin of the Getty Conservation Institute, based in Los Angeles. Design: Joe Molloy of Mondo Typo Inc. located in West Los Angeles, California.

Design Evolution—It's a Good Thing

Like many newsletters that have flourished for a number of years (*Conservation* is more than ten years old), the Getty Conservation Institute's publication has seen several design incarnations. The latest included a move to a large, square format that catches the reader's eye—especially at conferences and meetings—and provides room for photos and copy to breathe. Editor Jeffrey Levin acknowledges that a few librarians have a bit of a hard time archiving the impressive work due to its unusual size but this minor challenge is definitely offset by positive reviews from subscribers.

Besides the format change, Levin regularly instigated other incremental improvements. For instance, to improve readability the template has changed from two columns to three, and, in one section, four much narrower columns. The body font has switched from Garamond to Ehrhardt, a Monotype font that designer Joe Molloy feels is particularly readable due to a slightly heavier weight and taller x-height.

Odd Size—Good Idea? Bad Idea?

For Molloy the large, square layout is a dream for positioning photos. "A square set-up is ideal because it accommodates both horizontal and vertical images." However, when it comes to actual production, the format is a challenge. As Molloy points out, even with a 17" (43 cm) monitor he can't zoom in very far without losing some portion of a spread. Also, it's impossible to print full size on a laser printer; Molloy outputs his pages at ninety percent on tabloid-sized paper for proofing.

You Must Have a System

Designers are never surprised by oddball problems; few, however, often deal with type in another language. Since each issue of *Conservation* is produced in English and Spanish, Molloy created a system for fitting Spanish type without changing his English layout. Says Molloy, "I design the English version about a week ahead of the Spanish version, so all the images and headlines are laid out and created. To keep from having to redesign my headline type, I try to create graphic pictures that will work for both languages." For instance, on lovely spread with the title, "Face to Face with Landmarks" (the opposite page, middle), Molloy explains that his intriguing setup (Both "faces" butt against each other vertically; with the top word in black and the bottom in white, so they look like the reflection in a mirror) luckily worked perfectly in Spanish as well, appearing as "Cara a Cara."

Make the Most of Great Photos

Here's an inviting spread that depicts this publication's photojournalistic style. Note the lovely use of the full-page photo on the left balanced by two photos that are sized to fit in the outside column of the right-hand page. Molloy's template allows for longer-than-average photo captions.

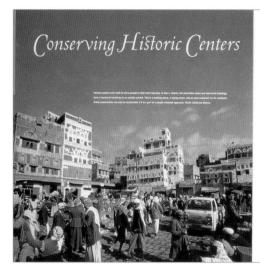

More'than Meets the Eye'

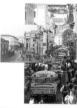

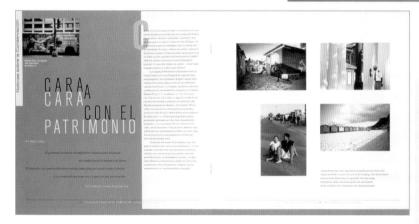

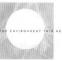

Journal of

Property Management

Since 1935, the Journal of Property Management has been dedicated to providing educational and trend stories to professionals in the field of property management.

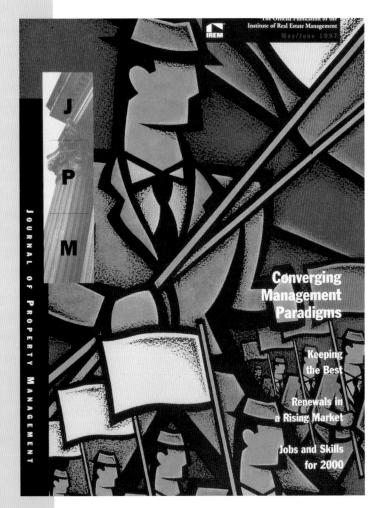

TRIM SIZE is 8 1/8" x 10 7/8" (21 cm x 28 cm)

NINETY-TWO-PAGE, FOUR-COLOR BIMONTHLY

Marva 80 lb (220 gsm) COVER STOCK; Delta Bright 50 lb

(75 gsm) BODY STOCK

Adobe Garamond BODY FONT

CIRCULATION: 23,500

FEATURE COPY LENGTH: 2,500 words

LAYOUT PROGRAM: QuarkXPress

HARDWARE: PC

EXECUTIVE EDITOR: Mariwyn Evans. DESIGN MANAGER:

Flint Weinberg. DESIGN: Michael Sonnenfeld. All are staff members of the Institute of Real Estate

Management located in Chicago, Illinois.

Modern Image

Since its redesign in 1995, the *Journal* has made continual steps toward offering a clean, easy-to-read format to its readers. The template has developed to include ample use of white space, bold sans serif headlines, and icons to set off departments and features.

Choose the Best; Leave the Rest

One of *JPM*'s chief assets is strong cover design. Artist Flint Weinberg explains that covers are usually custom created for each issue by freelance photographers or illustrators. For dealing with out-of-house artists, editor Mariwyn Evans offers the following rule of thumb; "Most freelancers fall into one of two categories: they can either take our idea and simply produce it or they can take our idea and bring some of their own creative personality to the project. If you can," she says, "try to work with artists in the latter category."

Icons Are Our Friends

Each department in *JPM* features its own straightforward photo icon; for example, a fountain pen for the "President's Letter" and a photo of the Capitol Building in Washington for the "Legislative Update" (opposite page, top). What makes these fun is adding a duotone effect and clever cropping.

Evans notes that many of the departmental icons were taken by photo graphers on assignment. After computing the costs, Evans found it was cheaper to pay for original shots rather than pay royalties on stock images each issue.

Give 'Em a Theme

Every month the *Journal* focuses on a different theme. The design challenge is to come up with headlines and type that work for a series of linked stories, representing the overview. An excellent example appears here for a series about property redevelopment (opposite page, middle). Within this theme, the following three articles appear: "Boardrooms to Bedrooms," "Mills to Desks, Gurneys to Beds," and "Too Old to Be a Mall Anymore?"

Although other fonts are incorporated, note that each headline includes Franklin Gothic Condensed as a basic building block for creating a design based on type. The combination and reuse of blue and brown key the headlines into the overall look. In addition, each story opens with a iconographical portrait of a cityscape that horizontally gradates from black and white to color, a subtle feature that further reinforces the connection between stories.

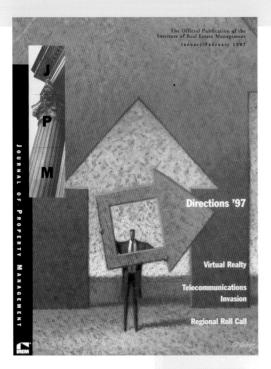

Ja Call

Boardrooms

Bedrooms

Change from the Inside Out

Mills to Desks, Gurneys to Beds

to Be a Mall Any More?

Chicago Volunteer Legal Services

1996 Annual Report

Attorney and paralegals from the Chicago Volunteer Legal Services work to ensure equal access to basic legal rights and responsibilities for the working poor throughout Chicago and its suburbs.

Trim Size is 5 1/2" x 8 5/8" (14 cm x 23 cm) Sixty-two-page plus cover, dust-jacketed,

TWO-COLOR-PLUS-THREE-SPOT-COLOR ANNUAL REPORT, with three spot colors on pages 1-28 and two spot colors on pages 29-62

Cheltenham Condensed BODY FONT

CIRCULATION: 5,000

LAYOUT PROGRAM: QuarkXPress

HARDWARE: Macintosh

WRITER: M. Lee Witte and Margaret Benson. DESIGN: Tim Bruce of Froeter Design Company in Chicago, Illinois.

PHOTOGRAPHER: Tony Armour.

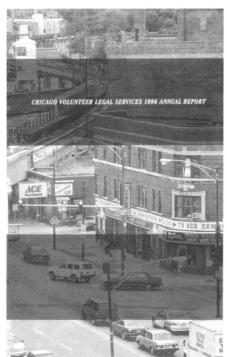

Wave Your Flag

Well, the headline "flag" doesn't exactly wave, but the jacket for this annual report is certainly an attention-getter. Bruce tinted this black and white photo of a Chicago neighborhood in red and blue to create the American-flag Stars and Stripes.

Bruce explains the decision to include a jacket, "I wanted to wrap the report up, like a flag, while also showing a working neighborhood in Chicago."

Conventional Theme

Because the Democratic National Convention was held in their city, the memory of 1996 has a very patriotic feel for Chicagoans. In preparation for the festivities, many parts of the city underwent much needed clean-up, which also led to a sense of pride. So, what better time, thought designer Tim Bruce, to make democracy a theme for the Chicago Volunteer Legal Services annual report?

Note the use of bold blue and red colors on glossy white paper as a reinforcement of this theme. To maintain a sense of community or neighborhood involvement, Bruce handbrushed this lettering and colored the words in the computer. "I wanted to have that handmade quality, like the handbills or homemade political posters you see on the street," says Bruce.

Total Immersion

Just like a documentary film crew, Bruce and photographer Tony Amour went to clients' homes to get the real stories behind their cases and the legal services that made such an impact on their lives. Citizen Augie Santana had been to court eighteen times trying to obtain visitation rights before he found the Chicago Volunteer Legal Services. With the help of attorney John Van Harken, a settlement is pending.

Says Bruce, "There was little structure to our photo shoots, we just sort of let things happen. When we met Augie, he brought out his case files and showed us a note he had written to the courts and a photo of his daughter that he keeps on his dashboard of his car. His ex-brother in-law actually had to smuggle it out to him."

In keeping with Santana's honest and open telling of his predicament, the layout of his photos (opposite page) is straightforward. Bruce allows images to make full impact by giving them room and, where needed, white space. Note the unusual use of white space in the lower left-hand quadrant of the second spread. It feels like a reflection of Santana's feelings: lost and empty.

CVLS & Corporations

TALONE SANAMA FOTHER CYTTHIS STHERE AND THE SANAMA FOTHER CYTTHIS STHERE STREET AND THE SANAMA SO EVET WOULD BE TO HAVE THE TO HAVE THE THE SANAMA SO EVET WOULD BE THE TO HAVE THE TIGHTS TO SEE MY CHARLES

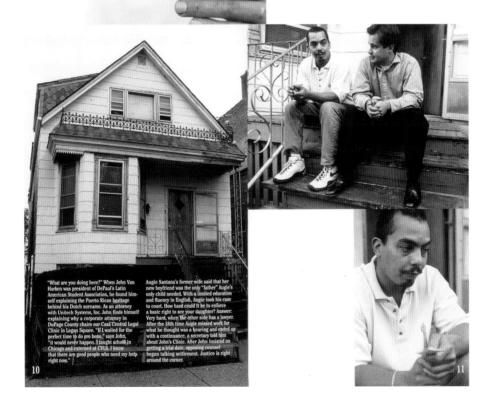

C/ H/ A/ P/ T/ E/ R

6

g o o d s

Stee Comp sense Calle Lier Clanbonas to Box Appete subsolit expense back in Callenas Vincond its West 's grope arbi-

Bon Appetit Magazine Invites Area Subscribers to Callaway

House organs must remind every salesperson, execu-

tive, and factory worker that both their company and

und chicken lineast institut with teeth grilled vegetables topped with numbers squash and insated auditioner, accompanied by har-sected rise with a hint of ginger and California's 1993 California and 1992 Caberton Dandonius and 1992 Caberton Santigeon.

As a special trast, hinchesis posts over served California's control of the caberton state of the caberton state of the caberton served.

the distinctive style of or witnong Cafe-Lee Chands which our winery has sexionally noted. Dwayne has more Callaway wine innovation ing, but that's for another it

Publications that showcase goods have to tap into something special. They have to make a customer giddy with anticipation, unswervingly loyal, or simply out-and-out happy to contribute, through their purchase, to the growth of the product itself. House organs for manufacturers have to keep employees just as inspired; in effect, they are designed to remind every salesperson, executive, and factory worker that both their company and their product are winners. And they have to do all this with absolute honesty.

Under the honesty-is-the-best policy edict, is the clever and genuine newsprint report for the Portland Brewing Company. When artist Adam

McIsaac and his partners from The Felt Hat sat down

with their client, they quickly understood that it had been a less than impressive year for the company. Unfortunately the micro-brewing industry had taken a downturn due to market oversaturation. Although Portland Brewing execs had gallantly rebounded, their end-of-year numbers would not reflect their efforts. Instead of

trying to hide this irritating turn with fancy graphics and trumped-up charts, the designers suggested that Portland Brewing put their cards on the table and tell the real story to their investors. Not only did this approach win hearts and ultimately dollars for the client, it led to a charming, humorous design that is

their product are winners.

LS&CO.'s
historic Valencia
Street plant in
San Francisco
or manufacturing the best
known brand in the apparet
business. The factory, which
operated its doors in
November 1996,
is LS&CO.'s oldest facility.
It was built to replace
two CS&CO. factories that
were destroyed by the
1996 cemployees and produce
writage Lev's jackets and
501 pears.

Localistic and List Kinhommhal in
fraction of the histories Valencia's Street plant in San
floors the factory has 80
employees and produce
writage Lev's jackets and
501 pears.

Localistic and List Kinhommhal in
fraction of the histories Valencia's Street plant in San
floors the wash floors to mere than 6,000 Lev's Bread fan a year
house the san floors the men floor
floors the factory has 80
employees and produce
writage Lev's jackets and
501 pears.

Maria Casarettowho getted last
years with the
some play produce
who getted last
years with the
some play produce
who getted last
years with the
some play produce
who getted last
years with the
some play produce
who getted last
years with the
some play produce
who getted last
years with the
some play produce
who getted last
years with the
some play produce
who getted last
years with the
some play produce
who getted last
years with the
some play produce
who getted last
years with the
some play produce
who getted last
years with the
some play produce
who getted last
years with the
some play produce
who getted last
years with the
some play produce
years with the
some play play play
years with the
years with the
some play play play
years with the
years with the
years with the
years with the
years with years
years with the
years with the
years with years
years with ye

OPERATIONS & SOURCING NEWS . WINTER 1987

Portland Brewing Company

1996 Annual Report

This popular craft brewer also runs two successful restaurants . . . make that "brewpub and eateries."

TWENTY-EIGHT-PAGE, TWO-COLOR TABLOID ANNUAL

NEWSPRINT STOCK

Monotype Grotesk BODY FONT

LAYOUT PROGRAM: QuarkXPress

HARDWARE: Macintosh

DESIGN AND EDITORIAL: The Felt Hat, located in

Portland, Oregon.

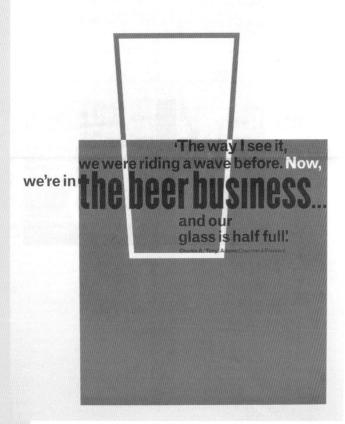

The Truth Doesn't Always Hurt

Due to oversaturation of the marketplace, the microbrewing industry suffered in 1996. Literally up to their ears in suds, every company reported losses. Even though the popular Oregon-based Portland Brewing Company made a comeback in the fourth quarter, it was not enough to offset losses and show a profit for the year, an obvious disappointment to the shareholders.

When designer Adam McIsaac and his partners in The Felt Hat met with executives to discuss their annual report, he found them less than enthusiastic about the project. "They were pretty depressed," says McIsaac. "But they told me two interesting things. Last year was bad, but the prospects for the next year were good. They were already out of the storm. So we suggested that they say just that, that the company carry on a frank discussion through the annual report to shareholders concerning the condition of the industry, how that related to the company, and how they were fighting back."

This "honesty-is-the-best-policy" approach resulted in a marvelously unique publication. To keep costs down, McIsaac and his partners built a layout for the tabloid format to be run in two colors on newsprint. Both copy and illustrations are uncharacteristically appealing in their frank, but humorous, take on the facts. Here's an example from the opening spread (opposite page, middle): "It takes no Sherlock to see that '96 was a less rosy year than others we've had…the market changed on us . . . the demand we were chasing dropped off. The result was Economics 101." Illustrations show ninety-nine bottles of beer (a hint at over-saturation) and pint glasses that are meant to appear half full rather than half empty (homage to the company's optimism).

The happy ending to this design story is that the shareholders were so proud of their company's brave publishing move that they honored the owners with a standing ovation at the shareholders' meeting, even offering to do whatever it might take to put the company back on its feet.

Ye Old Type

Type selection in this report honors the Bauhaus school of Germany (definitely a great art and beer culture). Here McIsaac gives a little historical perspective. "Germans were using sans serif typefaces extensively during the final years of the Weimar Republic (the forms, which the Germans called Grotesk, first appeared during the Industrial Revolution). The use of these letters—and of red and black—refers to the European craft tradition. The absence of capital letters in the text and the asymmetric compositions are pure Tschichold (who taught at the Bauhaus)."

Set the Pace

"It's harder to manage the flow of design in a simple book like this," explains McIsaac. "So we relied on the genius of our copywriter. He is a bit of a stand-up comedian—with a very specific way of speaking that is mirrored in his writing—so we actually had him perform the copy and record it. We listened to this over and over to help set the pacing and syncopation of the layout."

this was the year our flanders street pub was transformed into the second of our full-ser-vice restaurants and a fine big place to try true brews and listen to live blues.

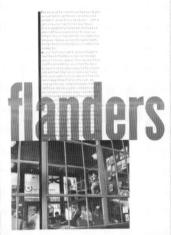

s part of the country espec ally—that looked like it would live forever, but there were quirks.

it takes no sherlock to see that '96 was a less rosy year than others we've had at portland brewing, just take a look at the highlights and this straight-up report. story the short

2|3

well, the market changed on us. while we were ramping up production (along with every other craft brewer), the demand we were chasing suddenly dropped off. the result was from economics 101: supply outpaced demand. conditions changed so fast that, even though we course-corrected, we still turned in a bum fourth quarter. and showed a loss for the year.

we're not whining, mind you, what happened happened and we're dealing with it, matter of fact, as you'll see when we describe context (e.g., how other brewers are faring), we're dealing pretty well, our true brews — mactarnahan's amber ele, oregon honey beer, wheat berry brew, haystack black, our new zigzag lager, and the sea sonals — are great, our installed capacity is up to iss, oso barrels of full alle production, our processes and controls have improved abunch, and we work in a great brewhouse.

a bunch, and we work in a great brewhouse. we like our prospects a lot, but we wanted you to know going in why we sound a little more deliberate this time.

The World of Kashi

A story is told on every package of Kashi cereal—the genesis of the product, for example. The mission of The World of Kashi is to tell stories about how consumers and Kashi employees make the cereal part of their healthy lifestyle. The publication also includes fun trivia such as the fact that "Jerry Seinfeld stocks Kashi Medley in his cupboard on the 'Seinfeld' T.V. show."

THE World of Kashi

Take but the following from the

TRIM SIZE is 8 1/2" x 11" (22 cm x 28 cm)

FOUR-PAGE, FOUR-COLOR NEWSLETTER

Recycled Evergreen Glossy BOOK STOCK

CIRCULATION: 250,000

FEATURE COPY LENGTH: 200 words

LAYOUT PROGRAM: QuarkXPress

HARDWARE: Macintosh Power PC

EDITOR: Karen Moyer, Public Relations, Kashi Company,

La Jolla, California. ART DIRECTOR: Roxanne Barnes,

Roxanne Barnes Creative Services, San Diego, California.

3-D ILLUSTRATOR: Pak Sing Chan, San Diego, California.

Come Together

Kashi's product message and newsletter design are intertwined. As the newsletter copy explains, Kashi is "a synthesis of 'kashruth' or kosher and 'Kushi', the last name of the founders of macrobiotics (a whole foods way of eating/living)." Happily for the company's marketing pros, Kashi also means energy food in Japan, happy food in China, and pure food in Hebrew. The world over, Kashi's "Seven Whole Grains and Sesame" mixture is known as a natural wonder.

Thus the cover of the premiere issue of *The World of Kashi* (left) features a plate decorated with a map of a large part of the world. A fork and a spoon lead the reader to think "the world of Kashi" and to open a box, pour a bowl of cereal, and spoon away. Inside, both copy and images reflect the multicultural viewpoint and market base of the company.

Is It Real or Is It Digital?

If you can't find an illustration or photograph for your perfect cover, go ahead and make it. Editor Karen Moyer explains that, although the premiere issue cover looks like it was photographed, it was actually created on the desktop. Says Moyer, "We received a call from a woman who wanted to know where we purchased the plate pictured on the front, as her daughter, who's in the Peace Corps, collects world-theme items. I had to break the news to her that the world plate existed only on computer—designed by our graphic artist."

Don't Forget Your Copy Machine

Adding a little texture to design doesn't mean hours of extra work. Designer Roxanne Barnes enlarged an actual postcard—pictures and postmark—mailed from Kashi, China, on a photocopier, then scanned this into her computer. "The rough texture," she says, "gives an earthy feel. It's like traveling the world," the world of Kashi, that is.

Photos Should Stress Theme

According to Moyer, *The World of Kashi* tells a story on every page. She says, "We want to show the folksy, honest, real people behind this company." The premier issue shows employees in colorful clothing, including Kashi T-shirts, who ran in the 1993 Chicago marathon.

White Space Creates Focus

Lots of white space on each page of the Kashi newsletter directs the reader to notice vibrant colors. For instance, the colorful product packages and page edge make the newsletter seem charged—adding to the theme of good health obtained from good nutrition.

thousands of entry forms, newspaper ads, posters and t-shirts.

Some of the larger events we sponsor are the March of Dimes "Walk America,"

the Susan G. Komen Breast Cancer Foundation's "Race for The Cure," the Heart Walks put on by the American Heart Association, the Alzheimer Association "Memory Walks," the Portland and

New York City

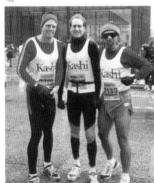

Kashi Employees at Chicago Marathon '93

Marathons, Pittsburgh's Great Race 10K and the San Francisco Bay to Breakers 10K.

What Is Kashi?

FROM SEVEN WHOLE GRAINS AND SESAME SPROUTED...

m Kashi Breaklast Pilat Something

m Puffed Kashi - America's favorite

m Kashi Medley Sov

m Kashi Vegetarian

■ Spa Kashi Salads Nine ditteren

m Honey Putted Kashi Now Putte

KASHI DOWN UNDER AND OVER YONDER

MAD ABOUT KASHI

AND ON THE BIG SCREEN

Kids often take time so write and t how much they love our cereals. I fact, Kashi Medley recently won fir

KASHI JUST DOES IT

Kashi Company was one of the first food manufacturers to aggressively develop the sports marketing niche. At hundreds of events across the country ranging from runs, walks and trathforts to acrossics, sking competitions and health fairs, participants receive samples of

THE OFFICE THE MACH OFFICE AND THE MACH OFFICE

KASHI FLYING HIGH

Operations &

Sourcing News

Operations and Sourcing is the division of Levi Strauss & Co. that manufacturers garments for sale in the United States. Operations & Sourcing News keeps this worldwide base of employees up-to-date on new policies, systems, and their company's cutting-edge approach to customer satisfaction.

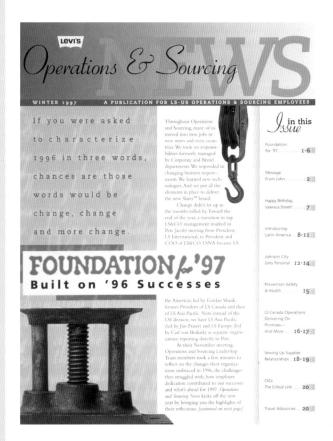

Trim Size is 8 1/2"x 11" (22 cm x 28 cm)

TWENTY-PAGE, THREE-COLOR QUARTERLY

Simpson Evergreen Text Stock

BODY FONTS INCLUDE Bembo, Caecilia, and Ribbon 131

CIRCULATION: 4,500

FEATURE COPY LENGTH: 750 words

LAYOUT PROGRAM: QuarkXPress

HARDWARE: Macintosh

EDITOR: Linda Butler of Levi's headquarters. DESIGN:

Joshua Chen of Chen Design Associates. Both are based

in San Francisco, California.

Dealing with Images

As with most newsletters, designer Joshua Chen doesn't always get professional quality photos from the field. Many of the images he works with are snapshots or, worse yet, Polaroids. "I have to do a lot of cleanup work on images in Adobe Photoshop," says Chen. "For one picture that showed a group of three people standing together, I actually had to extend their bodies so that they didn't look chopped off at the neck. Now, that may sound like a lot of work, but, if you know what you're doing, it's actually easier than asking for a re-take or trying to find another image. Our time frame doesn't allow for that sort of thing." *

Chen also mixes up the types of frames he uses. As he points out, square black and white pictures get boring fast. He often blurs the edges of photos or turns them into duotones or tritones to create interest. These extras are meant to help the reader focus on a particular area of the image.

To Grid or Not to Grid?

When Chen sits down to design a newsletter he doesn't spend much time sketching it out. "I find that it's best to jump on the computer fairly early and not get too hung up on thumbnails. The computer is just so much more accurate. Plus, because *Operations & Sourcing News* was a redesign, I was able to import text from a previous issue for good word counts—a much better system than working blind," Chen says.

The template for *Operations & Sourcing News* is an eight-column grid Chen uses as a guide. "I do base the publication on a grid, but I'm not locked to it. The grid runs through the publication, but it doesn't scream out at you. Instead I tend to design each article specifically, more like a magazine. It's a lot more work this way but it ensures that each issue is fresh and different."

It All Stacks Up

Chen often stacks type in headlines because he likes the geometric shapes the combinations of fonts create. However, he is careful to use complementary type-faces in combination. "Basically you want to give the reader the impression that these faces are meant to be together. Still, don't feel this is a hard-and-fast rule. Always feel free to experiment."

In the "Happy Birthday, Valencia Street" spread (opposite page, middle left), notice how the "y" descenders in this headline perfectly frame the word "Valencia." When stacking, be doubly sure that words are legible.

White Space

"I try to create variety from feature to feature—to give the reader a different feel. For instance, the 'Happy Birthday, Valencia Street!' page is very active. The next spread, an article called 'Latin America: A Lesson in Leadership,' is very open and sparse."

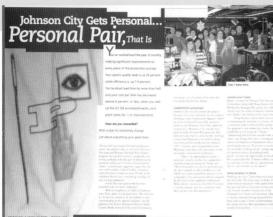

A Lesson In Leadership

LS-US. The team's vision: continuous improvement, e world-class leader in product customers and consumers." To p, the team is working on an t of Levi's jeans compared to such as fit, strength and ined with consumer e need to improve.

Ewing Up

Supplier Relationships

Relationship Planning team had its hands full in while plans. The suppliers Burlingtor Processors. The elays, wings the total

v years. lave a lot of

bLink

EarthLink Network, one of the world's premier Internet service providers, developed its monthly bLink newsletter as a printed guide for new Internet users. bLink serves as both a teaching tool and an entertainment guide to the Web. Says editor Mike Brown, "New media generates a lot of fear. Print does not. The newsletter is a safety blanket for new users, something they can keep beside their computer when they're online."

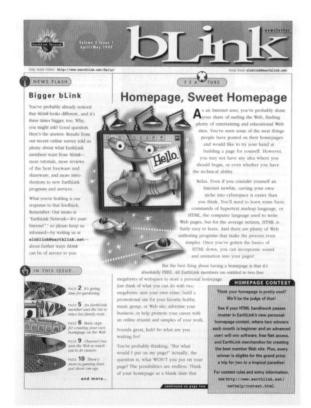

TRIM SIZE is 8 3/8" x 10 7/8" (22 cm x 26 cm)
TWENTY-PAGE, FOUR-COLOR COVER AND TWO-COLOR
CONTENTS BIMONTHLY

60 lb (90 gsm) Husky offset Smooth Text Stock

Garamond BODY FONT CIRCULATION: 300,000

FEATURE COPY LENGTH: 900 words

LAYOUT PROGRAM: QuarkXPress

HARDWARE: Macintosh

EDITOR: Mike Brown. ART DIRECTOR: Teri Osato. Both are staff members of Pasadena, California-based

EarthLink Network.

To blink or Bunk?

The *bLink* flag was designed digitally and went through some twenty different variations before it was approved. "We had to try dozens of different fonts because the word '*bLink*' kept reading like 'bunk," remembers Osato, with a laugh. "Finally we settled on Garamond Book and made the 'L' a cap."

Newsletters; Baby Magazines

There are thousands of elements that go into the production of a magazine: making sure that scans stay with the correct articles, that service bureaus have necessary fonts, and that all four negatives from a particular advertisement actually make it to the printer. Keeping all those elements in order takes massive amounts of organizational knowhow. New publishers can jump right in and tackle all this at once or they can get in shape by printing a newsletter first.

bLink is an example of a newsletter that plans to be a magazine. With each issue the bLink team adds another four or so pages, and every few months a new element—like a bump up in quality from two- to four-color.

Words and Pictures

Sometimes an illustrated flag just isn't enough. *bLink* department flags (opposite page, bottom) feature both a short phrase and a unique icon. Says Osato, "Some people are comfortable with words, others are more visual. Hopefully, our mastheads attract both types of people."

Notice how small *bLink* department flags are relative to the rest of the page. They're definitely big enough to read but don't take away precious real estate from body copy—something a newsletter definitely can't afford.

Cyan, Cyan, Cyan

"Dealing with duotones can be really tricky," says Osato. "Photos hold up well, but illustrations tend to get muddy." To combat this, Osato has her artists develop their designs in Adobe Illustrator and Photoshop and save them in cyan and black, which adds depth to the drawings and also eases reproduction.

Illustrations are then imported into QuarkXPress. When she takes her digital file to the printer, she includes a PMS sample from a Pantone color book along with her dummy layout. This way there is no question about the exact color she wants to replace the cyan.

We just couldn't keep it to o

EarthLink's new state-of-the-art data center, officially known as the Wes LeBaron Technology Center, Wes LeBaron Technology Center, opened its doors in March. With this new facility, we'll be able to provide you with even more reliable Internet access AND have the technological muscle for large-scale future expansions.

Go to http://www.earthlink.net/ tour/ to embark on the next tour.

The Family That Surfs Together...

NEWS FLASH

EarthLink Wins Best ISP Award

along-but now it's official: EarthLink leads the pack of the nation's top Internet service providers (ISPs) and online services, earning PC Magazine's prestigious Editors

Choice award.

Take It Personally

Your all-new Personal Start PageSM puts you in control

on the Internet: sports, news, weather, financial data, plus Web sites for every imaginable interest. But because there's so much available, it can be real chore to track down the resources that matter most to you. But with the recent release of our version 2.0 of the Personal Start Pagelocated at http://start.earthlink. net—EarthLink members now have a

solution for this information overload.

Pushing it to you You don't have to scour the Web for the to one easy-to-access location: your Personal Start Page. The term "push" refers to how Internet content is proactively delivered to your computer, eliminating the need for you to go out and search for it vourself. And because you can specify which news sources and topics interest you most, it's like subscrib ing to your dream list of newspapers and magazines and having the best articles from each delivered to your desktop every day-free of charge.

Organization In-Site

How to organize single- or multiple-page Web sites

If you just made your first homepage, it probably only needed to be a single page with some text, a graphic or two, and several links to favorite sites, all fitting easily onto the computer screen. Though the original HTML may have been difficult for you, the challenges mount as your site grows. And when you add to it, you'll need to decide whether this one-page homepage still works or whether you need to plan a Web site.

You can simply add any new material to your single page, so that visitors need to

-
- My Origin

- My Job

- My Hobbies

- <A HREF="#girlfriend": My Girlfriend

The tags above may look familiar if you've used links before-except that there are no URLs after the HREF attribu Instead, bLink links to "anchor names" located further down on the same page Anchor names always follow the # sign in

Finding a New Life Online

An EarthLink Internet account is more than just a toy. If you still need convincing, read how two EarthLink members are using the Internet to help others—and themselves.

fter he was involved in a serious car lent, EarthLink iber Eddie er (mlholder@ hlink.net) ght his life was Instead, the net helped him a whole new Here is Eddie's as he related it to us igh email:

Internet is more than a great

A Thermometer, a Bedpan, an a Homepag As a nursing student at Pasadena C College in Pasadena. California.

> EarthLink member Robe Bowman was

getting impatient th his school wasn't making

Choices

Instead of creating a traditional brochure boasting the accomplishments of Essex Two, this design office decided to make a statement. With the publication of newsletter Choices, Essex Two explains how it interprets the art of communication and how this relates to "the traditional values of character and individual achievement."

Trim Size is 9" x 6" (23 cm x 15 cm); gate unfolds to 9" x 18" (23 cm x 45 cm) Six-page, four-color quarterly Circulation: 2,500 Design and editorial by Essex Two, based in Chicago, Illinois.

Each issue of *Choices* deals with one compelling theme such as "Perception," "Commitment," or "Change." Each cover relates directly to the short essay inside. For instance, a story about Christopher Columbus and how he used a parlor trick involving an egg to prove to his naysayers that he was an original thinker features the object of his game.

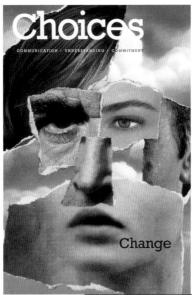

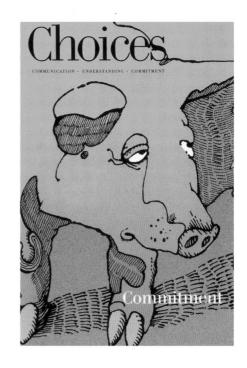

OBSERVATION: YHE COLUMBUS IDEA

The ideas of Christopher Columbus were more monumental than any of his discoveries. Most of us born just before World War II as well as the baby boomer

generation norm just after, were taught that "in 1 pags Columbus sailed the ocean blue." This was also the time when the motion that Columbus may not have discovered the New World was being presented. In fact, many suggest that it's ludi-course credit to fact, many suggest that it's ludi-course to credit any undividual with the discovery of a continent already inhabited has no nettice official.

Political corremons in non-month of the control of

return to Spain from America.
The news of his return preceded
Columbus by several days. Smaller, faster
ships met him at sea, provided supplies
and returned to Spain with word of his
arrival. When he arrived on shore, be still
had to cover a tedious distance over land
before he could present himself and his
discoveries to his benefactor, the Oncen.

This gave the Queen more than enough time to prepare an elaborate homecoming celebration. No detail was overlooked. The finest foods and wises were delivered. The castle and the grounds were prepared as though a visit from the Pope brinised was expected.

This all needed to be done for a variety of reasons. There was an enormous I rold-you so that the Queen in the royal court, including the King, and for it needed to be said.

the words. This level of reference to the words. This level of referen

Columbas' time as wellan today, nobesty liked ro lave are Indulysus so hanging over their heads. To diline the Queen's triumph, several of the miniters who spoke against the Columbus exploration started a runner. They said that while what Columbus did was significate, in a way it was neverable that wasterner would have bumped into the New World eventually, even if by acciOBSERVATION: THE COLUMNS THE

great half, everyone was feeling quite smag and self-satisfied, to the point that several ministers were openly hostile and sarcastic toward Columbus.

without support. As the dinner the Queen, almost un desperation of the Cholumbus to repond to these comments. He was searched at the head table used to the Queen with over their ministers and buscaucarts all around this. He stand up and facilitied for the chef. When he appeared, his and woweat from the kinchen, Columbus asked him to before exercise in the 150 to the control of the columbus asked him to before exercise in the 150 to the columbus asked him to before exercise in the 150 to the columbus asked him to before exercise in the 150 to the columbus asked him to before exercise in the 150 to the columbus asked him to before exercise in the 150 to the columbus asked him to be the columbus asked him

When everyone had a egg. Columbus said, "I can make my g stand upright using the small end, an any of you?"

A combination of laughter and dicule escaped from each participant,

an any of your.

A combination of laughter and idicule escaped from each participant, omething like had smelling gas.
Columbus' face changed from the warm,
round counternance of an intellectual
threath or that of a slave driver as he said,
Do it, if you can't Without a sound they
ill attempted the challenge.

After only a few minutes, no the dinner was able to complete th and had quit in frustration. With newfound courage, those ministers who had started the runners said in protest that it d could not be done and that Columbus was trying to avoid their assessment of his accomplishment as a hicky accident.

s on the dinner table. He reached
for the salt and poured
out a small mound, no
election bigger than a button. He
do placed the small end of
his egg in the mound of
salt and it stood up. He
then blew away the

has began to protest. "This is just take the discovery of the New World. Now we can all do the trick!

we can all do the trick!

Columbus stopped everyone with look, "Of course you can now do what has already been done, but only after someone has shown you how."

Some good ideas survive obstacles.

Many do not. Successful new products und services prosper because of the entrepreneurial spirit in senior managers whoecognize that ideas are America's prodrest, and that we base a prechant, an approach of the production of the contential production of the contential

Urban Shopping Centers Inc. 1996 Annual Report

From the annual report: "Urban Shopping Centers Inc. is a self-administered real estate investment trust (REIT) in the business of owning, acquiring, managing, leasing, developing, and redeveloping super-regional and regional high-end shopping malls throughout the United States."

TRIM SIZE is 8 1/2" x 11" (22 cm x 28 cm)
FORTY-PAGE, TWO-COLOR-PLUS-SPOT-COLOR
Sabon BODY FONT
CIRCULATION: 17,000
DESIGN: Essex Two, located in Chicago, Illinois.

Spreads at the opening of this annual report feature inviting black-and-white portraits. There's Sarah Dodd, store coordinator for the Pottery Barn in Urban's Old Orchard Center, hugging a dramatic vase; Jim Norman and Dottie Berger, Hillsborough County Florida county commissioners donning hard-hats and swinging shovels at the Brandon TownCenter; and Jeffrey Winograd, area supervisor for Lettuce Entertainment Restaurants, at Foodlife in Water Tower Place, toasting the reader. Each photo serves as a background for intriguing sidebar copy run in white (or black if it covers a white area of the photo) and a large, salmon-colored headline. The activity in the photos and the dramatic typography draws readers into the dense one-column text on the right-hand page.

TRIM SIZE is 8 1/2" x 11" (22 cm x 28 cm)

Screen Actor

Screen Actor, the official publication of the Screen Actors Guild, provides members with news on Guild activities and benefits, along with entertainment industry trends.

EIGHT-PAGE, FOUR-COLOR BIMONTHLY
Garamond 3 BODY FONT
CIRCULATION: 90,000
EDITOR: Greg Krizman of the Los Angeles-based Screen Actors Guild.
DESIGN: The Ingle Group located in Inglewood, California.

Screen Actor has a simple, classy design. The drop shadow behind "Actor" in the flag brings real life to the serif font. One of the most pleasing features of the design is the ample amount of white space. This gives the photos some breathing room—which is particularly fun, considering that everyone likes to look at stars, even other stars.

Contrails

Devoted to the transportation needs of corporate leaders from the world, Bombardier publishes Contrails to showcase the benefits and diverse use of their business jets.

TRIM SIZE is 8 1/2" x 11" (22 cm x 28 cm)
TWENTY-FOUR PAGE, FOUR-COLOR QUARTERLY

Perpetua BODY FONT CIRCULATION: 10,000

EDITOR: Steve Phillips, at Bombardier headquarters based in Montreal, Canada. ART DIRECTORS: Sonia Greteman, The Greteman Group located in Wichita, Kansas.

This design is as bold and diverse as the line of corporate aircraft it represents. The color palette is rich and headlines are large and straightforward. Business jets, silhouetted in Adobe Photoshop, add excitement and beauty to the pages. A particularly stunning spread is this one for a feature titled "East Meets West." Notice how all the elements feel like the Far East and yet have an international touch. The headline font, with letters butted up against each other, remind us of Kanji figures. The layout, which stretches across the page, seems patriotic, like a flag.

H.J. Heinz Co. 1996 Annual Report

The company that produces the world's most famous ketchup specializes in more than just condiments. It also creates foods for infants and pets as well as specialty foods for weight control.

TRIM SIZE is 8 1/2" x 11" (22 cm x 28 cm) SEVENTY-TWO PAGES

WRITERS: Eleanor Foa Dienstag, of Eleanor Foa Associates, Jack Kennedy of Ketchum PR. Design: RKC! (Robinson Kurtin Communications! Inc.) located in New York, New York.

Akin to the saying, "never act with an animal, because it will steal the show," is the simple fact that engaging photos of babies always catch the eye. The Heinz annual report makes the most of fun toddler shots—on the cover and on this appealing spread that opens the section on Infant Foods—by running them extra large.

Type appears in a sans serif with a PMS gray. Combined with ample leading, this makes for easy reading and a designerly look. Note that paragraphs are separated by a box dingbat instead of an indent, another tasteful addition.

pleasure of eating out. That is god adds up to more than \$2 billion, ovice is now Heinz's number-one I

every food done-third in 6% in the Uand Asia.

to the foodservice market and nurange of items — including ketchesauces, baked goods and tomato p

In the United States, the comm

twice as fast as the retail sector. Heinz's foodservice

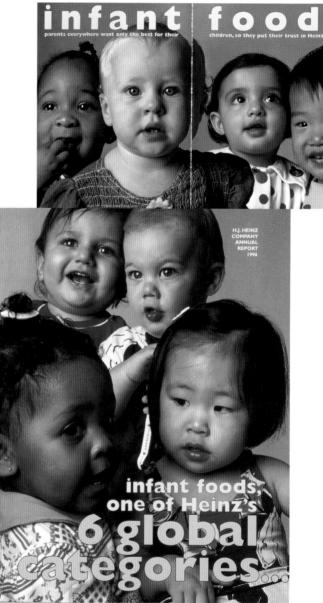

GDAPEVINE

The Callaway Grape Vine

This publication tells of recent and upcoming events at the Callaway Vineyard & Winery, announces the introduction of new wines, and offers some great recipes to accompany particular selections.

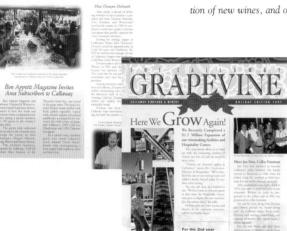

TRIM SIZE is 8 1/2" x 11" (22 cm x 28 cm)
SIX PAGES, BLACK PLUS THREE SPOT COLORS
Adobe Garamond BODY FONT
CIRCULATION: 40,000

EDITOR: Bev Stureman, Callaway Vineyard & Winery. DESIGN: Anne Howell of Maurice Printers. Both are based in Temecula, California.

Editorial content for *The Callaway GrapeVine* expresses the vineyard's commitment to community, environmental issues, and living well. Design emphasizes this mission through the use of colored photos with feathered borders. These images show happy people enjoying the great outdoors at Callaway. The feathered treatment softens the images, recreating the feel of pleasant memories.

This illustration of a baby owl by Mike Smith of the Callaway Wineshop accompanies a short story about an owl rescue in the vineyard. The simple inclusion of both illustration and story allow the reader to connect with the vineyard's mission: to feel good about the owners and workers and, thereby, their product. It's a nice touch to use an illustration by a staff member; it's a feel-good addition for the reader.

Big Blue Box

Big Blue Box really is a big blue box sent to subscribers who work in the kids' market.

TRIM SIZE is $8\ 1/2" \times 11"$ (22 cm x 28 cm); box measures 12" (30 cm) on all sides One Hundred-Page, four-color quarterly Circulation: Varies

EDITOR: Sue Edelman, staffer at Big Blue Dot. DESIGN: Big Blue Dot, A Studio of Corey & Company Inc. located in Watertown, Massachusetts.

Big Blue Box isn't a newsletter or a magazine. In fact, it doesn't fit neatly into any publication category. So, we thought, all the more reason to include it, as its trendy, interactive, budgetwise design makes it too good to leave out.

Inside the box is a corrugated orange-and-limegreen binder containing more than a hundred pages of editorial about the hottest goodies the market has to offer. Better yet, the box also contains samples of products that relate to current kids' trends. Big Blue Dot created the binder, box, and video that are included and also publishes a one-page tabloid-size newsletter called Big Blue Box Between Boxes Bulletin.

Highlights of design? Simplicity, no-fear color usage, a retro feel, and a unbeatable printing price (the binder pages are actually photocopied).

BABY OWL RESCUE

Novellus 1996 Annual Report

Novellus is a leader in the semiconductor and chemical vapor deposition industries. In other words, Novellus is making a big impact in the high-tech manufacturing business of Silicon Valley.

Trim size is $8\ 1/2$ " x 11" (22 cm x 28 cm), annual report

THIRTY-SIX PAGES

BODY FONTS include Sabon and Franklin Gothic

CIRCULATION: 30,000

DESIGN: Larsen Design Office Inc. located in Minneapolis, Minnesota.

One of the most striking elements of this sleek design is a four-page gatefold that visually tracks the company's growth, quarter-by-quarter, for 1996. This intriguing chart has a high-tech feel but is easy to read. To help tie the work, the brilliant orange of the cover is used throughout for backgrounds, subheads, and rules. Photos of equipment in surreal-istic ultraviolet light add a futuristic touch.

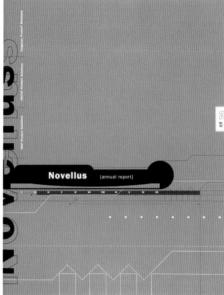

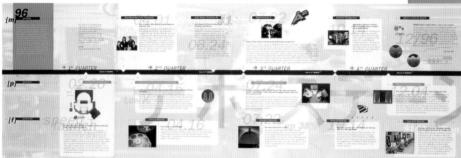

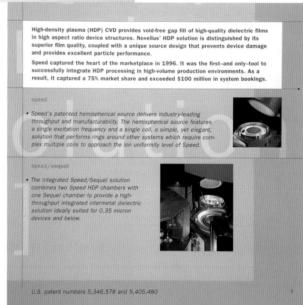

Stant Corporation 1996 Annual Report

From the Annual Report: "Stant Corporation is a leading designer, manufacturer and distributor of a broad range of automotive parts and tools. It is one of the world's largest manufacturers of automotive windshield wiping systems, windshield wiper blades and refills, closure caps and engine thermostats and a leading North American manufacturer of a variety of other automotive products including grease guns, hose clamps, automotive heaters and automotive tools."

SIZE: 7 1/4" x 10 1/8"
FIFTY-TWO PAGE ANNUAL REPORT
Frutiger BODY FONT
CIRCULATION: 12,500

Writer: Tom Margetts. Design: SamataMason Inc. based in Dundee, Illinois. Creative Director: Dave Mason. Design, Dave Mason, Pamela Lee. Photographers: Victor John Penner, Ray Fitzgerald. Illustrators: Joe Baran, Pamela Lee. Typographer: Pamela Lee.

Imagine the perfect car. It could come in any form, but typically it will have sleek, classic lines, shiny chrome, and a clean, inviting interior. Designer Dave Mason must have had these details in mind when he created this annual report, because it boasts the same stunning stylistic impressions. There is a sexy black cover with two words in striking type—"Stant" and "1996" embossed in a small rectangular box that looks exactly like an odometer. In fact, the "6" at the end of "1996" is rolling up, followed by the number "7."

The contents include slick metallic inks, a glossy paper that feels like a new paint job, and distinctively "engineered" type. This fascinating three-dimensional, sans serif face, reminds the reader of blueprints or computer wireframe figures depicting some amazing new auto of the future—the perfect touch for a company that creates reliable products that even a beautiful car can't drive off the lot without. Also note the exquisite product lighting achieved by the photographer Victor John Penner. These black-and-white photos make grease guns look like Tiffany gems.

building awareness

the global leader in heart valve disease management; Pacesette, a leader in innovation for cardos elistina management; and Date, a monter in one calls carbotree.

nere in specialty catherers.

The Company's products are sold in more than 100 countries. Sr. Jude Medical has fourteen operations and manufacturing facilities around the world. As of December 31, 1996, the Company employed 3,620 people.

Nashville, Temeswe, rador recipients De Siescart Perlman and Rubbi Stephon Puchs maintain demanding work schedules while still excelling at their ith Gassa calls Seven
life "hyperactive" surger
sles skis, truvels Johnso
ensively for more s
player IBM, and ever as
nonteen with the of nois
erican Heart SJM In

ofter Surgeon 8

off happily in

he's from 199

han value put

'peace Stack, wh

h his include fi

hre, skiing an

one, M.D... According to (1) is a gift cardiologist, she 0,000th does more than route people her age, sehich, in Clinat, includes or tubing.

Retired bus driver Thomas Hayerty enjoys trading and dancing and is proad to be one of St. Jude's

JaAnne Lamoroans, Utab teacher and homeback rider, is grateful for the heart salve received in 1993 that let ber enjoy a first mount-half the sure

Seventeen-year-old Denise Opland now has the endurance to do it all — play guitar, "surf the Internet" and run on her high school Maria Eugeria Viverno. 12, of Cala, Colorobia, can run and play again thanks to a beart valve donated to Children's HeartLink

run valve in 1996.
Kent Adee joines
vt the celebration is
to St. Jude Medical
tLink moved its listing
fireal. to the New York
Stock Exchange.

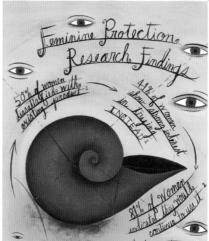

1 November 1991 - CLT Research Associates
2. Population Research Top 1957

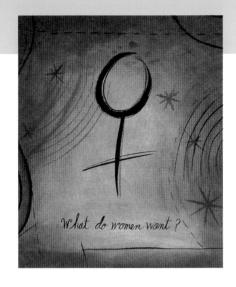

It's not an easy matter to visually explain the science behind the process of aging, a new system for open-heart surgery, or the philosophy of an Eastern religion. To do this well,

the designer must assume that a majority of the publication's readers, whether investors or laypersons, possess only limited knowledge of the topic.

Laypersons possess only limited knowledge of the topic. However, the artwork that lays the foundation for the text must not be juvenile; it must also attract the knowledgeable scientist, doctor, or philosopher.

However, the artwork that lays the foundation for the text

must not be juvenile; it must also attract the knowledgeable scientist, doctor, or philosopher.

Portraying the physical or the metaphysical is definitely an art in itself. In a very real sense design must walk a tightrope between hard facts and entertainment. It must also pull the reader in through stages. For instance, many of the publications in our "Building Awareness" section tend to provide information in an inverted pyramid, a writing style used in newspapers to explain the most important details first. Graphics and pull-quotes that take up a large portion of page space provide the layperson with enough basic info to grasp the concept. Dense information is provided in tightly written, typically smaller blocks of text.

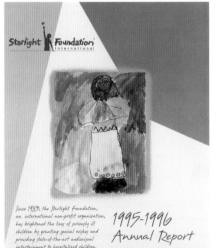

Another intriguing design challenge for the artists featured in this section is imagery

itself. How do you make surgery, test-tubes, and aggregates appealing? How do you make dense, highly allegorical ancient texts understandable? Turn the page and you will find some brilliant solutions.

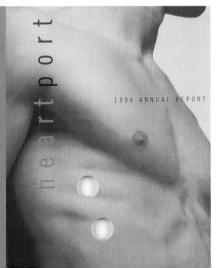

C/ H/ A/ P/ T/ E/ R

7

s c i e n c e s

Remember that cool science project you created as a kid? Whether your miniature volcano blew up or your rocket never flew, you still got a thrill out of the sheer fantastic nature of science. Your curiosity was piqued and your willingness to investigate the world around you was enhanced. The designs in our "Sciences" chapter bring this sense of childhood awe back to the reader.

Notice how the collage-like design of Sydney's Koala Club News becomes a feast for the inquisitive. Its frenetic, clustered energy makes You will find that the magic in this chapter is often spelled out best in visuals rather

than words.

you want to investigate every part of the text all at once—and, like a child, drink it all up at once. The annual report for CalMat features unique tools of the mining trade along with topographic

charts used as backgrounds. Flipping through this beauty is enough to make anyone consider changing profession in order to truly explore the riches of Mother Earth.

You will find that the magic in this chapter is often spelled best in visuals rather than words because visuals are the common denominator: the language all understand.

Sydney's Koala

Club News

Joining the children's membership category of the Zoological Society of San Diego means receiving Sydney's Koala Club News as a benefit. The newsletter generates interest in the events, exhibits, and research of the San Diego Zoo and Wild Animal Park and educates children about animals, plants, and the environment. The liveliness of the newsletter makes learning fun.

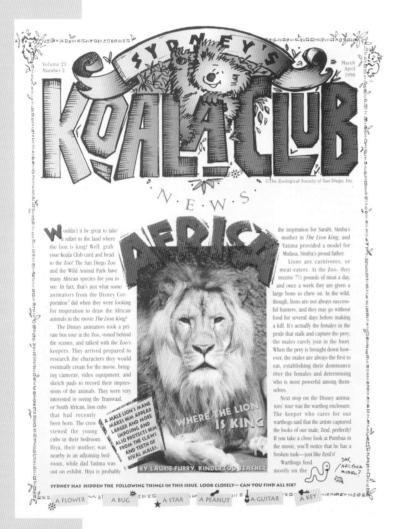

TRIM SIZE is 8 1/2" x 11" (22 cm x 28 cm)
SIX-PAGE, THREE-COLOR BIMONTHLY
70 lb (105 gsm) White Endeavour Velvet Recycled Text Stock
Random Typographics BODY FONT

CIRCULATION: 135,000, mailed to members of the Zoological Society of San Diego children's membership category, ages three to fifteen

FEATURE COPY LENGTH: Main feature: 600–800 words; secondary feature: 500–600 words

LAYOUT PROGRAMS: QuarkXPress, Adobe Illustrator, and Adobe Photoshop

EDITOR: Karen E. Worley, Zoological Society of San Diego.

DESIGN: Warner Design Associates Inc., San Diego,
California.

Kids Love Color

Bright colors and new looks appeal to kids. Each issue of *Sydney's Koala Club News* is bright, almost neon, in appearance. The color scheme changes with each issue.

Make Everything Count

Everything about a well-designed newsletter works toward a central idea. Unless clutter is the result, all available space should be used to keep a theme going. In *Sydney's Koala Club News*, for example, even the cover's border promotes learning about animals and plants. What appears to be a line of bits of stems and leaves—eucalyptus, of course—surrounds the page. The border meets the flag, cornering with a sketch of a busily eating koala at the upper left and, to achieve an artful not-square balance, showing another sketch of a koala just below the upper-right corner. The bottom of the border is broken with names and pictures of animals to be searched for inside.

Regular Features Create Interest

Consider including regular features in newsletters—even ones not just for kids. Each issue of *Sydney's Koala Club News* features kids' questions in "Ask Mother Meerkat" (opposite page, right). In the July/August 1997 issue, a nine-year-old reader asks, "What is a meerkat's most keen sense?" Mother Meerkat answers and gives an example of the incredible vision of three meerkats who live in the Children's Zoo. Thus we have another instance of keeping to purpose. This example follows the goal of the newsletter contributing to members' knowledge of exhibits at the San Diego Zoo and the Wild Animal Park.

Keep Those Kids Busy

Making this newsletter interactive is the foremost design concept of editor Karen Worley, and *Sydney's Koala Club News* does seem to move about as fast as most kids. It presents a variety of information in a format that ranges from small to large photos and graphics, a template that varies in width and direction, and type styles that vary from feature to feature (one feature on field notes, for example, is printed as if copied from handwritten journals made during field research.)

Always Keep Audience in Mind

Designer Richard Warner says, "One thing that makes *Sydney's Koala Club* effective is that we're really clear on who the issues are for. We design with audience strictly in mind. Often a designer, especially those new to the field, will change the plan to suit the designer's taste. The designer falls into the trap of designing for himself or herself."

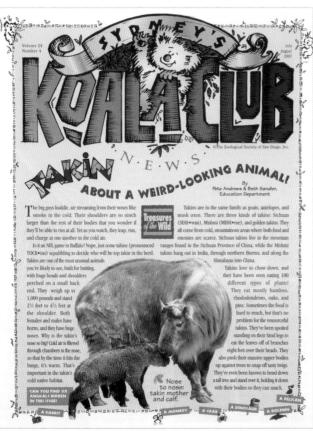

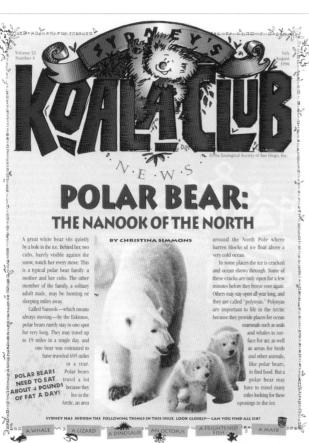

Visit the Zoo's Sumatran orangutan exhibit at the Zoo and find Karen, the larger of the two youngsters. You'd never know that she was born with a hole in her heart. Her condition caused slow growth and weakness. After an operation that repaired her heart (her red hair hides the scar), she's the peppiest one in the group.

Bunyip the koala was born with scoliosis, a curvature of the spine. His condition can't be treated with surgery, and nobody knew if he'd live very long. But the keepers report that at age 6, Bunyip is pain-free and a happy camper. They'll always keep an extra-special watch on him, but they say that hopefully he'll have a "long happy koala life." Bunyip is currently on exhibit at the Wild Animal Park.

WHAT IS A MEERKAT'S MOST KEEN SENSE?

Isabel Tellez, age 9

Their vision is incredible. Moses, Ricky, or Timon (the Children's Zoo meerkats) stare overhead and sound an alarm long before we see the hawk. Also, everyone else who knows this meerkat trio laughingly says "don't forget their sense of hunger!" These little guys are truly voracious at dinnertime!

r Timon
's Zoo
e overn alarm
see the
eryone
vs this
ghingly
et their
These litvoracious

Send questions to: Mother Meerkat, Education Department, San Diego Zoo, P.O. Box 551, San Diego, CA 92112-0551. Unfortunately, we cannot print or answer all the letters we receive.

A PELIKAN

A MONKEY E III A CRAB THE A DINOSAL

Geron

1996 Annual Report

Geron is dedicated to understanding the biological mechanisms "underlying age-related diseases, including cancer." Their efforts help make living better for the elderly.

Go For the Unexpected

Most annual reports covering the achievements and activities of science-related industries do so by focusing on sterile images. As Bill Cahan of Cahan & Associates says, "You usually just see ubiquitous photos of labs, lab coats, and test tubes." For Geron's first annual report, Cahan wanted to provide more. He not only wanted to help brand the company identity, he wanted to bring a human element to Geron's exploratory work.

To do this, Cahan made science more human by concentrating on juxta-positions such as the idea of "science" and the idea of "old age." For instance, the inside front cover (opposite page, top left) shows an enlarged image of young cells. Next to this is a picture of a seventy-year-old belly dancer in front of a portrait of her painted when she was twenty-five. Because the woman looks as good in old age as in her youth, the spread becomes a celebration of opposites.

TRIM SIZE is 7" x 11" (18 cm x 28 cm)

SIXTY-FOUR PAGES, FOUR-COLOR ANNUAL REPORT

80-lb (120 gsm) Endeavor TEXT STOCK; COVER: Lexan Mylar

BODY FONTS INCLUDE Rosewood, Trade Gothic

CIRCULATION: 10,000

LAYOUT PROGRAM: QuarkXPress

HARDWARE: MacIntosh

EDITOR: Carole Melis, a freelancer also from San Francisco.

Art DIRECTOR: Bill Cahan. DESIGN: Bob Dinetz, both of
Cahan & Associates, located in San Francisco, California.

Note that the juxtaposition is furthered by running the image of the young cells in color and the photo of the dancer in black and white.

If They Don't Get It—Why Do It?

The science behind the Geron approach to the inhibition of aging goes over 99 percent of the population's collective head. However, senior designer Bob Dinetz provides a visual explanation for the layperson (opposite page, middle right). His sketches, which explain the basics of Geron technology, are meant to imitate the wild scratches a professor might doodle on a napkin while trying to communicate the wonders of the natural world to a group of undergrads. They also look a great deal like the sketches in Dinetz's own journal.

Ideas From the Source

Note the use of grids for photos and captions. Dinetz explains that the idea for this template came from exploring Geron labs. "You find this pattern everywhere, from the holders for test tubes to the grid patterns for staining cells." In keeping with the personal touch of this report, the designers asked scientists to send photos of themselves in relaxed settings, possibly on vacation or playing in a park; thus the wide array of looks found here. Of course, photo quality was less than adequate, but Dinetz turned each into a compelling image through unusual cropping.

Presents Are Nice...

When the Geron annual report is mailed to potential stockholders it is accompanied by a smaller book (opposite page, bottom) titled *What Does Getting Old Mean to You?* Inside is an array of portraits accompanied by the subjects' answers to this question. At the back is a postage-paid return postcard for the reader to use to provide his or her view on what it means to get old. These responses are being collected for use in next year's report. Cahan explains that the publication of this little book has been amazingly helpful in terms of appeal and name recognition—hundreds of postcards now decorate the company's hallways.

And For the Observant

Page numbering for the Geron annual report begins with age "59" and ends with age "115."

WHAT DOES GETTING OLD MEAN TO YOU?

When you bend down you don't get up as fast.

Take one day at a time sweetie,

CalMat 1996 Annual Report

The largest owner and producer of aggregates in California, CalMat supplies the sand and gravel used to build roads in the Sunbelt (California, Arizona, and New Mexico).

CalMat

1996 Annual Report

TRIM SIZE is 7 1/2" x 11" (19 cm x 28 cm)

FORTY-FOUR-PAGE ANNUAL REPORT

with 5/4 COLORS on cover stock, 5/5 colors on Signature stock, and 2/2 colors on the Benefut stock

Signature Gloss 100 lb (270 gsm) COVER STOCK; TEXT

STOCK: Signature Gloss 100 lb (150 gsm) Text and

Benefut 70 lb. (105 gsm) Text Ivory, Squash, Kraft

Bodoni BODY FONT

CIRCULATION: 15,000

LAYOUT PROGRAM: QuarkXPress

HARDWARE: Macintosh

DESIGN: Douglas Oliver Design Office located in

Santa Monica, California.

Limited Budget? Get Creative

The health of an industry definitely affects the design of a company's annual report. Every California business suffered during the recession of the early 1990s. The aggregate supply industry took one of the hardest hits. As testament to this, designer Douglas Oliver reports, "In 1994 my design budget had to be cut by 40 percent, which meant we couldn't afford photography." Happily, Oliver's solution ended up being an award-winner.

"If it was laid out as a one-lane wide road, CalMat's asphalt production would extend across the country and back two and a half times. So we built the book around the milestones you see on the highway—road signs." These signs boast intriguing catch phrases like "Road Construction Next 32,945 Miles" or "Cautious Optimism Ahead."

By 1996, Oliver's budget had increased enough to include photography again, but was still . . . challenging. Since the economy was definitely on an upswing and business was at last returning to normal, Oliver decided to say something about the staying power of the company itself, a company that could ride the storm and come out on top. "Management explained that they had done everything possible. That they were positioned and ready and now all they had to do was be patient. These comments led to the phrase, 'staying the course,' which became our theme for design."

Beauty in the Unexpected

By treating photos of old-fashioned surveyors' tools as art, Oliver achieves a sense of CalMat's tradition, longevity, and knowledge. Accompanying text explains the technology that has replaced these instruments. "I really went out on a limb with this one," says Oliver. "I knew that I couldn't show the client drawings or a mock-up of the look I was going for; it simply wouldn't have the impact of real photos. So I sprung for a couple days of studio shooting."

When Oliver went in for his first brainstorming meeting with his client, he was actually showing them his finished idea. Fortunately, management was impressed and immediately signed off. "You can't really do something like that unless you've worked with a client for a number of years. CalMat had a lot of trust in us. I knew exactly what they liked. Of course, that doesn't mean that I wasn't petrified when I walked in!"

Oh! Those Financials!

Says Oliver, "Designers have a lot of unwritten rules about the financial section—that you should never use one wide column because the reader's eyes will get tired and so on. Frankly, I think some of these rules are voodoo. What you should avoid is designing the report for you rather than the client. A chairman should be able to pick his book up and immediately recognize his company."

1994 Annual Report

B

CalMat one and from mostly 19 folion two of against Armon and New Merico, from which or praces and amphases in naturals used as utilially over Our aggregate-based products include constant and general and range undiscurred so these consisting by whiten of ICA's and 50's aggregate consisting by whiten of ICA's and 50's aggregate.

Increased sales volumes and slightly higher average selling prices raised earnings in both our aggregates and ready mixed concrete operation). A rate was also taken a few of the consideration of the

CalMat

PAVEMENT

NEVER ENDS

THIS IS THE
FUTURE SITE OF THE
FUTURE AND RICHARD
GERI AND RICHARD
BRAWERMAN
BRAWERMAN
OUTPATIENT CENTER

C/ H/ A/ P/ T/ E/ R

8

h e a 1 t h

Like most achievements, the goal of good health is at once terribly difficult and infuriatingly simple. Good health requires regular exercise, good eating habits, and an optimistic mental outlook, all of which are difficult to acquire but, once established, relatively easy to maintain.

Yet, no matter how hard we struggle to keep up our health, we are often sideswiped

by the unexpected: a traffic accident, a disease carried in our genes. That's when health must be maintained and enhanced through the complex practice of medicine.

Unlike the publications in the "science" chapter, design for health-related industries must appeal to the ambitious in nature, people who wish to care for their bodies in new and innovative ways.

This chapter honors both aspects by celebrating the health goals of the layperson and the miracles of the medical industry. Design in this case, much as in the previous chapter, must appeal to two categories of readers, the informed and the yet-to-be-informed. Unlike the publications in the "Sciences" chapter, design for health-related industries must often go one step further by appealing to the ambitious in nature, those who wish to care for their bodies in new and innovative ways.

For instance, the design of Health Matters intrigues both the certified exercise

instructor and the avid amateur through an energetic combination of illustrations and photography. The illustrations symbolize the person we all want to be, while photos represent the goal achieved. The transition between the soon-to-be-healthy body and the healthy body is often shown through photographs that have been digitally manipulated.

A suggestion for artists in the health field is to remember that they are dealing with an audience in transition and that design should reflect that positive energy.

City of Hope

1996 Annual Report

From the annual: "City of Hope, inspired and supported by a philanthropic volunteer movement, is dedicated to the prevention, treatment, and cure of cancer and other life-threatening diseases through innovative research and patient care." TRIM SIZE is 8 1/2" x 11" (22 cm x 28 cm)
SIXTY-TWO PAGE, spiral-bound, SIX-COLOR ANNUAL REPORT

Classic Crest STOCK

Matrix BODY FONT

CIRCULATION: 20,000

LAYOUT PROGRAM: QuarkXPress

HARDWARE: Macintosh

DESIGN: Maggie van Oppen of Kimberly Baer Design
Associates, located in Venice, California. PHOTOGRAPHER:
Mark Robert Halper. ILLUSTRATOR: Richard Tuschman.

Sure I'll Limit My Themes...But How?

Says project manager Michael Lejeune of Kimberly Baer Design Associates, "Annual report designers advise their clients to limit text to three or four key messages. That way design can constantly reinforce them through type choice, color illustrations, photos, everything. Because City of Hope is such a complex place, that's a difficult task. Not only does the center engage in many different health care activities, the annual report itself has to communicate to a diverse audience made up of insurance providers, doctors, research groups, benefactors, and so on."

To solve this conundrum, Lejeune worked with writer Dave Gurzenski, who pulled impressive stories from recent City of Hope publications. These stories led Gurzenski to develop four broad sections of interest—research, treatment, philanthropy, and contributors. Through the use of sidebars, each section focuses on three topics of interest—people, places, and programs—a slogan that City of Hope president, Charles M. Balch, M.D., brainstormed. The main body copy is a narrative describing current medical and research affairs.

Bind-In Texture

Building texture into design creates automatic interest for readers. One surefire way to grab a reader's attention is to bind in different-sized cuts of paper. In the City of Hope report, intriguing stories about donors appear on 3 1/2" x 9 3/16" (9 cm x 24 cm) cards (opposite page). Hiring one photographer ensured that images have a similar look. Note that bind-ins offer another money-saving alternative to collateral materials. They can be overrun and used in press or sales kits.

Fine Art

One of the most attractive features of this design is the use of photo collages. As Lejeune points out, "Collages allow you to create images of ideas, themes, and specific situations that are hard to capture in a traditional photograph. They also give a rich, free-form feeling to the design."

For this, the design firm hired photo artist Richard Tuschman, who provided very detailed first sketches showing how he intended to interrelate various objects. After receiving the go-ahead on a sketch, he worked with all media—photography, illustration, and found art—to create collages in Adobe Photoshop and Illustrator.

Lejeune explains that one of the most difficult photo illustrations was for the section on philanthropy. "Without focusing on money outright, we had to come up with a way to show the spirit of the people who donate to City of Hope." The solution was to use a dollar bill as a background texture, to fill in the famous central oval with sharing hands holding a rose of hope, and to surround this with group shots from fundraising events (opposite page, bottom).

THE STREAM OF THE STREET AND THE STR

A second second

TOO INTERNAL MERCEL CHIEFE
TO INSTITUTE OF THE TOTAL CHIEFE
TO INSTITUTE OF THE TOTAL CHIEFE
TO INSTITUTE OF THE TOTAL CHIEFE
TOTAL CHIEFE
TO INSTITUTE OF THE TOTAL CHIEFE
TOTAL CHIEFE
TO INSTITUTE OF THE TOTAL CHIEFE
TOTAL CH

will with the controlling of portion company. The finance requires the thin body. This is the budget in it which is a service of the many of the man COLOR DE ARRESTA MANTONIONE AL MANTONIONE AL

CET OF WAR BY BALLEY THE STATE OF THE STATE

Exist Station Television (E)

Exist of time has developed an international requirement of parameters and processor of the parameters of parameters of parameters of the parameters of the parameters of the time to be to the first of the parameters of the parameters

tastic russ longly reset to disone.

City of like researches are
like researches are
unreling seen of their energies
use provesting disoner before it
largers. Such this livers show in
this lipid proves are
structured convert agreements in
actual convert agreement his long.
These traconesis—in combination
with gene theroids,—effer a previous
future. One that may somedy include
unare for eater couldness or AUS.

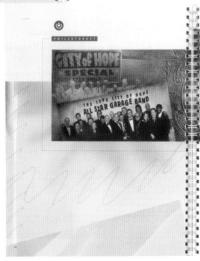

in open City of Repr resruited more narroundly recognised understant, expanded factories and purchased we well-confide the Republic shade soverwised broads to this would have been impossed to status and anyons. Technical parts allows ever anyons. Technical parts allow ever excl. compare Sid-Perstanting diseases. Yes checks to additional pressor imports, the bare safet sprecious trayers, the bare safet sprecious.

HealthWise

HealthWise is published by Clarian Health Partners Inc., a merger of the Methodist Health Group of Indiana and the University of Indiana's Medical School. Its purpose is to provide health information to patients and employees so that all can avoid hospitalization.

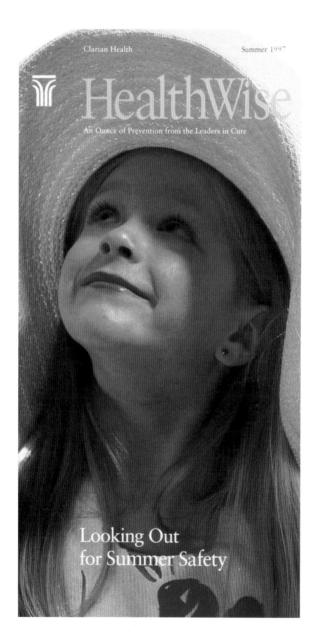

TRIM SIZE is 5 1/2" x 11" (14 cm x 22 cm)
TWENTY-FOUR PAGE, FOUR-COLOR QUARTERLY
Mead TEXT STOCK

Sabon BODY FONT
CIRCULATION: 45,000

FEATURE COPY LENGTH: 500-1,200 words

LAYOUT PROGRAM: QuarkXPress

HARDWARE: Macintosh

Editor: Susan E. Spence of Clarian Health Partners, located in Indianapolis, Indiana. Design: Essex Two, based in

Chicago, Illinois.

The Power of Print

Hospitals are facing hard times. Consolidations are cutting overhead, thus making bed space a precious commodity. With the healthcare industry undergoing such radical change, it is more important than ever that healthcare providers teach people how to stay well. Education, it is believed, will help patients avoid lengthy hospital stays that ultimately overburden the system. To help Clarian Health Partners communicate advice for healthy living, design firm Essex Two created HealthWise.

Covers They Can't Resist

Each issue of *HealthWise* boasts a knock-out cover. The cover from the February 1994 issue (opposite page top right), with a face made up of pills, is especially eye-catching. Note that the illustration continues from front cover to back. This image is so strong that a close-up is actually re-used within the article, a definite money-saver.

That Friendly Touch

Another appealing feature of *HealthWise* is portraits. As the head of Essex Two, Joseph Michael Essex explains, these images help make healthcare a little more human. "*HealthWise* portraits are about relationships. You'll notice that each image has a person looking at you. That's very intentional as it creates a friendly bond between the reader and the industry. The images help defeat that adversarial feeling that a lot of us have toward hospitals."

Type That Speaks

Essex chose Sabon, a classic serif face, for the body copy as it feels familiar and comfortable to American readers. "Sabon is a variation on Times. It has a high x-height so it's still legible even in a small point size. It is an open face and very familiar to readers here who were taught to read using serif fonts. In Europe, the opposite is the case. Children learn to read with sans serif fonts."

Creating a Feel

"HealthWise has to sell first as a picture book and second as a communication tool for text. The pictures have to be a tease for the editorial. So, to create interest, we use both simple images that bleed off the page and complex collages that are created by hand."

Arrive Alive

You hold the keys to preventing traffic accidents

Cover Story

Here's the bad news:

lotor vehicle crashes are the ading cause of death for people ges 3 to 27 years.

from a car crash as from being murdered.

 Five Americans die every ho from a traffic crash.

Because most crashes are caused by human error, you can take across to keep you and your family from becoming one of thes tragic statistics.

The portion of accidents caused by human error could be as high as 95 percent, according to the National Safety Council.

dents' is really a missioner," said Debbse Milas, trarketing director, Governor's Council on Impaired and Dangerous Driving. "Rather than someone's brakes failing or a roadway caving in, most crashes are preventable and caused by things like mattention or failure to weld right of way."

Alcohol and other drugs play a role, too, and are involved in about 42 percent of all accidents participated.

"In Indiana, in 1994, the number of impaired driving accidents was lower than the national average, at 23 percent," Milas

"Inattention was the major contributing circumstance in 20 percent of accidents. What cause the inattention — talking on a cellular phone, reprintanding chi dren, or just daydreaming — isn Safe Driving in the Workplace

Money-whick crashes are a big problem for employers as well. In addition to being the leading cause of datah in the workplace, they are a lange cost. In 1993, ratific mushaps both of and on the job cost employers close to SYA follow in loss of worker availability and health-care costs. A publicipers are partnership called Newsork of Employers for Traffic Safers (NETS) was assented in 1989 to corcourage safe driving habits in the

NETS is a Methodist program funded by the Governor's Council on Impaired and Dangerous Driving, Locally, Methodist Hospital is working with Eli Lilly & Co, futted Parcel Service and Ameritech to hely other companies implement traffic

These companies have policies that require occupants of a company vehicle to woir seatbelts, and all provide specialized defensive driving training to employees who drive fleet vehicles.

municates traffic safery tips in in employees and their families. The 2,000-timenthe sakes boxer receive a newsletter every other month that focuses on a specific driving skell, such as controlling speed, bandling interactions or avoiding rear-end collisions. Managers gar aquarterly accident report that compares recent months with the last two years. And a monthly vocational defensive driving message features voices of company security and restrict driving message features voices of company securities.

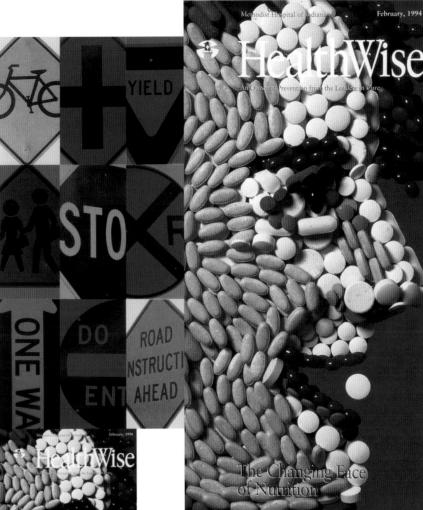

Fitness Matters

Published by the American Council on Exercise, a nonprofit organization dedicated to "promoting active, healthy lifestyles," Fitness Matters is distributed as a membership benefit to certified fitness instructors and fitness enthusiasts who have joined the organization's "Friends of ACE" public membership club.

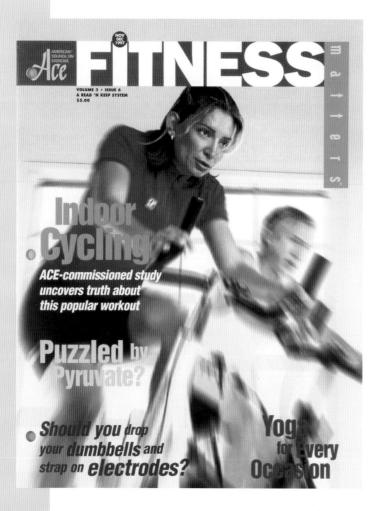

TWENTY-FOUR PAGE, FOUR-COLOR BIMONTHLY
Royal Impressions STOCK
Garamond Book Condensed Body Font
CIRCULATION: 42,000
FEATURE COPY LENGTH: 800–1200
LAYOUT PROGRAM: QuarkXPress
HARDWARE: Macintosh
EDITOR: Richard T. Cotton, M.A. CREATIVE DIRECTOR: Steve
Lux. ART DIRECTOR: Karen McGuire. All are staff
members of the American Council on Exercise, based in
San Diego, California.

TRIM SIZE is 8 1/2" x 11" (22 cm x 28 cm)

The Personality of Design

After a thorough survey of ACE membership, the editorial staff learned that their constituents wanted to store copies of *Fitness Matters* in binders rather than magazine boxes. The simple solution to this request was to three-hole punch the publication. However, this survey also led to the idea of breaking the publication into stand-alone, four-page pullouts, each with a title that keys to the newsletter's flag; i.e., "Research Matters," "Taste Matters," "Consumer Matters," etc. This way each section can be stored in a binder of its own.

An interesting thing about this layout is that each of the five sections has its own look and personality—yet each appears to be part of the whole. This is achieved by keeping the template virtually the same for each section but changing the color and style of illustrations.

Says art director Karen McGuire, "The ability to provide a different personality for each section, design-wise, comes from the material itself. The look of 'Consumer Matters' is related to technology—more graphs and charts—because the copy reads like that. The look of 'Info Matters' is lighter, more easygoing, because the text is lighter in tone."

Working Together

Editor Richard Cotton says that working on this publication is a real joy because editorial and design work hand-in-hand. "We always come up with design concepts together. No one stonewalls anyone else. If editorial is uncomfortable with something in design, the design team will figure out a way to make it work. If design needs a new headline to make a typographic element work, then editorial steps in and comes up with something new."

Nothing Ordinary Here

"I never like to use clip art as is," says McGuire. Note how she manipulated this image for an article called "A Shock to the System" in "Research Matters" (opposite page, bottom left). Taking a lead from the headline, McGuire took the image into Adobe Photoshop, posterized it, blended it with a lightning-bolt effect, and brought it down from full color to duotone. The result is a small piece of modern art that relates directly to the story's theme.

Another great example of photo manipulation is this cover shot of an indoor cyclist for an article on indoor group cycling (left). The original image was actually a perfectly sharp and clear studio shot. "However," says creative director Steve Lux, "We wanted the active feel of 'spinning'—how intense it is and the fact that it's an incredible workout. The static shot didn't have any of that energy." So Lux took the image into Photoshop and created an effect that simulates motion blur.

ACE EITHESSMATTERS

WHAT'S INSIDE

PAGES TWO AND THREE

(1)

(1)

routines tailored to your body's daily fluctuations

PAGE FOUR A brief education on types of hatha yaga.

YOGA IS A PHILOSOPHY

not a religion — that originated in India more than 5,000 years ago. The repertoire of yoga is described in Sanskrit, the language of India's classical texts and scriptures as well as one of the oldest of the ancient Indo-European lan-guages. Yoga, which means ion, is a the whole person an fe discipline, addressing ethical and moral standards as well as he care of the body, mind, emo

ions and spirit.

Hatha yoga is the physical component of this discipline. component of this discipline.
Commonly interpreted as "ha"
meaning "sun" and "tha" meaning "moon," hatha also means
"determined effort. "Thus, hatha
yoga is a method or discipline
designed to bring halance to both
hody and mind through effort complemeant he relaxation.

The repertoire of hatha yoga includes asana (Sanskrit for pose or posture) and pranayama (Sanskrit for the extension of one's life force) or breathing techniques. The postures are designed to move the spine through its full range of designed to move a spine an object in motion — extension, hyperextension, forward and lateral flexion. Other exercises involve torsion (twisting of the spine) and inversions (e.g., head and shoulder stands). Postures are performed

while standing, seated, prone and supine.

There are numerous styles of hatha (see *Yoga* Primer, page 4), each with its own unique

Stress Buster

characteristics and benefits. There are, however, several key elements present in all hada syles: developing steadiness and ease; creating balance through pose and counterpose; and being conscious of the breath. Being seasely or saddle in a posture shide entantiating at soes is a build-in safety feature of the practice. You always should feel sateupings a challenging pose. Pose and counterpose is accomplished by including eservises that work opposing muscle groups. For example, at routine focused on forward flexon should include back-bending postures, and vice versa. As for breath, some syles place greater emphasis on breathing by including more pensuanas techniques within an assana class.

The two programs outlined here include postures and breathing techniques drawn from several syles; being; Arkang, Valvioga and Groudflux; The first set of breathing and strengthen the system.

continued on page 4

Spin It

SOME CALL IT TORTUROUS, OTHERS SOME CALL IT TORTUROUS, OTHERS childrating. But there's no denying its popularity—some see indoor cycling as the biggest thing to hit the flances industry since step aerobics. What sees these clauses again from the usual boredom of stationary cycling is the visual insury provided by instructions. Participatus are led on a "witten!" outdoor rust area complete with hills, edites, straight aways and finish lines. But before you reserve your spot (most clauses are so popular that recervations are a must) and start composing your victory speech, there are a few questions to ask, yourself, as well as a few precunitions to ask, you make your first ride a smooth and entoy-

ACE Puts Cycling to the Test

various fitness levels rated their lev-Borg's Rating of Perceived Exertion a scale from 6 to 20) during a typical indoor cycling class Most reported an exertion level in the high teens throughout much of the class. (Heart-rate measurements exercising close to their maximum heart rate, which validates their

0

0

perceptions.) This means that partiopants were exercising at a higher level of intensity than their bodies were accustomed to despite being fy their intensities to suit their per-

sonal fitness levels. PAGE ONE . ACE FITNESSMATTERS

to make your first ride a smooth and enjoy-

What Kind of Shape Am I In?

This question is crucial. Despite its heavy pro This question is crucial. Despite its heavy pro-motion as a workout for even the most uncoordi-nated, indoor cycling is by no means for everyone. The intensity levels of many classes are far beyond what most notices or part-time exercises can achieve and maintain, particularly for 40 minutes or more (see sidebar, left).

It's easy to get caught up in an instructor's chant of It's easy to get caught up in an instructor's chant of Taster RPMS⁴, and "Don't sit don't even if your body is selling you otherwise. That's why it's so important that participants either be in very good cardiovascular condi-tion, or have the discipline to monitor and adhere to their body's cries for moderation.

Get in Cycling Shape

Just because you may not be ready for a cycling class now doesn't mean you can't be in the very near class now doesn't mean you can't be in the very near future. Consider doing some cycling-specific training before you take your first indoor cycling class. Spend some time on a stationary bile, but make it interesting by creating your own 'virtual' experience by 'traveling' some of your favorite road trips in your nind as you lis-ten to music. You can increase your endurance by inter-spersing periods of high-intensity cycling with more spersing periods of ingramensary cycling wan more leasurely pedalling.

In just a few short weeks you'll be ready to sign up for your first indoor cycling class.

Indoor Cycling Essentials

plenty of

fluids

The following helpful tips can make your first cycling

perience a positive one:

Don't make the dreaded mistake of showing up in
your usual boxers or running shorts — there's no better way to make your ride unbearable. Opt instead for bike shorts, preferably padded like most outdoor cyclists wear. While this won't eliminate the chaffing

cycless wear. While this word eliminate the chaffling and deconfect altogether, it helps — a lot.

Your second most important items: a full water boule. Get ready to consume plenty of fluids during this class.

Adjust the sent to the appropriate height. If the sent is not low, you word be able to get excoupling extension on the downstroke. If it's too high, you'll be straining to reach made might injury sourcell freet's a good rule to follow: Your upstroke kneer should never exceed hip level, while your downstroke kneer should be about 85 percent straight. And don't grip the handleburs too ughtly, so this will increase the tension in section. as this will increase the tension in your

as this will increase the tension in your neck and shoulders.

Above all, concentrate on exercising at your own pace. Don't be intimidated by the high speecks and furrious intensity of your cycling mates. Listen to your body and adapts the tension and speed accordingly, and don't be afraid to sit back and take a breask when

Compliments of:

A Shock to the System

What could be more appealing? That's the concept behind a new generation of products (coming soon to tate-night television) featuring electrical muscle stimulation (EMS). Originally used to help speed the rehabilitation process and to reduce atrophy in individuals confined to a bed, EMS is now being marketed through infomer-cials and home shopping networks

as a means for healthy individuals

to tone and strengthen their mus-cles and to lose fat.

RESULTS WITHOUT EFFORT.

When something sounds too good to be true it usually means that it is. In this case, while it is unrealis-tic for people to believe that they will transform their bodies by simply strapping on a few electrodes, there is a small measure of truth to the claims. Research presented at the American College of Sports Medicine conference earlier this year focused on the effects of EMS on 32 healthy,

but sedentary, individuals.

Subjects were divided into a con-trol group, which received no treat-ment, and a treatment group, which received approximately two dozen 30-minute treatments over a period of eight weeks. The rectus abdominis, the quadriceps and the gluteus maximus/hamstring muscles were targeted, with spantices and air gotten income instantion grounding most of adjocutive and grounding 10 minutes of stimulation per session. Anthropometric measures, taken pre- and post-treatment, included body weight, body-far per-centage, girth measurements, isometric abdominal strength and dynamic perstrength. Results showed no significant differences in weight, body far or girth measurements. Abdominal and hip strength, however, improved dramatically when compared to the control group.

According to lead researcher Julianne Abendroth-Smith of Utah State

University, Logan, "EMS may strengthen muscles to a point, but probably will no help [individuals] lose weight, lose fat, or change their basic body dimensions."

strengthen to a point, but probably will not help

WHAT'S INSIDE

PAGE TWO

PAGE THREE

(1)

PAGE FOUR

Red Peppers Turn Up the Heat on Workouts

THE METABOLIC EFFECTS OF CAPSAICIN, A SUBS

Starlight Foundation International

1995-1996 Annual Report

The Starlight Foundation is best known for granting wishes to children with serious illnesses. However, as explained in its publications, this foundation is up to much more good than that. For instance, Starlight helps provide mobile entertainment units that roll over hospital beds and Starlight pediatric playrooms, places where children can find solace from an often sterile hospital environment.

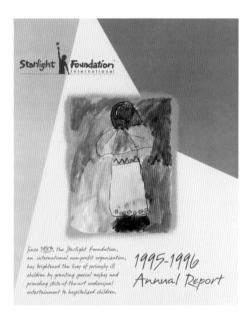

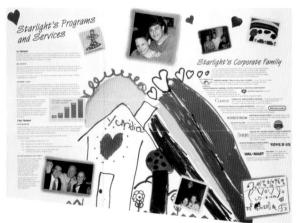

Trim Size is 25 1/2" x 19" (65 cm x 48 cm), folds down to 8 1/2" x 11" (22 cm x 28 cm)

TWELVE FOUR-COLOR FOLDED PANELS

Coated text 50 lb (75 gsm) TEXT STOCK

Eras BODY FONT

CIRCULATION: 6,000

LAYOUT PROGRAM: QuarkXPress

HARDWARE: Macintosh

1994–1995 annual report, CREATIVE DIRECTOR: Josanne DeNatale, Cognitive Marketing Inc., of Rochester, New York. ART DIRECTOR: Daniel Hoh, Daniel Hoh and Associates, Rochester, New York. 1995–1996 annual report, EDITOR: Deann Hechinger of the Starlight Children's Foundation, based in Los Angeles, California. DESIGN: Kim Ross of Kim Ross Creative.

Annual Report — Be Playful But Stay on Budget

Josanne DeNatale, creative director at Cognitive Marketing, explains that when she gave Starlight's annual report assignment to Daniel Hoh, art director, she told him to throw caution to the wind. "I asked Dan to come up with a variety of sketches that were no holds barred," says DeNatale. "Of course, he came up with some pretty wild ideas, which met the client's parameters for looking more fun and child-oriented, but after talking to printers and running the numbers, they simply cost too much."

In the end, it was decided to go with one of Hoh's simplest yet most playful designs. "I got the idea from watching kids drawing on big pieces of paper on the floor," says Hoh of his report that opens in three folds to reveal a lovely poster-sized child's drawing and an array of wish granters and recipients (bottom left).

Note the angle cut at the bottom. This simple addition cost no more at the printer's, yet it adds a lot in terms of Hoh's original concept—to convey the creativity of childhood.

Puzzle Pieces

Although the idea of an annual report that unfolds for the reader is intriguing, creating it is a lot like putting together the pieces of an intricate puzzle (without the help of the box cover). Says Hoh, "It was definitely a challenge to organize the information so that it made sense as a reader opened it. I had to build a lot of small-scale mockups to get the layout of copy versus images correct."

By treating copy and photos as individual pieces of the puzzle, Hoh could move things around on his mockups until they all fit together in both a sequential and an esthetic manner.

TRIM SIZE is 8 3/8" x 10 2/3" (22 cm x 27 cm)

TWENTY-PAGE, FOUR-COLOR QUARTERLY

Gloss Coated 80lb (120 gsm) TEXT STOCK

Baskerville BODY FONT

CIRCULATION: 30,000

LAYOUT PROGRAM: QuarkXPress

HARDWARE: Macintosh

EDITOR: Deann Hechinger of the Starlight Children's

Foundation, based in Los Angeles, California.

CREATIVE DIRECTOR: Josanne DeNatale, Cognitive

Marketing Inc., of Rochester New York. ART

DIRECTOR: Daniel Hoh, Daniel Hoh and Associates,

Rochester, New York.

Shining Star—a Balancing Act

To meet the foundation's guidelines, Creative Director Josanne DeNatale, Cognitive Marketing Inc., together with design firm Daniel Hoh and Associates, developed a format that incorporates hand-drawn and handwritten elements created by children the Foundation has helped. Entire thank-you letters are scanned and used as sidebars, while stickers and drawings are used as clip art. To provide a professional feel, Hoh keeps his leading tight and balances images with plenty of white space.

Star Tricks

To keep the newsletter easy to read, photos are placed adjacent to headlines, eliminating the need for most captions. He also avoids running a full page of text. As he points out, "People are time-compressed. They don't have time to read an entire article so you have to keep things light." Hoh's compartmentalized design allows readers to literally thumb through the publication and still digest a great deal of information.

The Shining Star

"We wanted the design of The Shining Star to resemble a photo album or a scrapbook so it would feel fun and warm," explains Starlight's marketing and communications coordinator, Deann Hechinger. "But we still wanted it to have an air of sophistication so that we could convey relevant information about the work we do to potential donors."

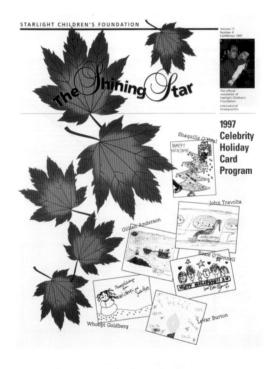

C/ H/ A/ P/ T/ E/ R

9

religion

AGAINST INTOLERANCE

AUDIT OF ANTI-SERIFIC INCIDENT

power Beland Brooken, Make-quinced Calcidentate teams for High, Regional Board Position Gauge Mose at the power conference amounting the selling of the 1996, built.

declined. In 1996, the total number of incide reported to the ADL was 1726. This total represented a decrease of 123 incidents or 7%, from the 1999 total of 1843. In 1999 the total, in turn, represented as 11% decline from 1994. This two-year drop was the first made on the first control of the 1994 to 1994.

Galifornia united bind in the nation in the number of organisal medicines (18th Indian New Josey, There were 12 it improved incidence of annial function and human medicines and humanime special pole one (who in humanime — done 27% to 18th Indian of variables in the decreased numerosis in 1996 - 58 incidence or function and selections and memorials in 1996 - 58 incidence one specula, done 1996 in 1997. The call cannot be a function of the decreased in 1996 incidence on the control of the decreased in 1996 incidence of the control of the decreased in 1996 incidence of the control of the decreased in 1996, selection of the control of the decrease of the control of the control of the decrease of the control of the contro

BATE CRIMES TRACAL

In an officer to increase the law enforcement community's knowledge and awareness of extremet group activity, as well as to assess them in ecognising and investigating biasmotivated crimes, the ADL has conducted essentive base crimes training somiours. The identity and activities of

Every instance of base or bigotry is one too many. We must continue on all forms of intolerance, and we must speak loudly as a community who This report indicates that ADI, and concerned Angelenos are making a r important bastle."

— Kickerl J. Piterler. Mayor of Lee Angeles, qualiting where the Andre of Ann-Senior Insulen

national coursing gauges such as the Sax Klass Klass, non-Nail Sichnhaus and Miller, and Chichine Meeting gauge are extrained, as well as have group activity on the Interest. In addition, the sentiment address retirons factors for schooling and definings have critica, contributional news in host prices enforcement and the restudent flower of have critical was communities. Our the part year, her reflecement agencies in Las Augules, Riversida and Vonnac Countries and Law Ryan her puriously in such sentiment.

ABL ATTACKED IN DAILY BRUIN

The part oping, U.T.A.'s neather necespace, the Duily Basis, permeat an insequence arease, and the American Schmiss primed an insequence arease, and the American Delimination League then consisted of smoderanciated Delimination League then consisted of smoderanciated Delimination League their properties of the Schmiss o

CSUN GIVES PLATFORM TO DAVID DEKE

One of the ration's most posminant ration, Devid Duke, accepted, institution in dabate the issue of affirmative acries as California Stat University. Northering, The institution consteaded with the dabate California's communical sari-quota measure, Proposition 209. A fortner "Canal Dingson" of the Kinglet of the Kin Kin King, Duke was also the founder of the self-study! Navional Association for the Advancement of White Prople." Attempting to soften his raciss:

Few religious organizations have the funds it takes to afford a good design firm. Even if they do have large coffers it often seems inappropriate to spend money on something that seems intangible at first blush.

The Pacific Southwest Region of the Anti-Defamation League dealt with this challenge in an unusual manner, the result of which you will find in the copy and photos that follow. Not only did the group's intelligent strategy produce a

clean effective product, it solidified two important precepts for the organization's board—good design doesn't have to be or look excessive to stand out in a crowd, and good design lends credibility because the reader concludes that the organization cares.

heavenly beings, they will enjoy exceedingly wonderful delights, and if they are born in the presence of a Buddha, they will be born by transformation from lotus flowers. (The Lotus Sutra, p. 185)

Katsuji Saito: You must be exhausted, President Ikeda, after your kengthy trip to the United States and Latin America. Your efforts in America, Cuba, Costa Rica, the Bahamas and Mexico to establish bonds of friendship

impressed me as actions truly reresentative of the practice of the Lotus Sutra.

Takanori Endo: In fact, the Lot Sutra, which elucidates respect f all differences of social system organization, culture and the lib connects people by urging them conduct dialogue as human bewind are who are all on an equal footing.

speaks to the principle of the tr entity of all phenomena (Jp. sho

It often seems inappropriate for religious organizations to spend money on something that seems intangible at first blush.

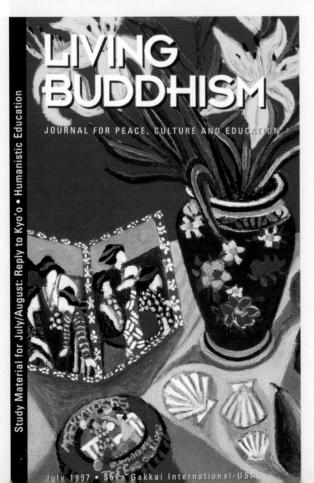

AUDIT OF ANTI-SEMITIC I

rep we aga is a enf of

Fo

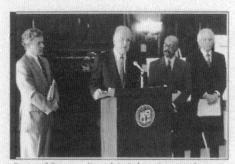

Regional Director David A. Lehrer, Los Angeles Mayor Richard Riordan, Multi-cultural Collaborative Director Joe Hicks, Regional Board President George

Anti-Defamation League

Pacific Southwest Region

1996 Annual Report

From the Annual Report, letter from the Regional Board President, George E. Moss and Regional Director, David A. Lehrer: "Since 1913, the Anti-Defamation League has worked tirelessly and effectively to fight anti-Semitism and bigotry through education, legislation and creative programming..."

TRIM SIZE is 8 1/2" x 11" (22 cm x 28 cm)

THIRTY-TWO PAGE, THREE-COLOR ANNUAL

Lustro Dull Cream TEXT STOCK

Garamond Body Font

LAYOUT PROGRAM: QuarkXPress

HARDWARE: Macintosh

EDITOR: Cheryl Azar. DESIGN: Helen Duval of Kimberly

Baer Design Associates. Both are based in the Los

Professional Graphic Design

Angeles area.

After many years of producing annual reports that were not designed by the pros, the Pacific Southwest Region of the Anti-Defamation League hired Kimberly Baer & Associates to create the original format and a rock-solid template which, in turn, was delivered to the organization's printer for the more time-consuming process of production. Says Baer, "Helen's template was so tight and organized that even a newcomer could have used it to create a clean final layout. This obviously saved the organization money, but it also enhanced their end-product."

A Ready-to-Use Template

Duval began by selecting a simple set of colors. "We chose two colors, PMS 1675 Rust and PMS 5753 Olive. These, plus black, definitely enriched the look." Duval added further sophistication by requesting a cream-colored paper. A notch deeper than white, it actually appears to be a very subtle fourth color. Duval kept her template to one column for ease of layout. To guide the layout artists, she created various sample spreads and saved them as master pages within her QuarkXPress document.

Dealing With Tough Images

Unless you are dealing with an organization that focuses on nature or the environment, nonprofits aren't necessarily going to provide stunning photography. The Anti-Defamation League was no exception. Instead of scrapping the images altogether, Baer and Duval decided to run them small and float them inside a thin rule. This delicate frame was enhanced by a dark green border on the outside edge of each image. The majority of photos in the 1996 annual run at 1 1/2" x 2 1/2" (4 cm x 6 cm). This does several things for the effect design has on the reader. One, it sets up a rhythm to the page and a pleasing sense of consistency—back to the trust issue discussed earlier. Two, it hides many imperfections in the art itself. And three, since some of the images depict offensive act or objects, such as hate flyers, the reader is at once relieved that the image is not shockingly large and yet, irresistibly compelled to look closer . . . and, of course, to learn more.

A Little Guidance

Part of the beauty of Duval's simple template are straightforward, impossible-to-miss section openers. Says Duval, "There are a lot of sections in this report, so I needed to come up with a design element that notified the reader in a clear fashion—'this is a new topic.' I also tried to create a little interest with subheads and callouts." As she explains, subheads make a large amount of type easy for the reader to navigate. The use of Garamond, a classic face, makes the type reader- friendly—less "bulky" as Duval puts it—especially when the leading is opened up a bit.

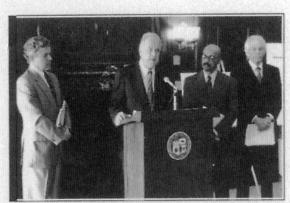

Regional Director David A. Lehrer, Los Angeles Mayor Richard Riordan, Multi-cultural Collaborative

VIGILANCE AGAINST INTOLERANCE

AUDIT OF ANTI-SERITIC INCIDENTS

Since 1979, ADL has recorded and tracked reported incidents of arti-Semitic vandalism as well as assaults, threas and hazasaments directed against Jess or Jessish institutions. This information is an important neocace for public officials and law

without distribution of Philidea Graymassing the
massing the

For the second straight year, the number of antimassing the
massing the

for the second straight year, the number of antimassing the

for the second straight year, the number of antimassing the

for the second straight year, the number of antimassing the

for the second straight year, the number of antimassing the

for the second straight year, the number of antimassing the

for the second straight year, the number of antimassing the

for the second straight year, the number of antimassing the

for the second straight year, the number of antimassing the

for the second straight year, the number of antimassing the

for the second straight year, the number of antimassing the

for the second straight year, the number of antimassing the

for the second straight year, the number of antimassing the

for the second straight year.

reported to the ADL was 1720. This total represented a decrease of 123 incidents or 7%s, from the 1995 total of 1843. In 1995 to total, in turn, represented an 11% decline from 1994. This two-year drop was the first

California ranked third in the nation in the number of reported incidents (186)

California malest threat in the namon in the number of reported moderns (180) behind New York and New Jures. These were 128 personed moderns of asseulus, threats and hazasomera tagainst Jess or Jewsh institutions—down 2706 from 1995. Incidents of vandalism also decreased state-week in 1996 - 58 incidents were reported, down 3706 from 1995. The total number of reported incidents were reported, down 3706 from 1995. The total number of reported incidents were reported, down 3706 from 1995. The total number of reported incidents were reported, down 3706 from 1995. No former affected the downward trend of the proposed incidents in 1906, down 9706 from 1995. Noting the decline, ADI, Regional Directors David A, Lebrer said "In rells to that the combination of community concern, law enforcement action and educational outreach is an effective approach that is reaping results in the traditional areas where anti-Semires are active."

HATE CRIMES TRAINING

In an effort to increase the law enforcement community's knowledge and awareness of extremest group activity, as well as no assist them in recognizing and investigating biasmotivated crimes, the ADL has conducted extensive hate crime training seminars. The ideology and activities of

"Every instance of hate or bigotry is one too many. We must continue our vigilance against all forms of intolerance, and we must speak loudly as a community when we witness injustice. This report indicates that ADL and concerned Angelenos are making a real difference in this important battle."

national extremits groups such as the Ku Klar Klan, noo-Nazi Skinheads, armed militius, and Christian Identity groups are examined, as well as hore group activity on the Internet. In addition, the seminars address various facers for Identifying and defining a hate crime, constitutional issues in hate crime enforcement, and the residual effect of hore crimes on communities. Over the past year, law enforcement agencies in Los Angeles, Riverside and Venzura Counties and Las Vegas have participated in such seminary

ADL ATTACKED IN DAILY BREIN

This past spring, UCLA's student newspaper, the Daily
Busis, printed an anonymous attack on the Anni
Defamation League that consisted of anotheranizated
accurations and gost distortions. Entitled 'Anni
Defamation Logue Infringes on Civil Liberties,' the

4000 repairs as morth in the ADI reposes was permitted by the Brain to shield Dobb Bouin-his/her identity "due to possible repercussions." As a result, the paper seemed to be signaling its racit approval of the writer's position his her fear of sperisal. Recognizing the error of its ways, the Brain ran an unprecedented apology. Principles of fear, it editorialized, "equite those who make specific accusations against a particular individual or organization to stand behind these accusations, and not hide behind a cloak of anonymity. seams extinut troes accutaments, and not may entired a cloud of anonymity.

Mereover, anonymity deprives randes of information necessary to determine if
the ellegations made are credible." In addition to in apology, the newspaper
also published an article by the ADL refusing the charges and detailing the
Legac's demonstrated record of support for civil rights and liberties.

CSUN GIVES PLATFORM TO DAVID DUKE

One of the nation's most preminerer raciest, David Duke, accepted an intrustation to debase the issue of affirmative action as California State. University, Northridge. The invitation coincided with the debase over California's Coursecrible and-isquent assument, Propositions 2019. A former 'Grand Dragon' of the Knighte of the Kn Klar Klan, Duka was also the founder of the aff-rayful 'National Nasociation for the Alexanorance of White Protein.' Attempting to soften his racities. Advancement of White People." Attempting to soften his racist

Living Buddhism

Living Buddhism is the monthly journal of the SGI-USA, an American Buddhist movement that promotes peace and individual happiness based on the philosophy and practice of Nichiren Daishonin's Buddhism.

LIVING
BUDDHISM
JOURNAL FOR PEACE, CULTURE AND EDUCATION

JOURNAL FOR PE

TRIM SIZE: 8 1/4" x 10 3/4"

FIFTY-TWO-PAGE, FOUR-COLOR, COVER; BLACK-AND-WHITE,

CONTENTS MONTHLY

White Porcelain Gloss book 100 lb (150 gsm) TEXT STOCK

Palatino BODY FONT

CIRCULATION: 20,000

FEATURE COPY LENGTH: 4,000

LAYOUT PROGRAM: QuarkXPress

HARDWARE: Macintosh

EDITOR: Margie Hall. ART DIRECTOR: Gary Murie. Both are staff members of SGI-USA, headquartered in Santa

Monica, California.

Form in Balance with Content

"Buddhist practices are easily applied to everyday life but studying the philosophy, history, and symbolism of Buddhism is definitely an intellectual pursuit," says art director Gary Murie. "So my goal for the design is to make the dense copy we provide accessible to both the intellectual and the average reader." To do this, Murie keeps his template simple and straightforward. Departments run in three columns, features in two. Leading is kept very open and, to engage the reader, pictures or illustrations run on every page.

"Most publications today are geared toward the hip-hop look of pop culture. Often that sort of design direction looks beautiful but is hard to read. Readability is the main focus of this design."

Dynamic Graphics

When Murie began including illustrations to highlight feature text, he spent a great deal of time communicating ideas for the visuals he wanted to his free-lance artists. "A group of three staffers and myself would sit down and carefully read each article. Then we would bat around ideas on the main points to be illustrated. Next we'd send the article and our ideas to our artist. After the artist read the article and our comments there would be a great deal of back and forth. Now that we have longstanding relationships with our illustrators, the process is less tedious." Murie adds that over time a sort of visual shorthand has evolved between him and the artists. "Now," he says, "we speak the same language."

A few examples of great end-product made through this continuing relationship include a series of illustrations for a serial feature titled "Dialogue on the Lotus Sutra" (opposite page, middle). This art brings the heady ideas about life and living into focus for the reader. To show how a person with faith in life takes action to promote positive change, illustrator Larry Ashton has drawn an archer intent on his target. To depict the Buddhist concept that "the true identity of life embodies the oneness of good and evil," Ashton depicts a woman who dreams of herself as a beautiful angel playing the violin and as a centaur carrying a pitchfork and a torch. Color isn't necessary when the art is this strong.

The Art of a Great Cover

In addition to supervising the art direction of *Living Buddhism*, Murie designs SGI's traveling fine-art exhibitions. This work gives him an inside scoop on Buddhist practitioners working at the cutting edge of the national art scene. As a result, works from the exhibition's outstanding artists grace the covers of *Living Buddhism*. Paintings shown here are "Still Life With Orange and Yellow Lilies" (left) by Rowena Perkins; "Honor Your Tears" on the October issue (opposite page, top right), by Donna Estabrooks; June features "Reef Dancers" by Tary Socha (opposite page, top middle); December features "Mardi Gras" by Joyce Martin.

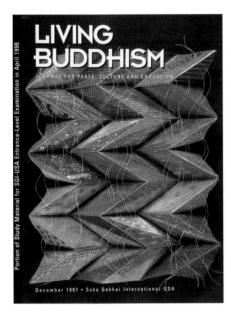

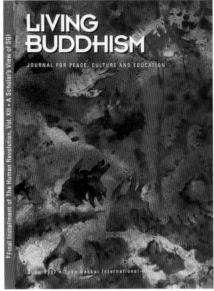

Illustrator: Larry Ashton

DIALOGUE ON THE

LOTUS SUTRA

Illustrator: Larry Ashton

The Fact Evil Peop Attain Er ment Pro

Evil People Can Attain Enlightenment Proves That Good Will Triumph

seaso of discussions on the Louis Sutrabersoon SCI President Bada and Soli-Galkar Study Department Chief Kotsoj Soin and Vier Chiefs Takenori Endo an Harno Sada. It appeared in the Augus 1996. Issue of the Daltysburengs, the

In the intellment they always be decrained of the enlighteement of earl people and the enlighteement of women the difference between the nay of this of Shakyamani and that of Devidants good, vol and the principle of the 'crossous' of good and earl', and other topics relating to the 'Devadatas' (medible chapter of the Lotto Sutra.

I good times are good some, who, on hunting the Devaders who, on hunting the Devaders of the Compared of the Lones Scars of the Wesselstein Laus. Believe as a Travece it with your hunts are harbor and duades or perplective they well zeroe fall times hall of the realth and busing youther one beauts, but with be learn in the postence of the Buddhas of the set directories and in the plea where they are been show who constantly beat this starts. If they are been a strong business of the Buddhas of the set of the set

heaverby beings, they will enjoy exceedingly userdefreld delights, and if they are born in the presence of a Buldba, they will be born by transformation from letter Blowers, [The Letter Sutra, p. 185]

Katsuji Saite: You must be exhausted. President liteda, after your lengthy trip to the Usined States and Latin America. Your efforts in America, Cuba, Coota Rica, the Baharnas and Mexico to establish bonds, of freedoline

impressed me as actions truly representative of the practice of the Lorus Sutra.

Sutra, which elucidates respect for all differences of social system, organization, culture and the life, connects people by unging them to conduct dialogue as human beings who are all on an equal footing.

Haruo Suda: Your trip abroad also peaks to the principle of the true entity of all phenomena (Jp. shoho THE WISDOM OF THE LOTUS SUTRAA DISCUSSION ON RELIGION IN THE
TWENTY-FIRST CENTURY

jisso, a tenet central to the Lotus Surra) that teaches us no realize that all phenomena in their magnificent diversences equally possess the true entity. This is easy to say, but very difficult to pot into practice; all the more so on a global

Daisaku Borde: This is work that I want young people to carry on. José Figueres Ferrer (1906–90), the father of President José Maria Figueres Obert of Costa Rica, is well Jenaen for Justine abolished.

Costa Rica) military. Reportedly
Mr. Figurers Ferrer's motto a
"lucha sin fin" (boundless strug
gle). He has used this metto sine
the days of his youth, even namin
his farm. Lucha Sin Fin.
Such a spirit is quite relevant fo

has farm. Lucha Són Fin.

Such a splint is quite relevant
us as Budéhiris. Budélitum ex, a
dl. a teaching of boundless at:
that I
gle where one experiences ei
on.
Vactory or defent. The true ages
life and society can be found
Maria
termal struggle between good
ica, is
evil, between the nature of depli

happiness and misery, peace and war, creatiest and destruction, harmony and turmoil. This is the true aspect of the universe. Therefore, the only path is that of

Saito: Shakyamuni spent his centre life engaged in uncessing and ardaous struggle. But it seems that more people – perhaps because of the inspession they were left with from seeing certain images of the Buddha and other relics – crivision Buddhism as a teaching of trainopility and repose. But ut realicy

fileda: That's right. But because of his great struggles, the Buddhs was able to cultivare a state of life as pucific and tranquil as a calm sea. No matter how much commercion there was around him, no one could upser the inner word be foot constructed. His sevene, dignified state of life as the Buddha entightneed store the remote past shoreend store the remote past shore-

Sada: Of Shakyamunik muny great struggles, the most Emmous concerns his betrayal by Devudatra. Unlike persecutions coming from without, this incident arose from within the Buddhist communery; It was all the more serious Secusies the trainor bad conspired with the ruler of the land. King Ayarasha-

Endo: Devodatza truly represent the "villain." Known as "trainorox Devodatza," in terms of evil would be difficult to find a person

St. Jude Medical Inc. 1996 Annual Report

St. Jude Medical is one of the largest global producers of high-quality medical devices. Their most important development is the St. Jude Mechanical Heart Valve; it has helped improve the lives of more than 750,000 people.

TRIM SIZE is 8 1/2" x 11" (22 cm x 28 cm)
FORTY-FOUR-PAGE, FOUR-COLOR ANNUAL REPORT
BODY FONTS INCLUDE Sabon body text, Trajan headline type
CIRCULATION: 85,000
DESIGN: Larsen Design Office Inc., located in Minneapolis, Minnesota.

To celebrate the twentieth anniversary of the first implant of the St. Jude Mechanical Heart Valve, this annual report focuses on people, specifically those who work to improve the technology and people who have been helped by implants . The cover is especially pleasing as it shows Dr. C. Walton Lillehei, "the father of open heart surgery," along with a broad cross section of patients who are happy and healthy due to the St. Jude's valve and Dr. Lillehei's pioneering work in cardiac surgery. Each photo tells us something important about the patient—something about what he or she loves in life. Some carry props, like a guitar or a pair of skis. Others simply wear their work uniforms. Although these photos are posed, they lack nothing in appeal since they so completely capture the personality of each patient. Notice how engaging the big smiles are!

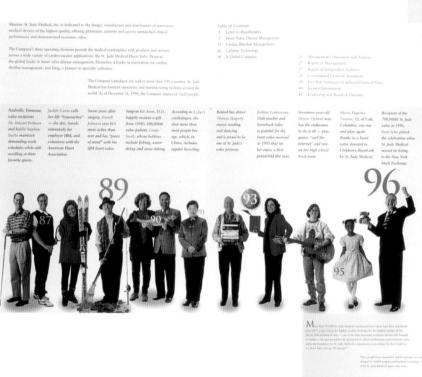

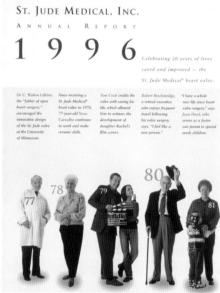

Heartport Annual Report

"Heartport is advancing the frontiers of cardiac surgery by developing, manufacturing, and marketing systems that enable minimally invasive approaches to major heart surgery."

—Heartport Annual Report

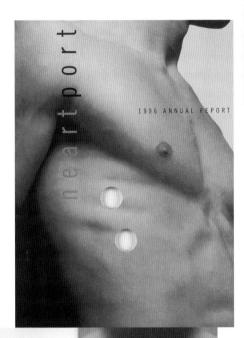

TRIM SIZE is 10 1/2"x 14" (27 cm x 36 cm) SIXTY-TWO PAGE ANNUAL REPORT Trade Gothic Condensed BODY FONT CIRCULATION: 15,000

EDITOR: Jim Weiss. ART DIRECTOR: Bill Cahan. DESIGN: Craig Bailey.
Both from the design firm Cahan & Associates, based in San Francisco,
California. PHOTOGRAPHY: Ken Schles, William McLeod, and
Tony Stromberg.

Heart surgery isn't something people usually want to talk about. However, if the need arises, patients do want to talk about their options. Instead of traditional methodology—reaching the heart by opening the entire chest—Heartport's systems create a path to the heart through two small incisions made between the ribs. This breakthrough became a base for Cahan & Associates' novel annual report design.

Cut into the heavy cardboard cover stock, and through the pages within, are two circular holes approximately the same size as the small openings produced by using Heartport Port Access Systems. Admittedly, a book with holes in it has something other than connections to the serious. One immediately thinks of interactive books for preschoolers, maybe even bowling balls. This playfulness makes the procedure seem more acceptable, even interesting to the lay reader. Powerful and beautiful photographs, like the one of the healthy young man on the cover, get back to seriousness and lend an air of sophistication, artistry, and balance.

This is a frank annual report. In fact, the opening spread explains exactly what happens in traditional surgery. Design follows right along by showing the instrument used to pry open the chest cavity. Notice that the sterile picture of this medical tool is once again balanced by a duotone image of a human chest. This is real, but it's OK. Balanced design allows the reader to absorb the material intellectually rather than emotionally. Color is mainly used for photos of patients who have found the surgery a remarkable, relatively painless experience.

Creative BioMolecules 1996 Annual Report

From the annual: "Creative BioMolecules is a biopharmaceutical company focused on the discovery and development of therapeutics for human tissue regeneration and repair. The Company's therapeutics are based on proteins that act in initiating and regulating the cellular events involved in the development of human tissue and organs."

TRIM SIZE is 7 3/4" x 11 3/4" (20 cm x 30 cm)
THIRTY-SIX-PAGE, BLACK-AND-WHITE ANNUAL REPORT
Bembo Body Font
CIRCULATION: 15,000
EDITORIAL: Feinstein Kean Partners of Cambridge. DESIGN: Thomas Laidlaw,
Weymouth Design Inc., located in Boston, Massachusetts.

Talk about using type as a graphic element! This report is one of the most elegant examples we've seen. The cover, which takes the letters from the word "creative" and scatters them about the borders of the design, initiates a pattern that is used throughout to set off departments. The effect reminds the reader of specimens under a microscope—how seemingly solid substances tend to break apart, revealing empty space where, to the naked eye, none appears to exist.

Ultrafem 1996 Annual Report

Ultrafem, a company dedicated to improving women's options in reproductive health care, developed an innovation in feminine protection called "softcup technology," trademarked Instead.

SIZE: 7 1/2" x 7 1/2" SEVENTY-FOUR-PAGE, FOUR-COLOR ANNUAL REPORT [BODY FONTS INCLUDE Perpetua, Officina] CIRCULATION: 15,000

WRITER: Ona Nierenberg, New York, New York. DESIGN: Belk Mignogna Associates Ltd. based in New York, New York.

For Ultrafem's first annual report, the BMA design team focused on two questions relating to the company's unique technology, "What do investors want?" and "What do women want?" Obviously, the answer to these musings is Ultrafem. However, the manner in which the answer is conveyed through design is intriguing.

BMA divided the book in two: One side opens to answer the question of investors and potential investors while the other opens to answer the question of the target demographic. Although each side deals with two different aspects of a product that is, at the very least, a challenge to discuss, both maintain a decidedly unique and illustrative feel and answer the question with visual and textual symmetry. Of special note are the painterly spreads that organize the four main topics of each section: "Opportunity," "Progress," "Strength," and "Success."

As you can see from these two chapter openers for "Progress," both have a similar feel and incorporate much of the same symbolism yet appeal to both types of readers. The "Progress" spread for "What do investors want?" features lovely feminine eyes that seem to be carefully analyzing research findings and the outside of a nautilus that is divided into parts representing the percentages of women interested in the product. Similarly, the "Progress" spread on the "What do women want?" side features a woman intent on the view. Her face is framed by a graphic representation of the inside of a nautilus shell, the dynamic swirls of which hint at natural forward movement.

Another intriguing visual element is the use of the symbols on both covers (the universal symbol of company success—a rising arrow on a financial chart—and the universal symbol for women) as paragraph marker dingbats.

nonprofits

he new Congress, acting on the Contract With America, ook aim at several conservation laws long thought to be inviolate. Some members went so far as to propose redefining the use of the National Wildlife Refuge System. The House and tic National Wildlife Refuge to increased mining. Meanwhile, a budget bill contained a rider that allowed salvage logging in national forests and suspended the enforcement of wildlife laws.

Of all our sections, this was the most fun to research. Everyone involved with a nonprofit, from the receptionist to the president, is wildly passionate about mission. In fact, most of the design teams

interviewed provide their services pro bono or at cost because they so strongly believe that the work done by their client is of value to

There is more than just good design inherent here—there is a great deal of heart.

the planet and one or many of its inhabitants.

You will find that the designs included in this section are diverse. Some are simple and straightforward, making the most of a budget-imposed limited color palette, while others boast amazing four-color photography, dynamic maps, and even expensive gatefolds and die-cuts. Whatever the choice, be assured that there is more than just good design inherent here—there is a great deal of heart.

Fish and Wildlife
Foundation

C/ H/ A/ P/ T/ E/ R

10

en viron mental

conservation

Any New York and Service State of the Control of th

App Northern Seed Control of the Con

Our chapter on environmental conservation includes some spectacular work. Of particular note is the work of Kinetik
Communications Graphics for Conservation International's first
"Decade" Report. Designer Sam Shelton told us that in honor of the organization's impressive history, he believed the book should have "plop value" (meaning if you plop it down on a desk it makes a very substantial sound). Conservation International's has both plop value and eye appeal. Every aspect of this design is clean, clean, clean. Along with ample white space, there are beautiful fonts, tight efficient layout, and amazing photo spreads. If this design can't sway even the most non-environmentally conscious

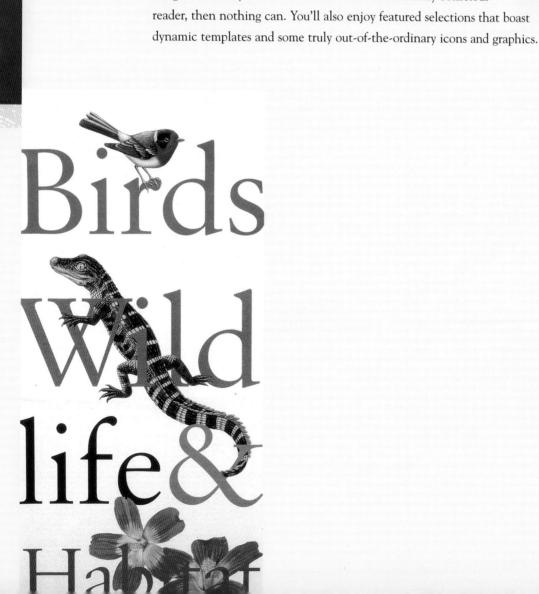

National Audubon Society

1995 Annual Report

Through a thriving network of grass roots chapters, the National Audubon Society carries out its exemplary advocacy work for birds and other types of wildlife.

Trim Size is 8.5/8" x 22" (22 cm x 56 cm), folding down to 8.5/8" x 7.3/8" (22 cm x 19 cm)

SIXTEEN-PAGE, FOUR-COLOR ANNUAL REPORT

Mohawk Vellum, 60 lb (90 gsm) text recycled, STOCK

BODY FONTS INCLUDE Sabon, Paula Wood

CIRCULATION: 7,000

LAYOUT PROGRAM: QuarkXPress

HARDWARE: Macintosh

EDITOR: Michael Robbins of the National Audubon Society,

based in New York City. DESIGN: New York-based

Pentagram Design. PARTNER/CREATIVE DIRECTOR: Woody

Pirtle. ASSOCIATE/DESIGNER: John Klotnia. DESIGNER:

Ivette Montes de Oca.

Previous Audubon Society annual reports are a standard 8 1/2" x 11" (22 cm x 28 cm) landscape, a format that the nonprofit wanted to adhere to but found restrictive in terms of design. To meet the client's request, the design team developed an unusually tall layout that conveniently folds down to 8 5/8" x 7 3/8" (22 cm x 19 cm), a size that fits in file folders. Explains Klotnia, "Our instinct was to go a step beyond what had been done in the past, to allow for more graphic design. The other reason for the size choice was a desire to give the document a newsletter sort of feel, more grass roots like the chapters themselves. The height added to this 'less precious' look."

With dimensions settled, Klotnia set up his template. "Text seemed too long with two columns, and three didn't allow enough room for images. So I added a thin fourth column on the outside of each page for photos and captions." As Klotnia points out, the fourth column for "odds and ends" also adheres to the newsletter-type format.

Easy to Read

Note the use of rules, which delineate columns and stories. This treatment provides visual organization for the reader. Also observe how the beginning paragraph of each story (opposite page) is run in large type and surrounded by a frame; this is good for catching the eye of flip-through readers. In addition to being user-friendly, the use of keylines and frames adds to the ad hoc feel, each compartment reminding us of the many chapters and people that make up the core of the organization.

Photo Jungle

Says Klotnia, "The tricky thing about images for this report was the number of different photographic styles we had to deal with. To reduce this visual smorgasbord, we ran photos small, balancing them with larger illustrations."

A particularly engaging spread (opposite page, top) features the front and back of a trout—on opposite pages; this is a fun design trick that hints at activity beyond the page, as if the annual report is actually in the middle of a school of fish. The reuse of different parts of the same illustration is a budget-conscious choice.

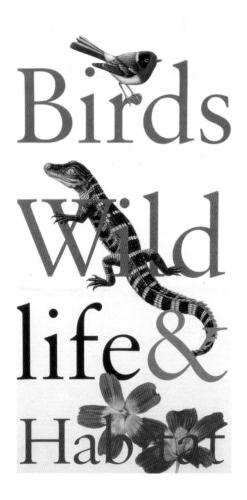

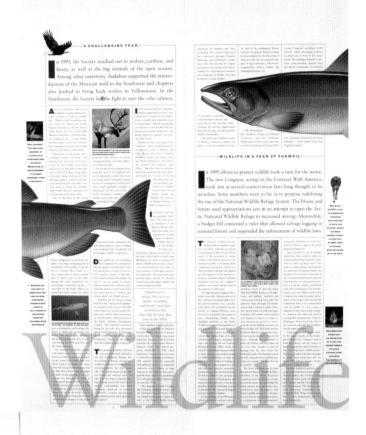

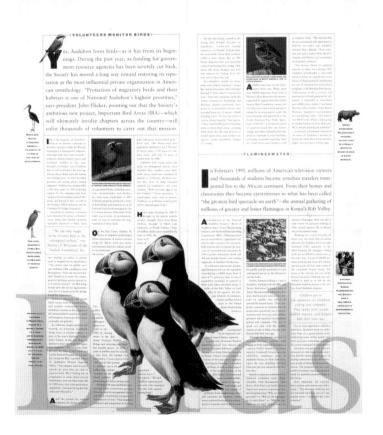

A Look Beneath the Surface:

Center for Marine Conservation

1996 Annual Report

The Center for Marine Conservation is a nonprofit organization dedicated to the preservation of marine wildlife and habitats.

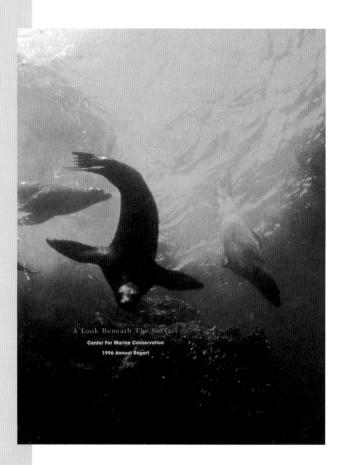

TRIM SIZE is 8 1/2" x 11" (22 cm x 28 cm)
THIRTY-PAGE, FOUR-COLOR ANNUAL REPORT
Mohawk Options and Foxriver Quest STOCK
BODY FONTS INCLUDE Garamond, Avant Garde
CIRCULATION: 3,000

LAYOUT PROGRAM: QuarkXPress

HARDWARE: Macintosh

ART DIRECTOR/DESIGNER: Rex Peteet, Mark Brinkman of Sibley Peteet Design, in association with GSD&M advertising. Both are based in Austin, Texas.

That Undersea Connection

Says designer Mark Brinkman, "Since this piece is used mainly to support and promote legislation, we needed to pack in a lot of information." It also had to offer something other than spreadsheets and scare tactics; the Marine Conservation annual needed to remind senators and House representatives about the beauty, fragility, and potential of the world's oceans.

To achieve these goals, Peteet came up with a strong theme, the idea of "looking beneath the surface." One of the most pleasing design elements that relates to this theme is the use of bound-in shortsheets that, when flipped, reveal hidden pictures. Each boasts its own reverse-line illustration of a mechanical milestone in the history of undersea exploration. Brinkman notes that these simplistic images add balance to the activity of the rest of the design and are fast and simple to create.

A Template Less Ordinary

This template is unusual in that it falls into four equal quadrants. The two upper quadrants are reserved for body copy, the inside lower quadrant for graphs, and the outside lower for a secondary story.

Those Sophisticated Extras

A wonderful demonstration of the theme appears in the opening spread (opposite page, top right). A sheet of vellum overlays a fantastic shot of a coral reef. As Peteet says, this literally suggests the act of looking beneath the surface. "As you turn back the vellum flysheet, or implied surface, you reveal the wonderful coral reef and all of the colorful life found there."

Opposite this effect, on the inside front cover, is a beautiful varnish treatment. Culled from a book of Asian patterns, this repeating design looks like waves and ripples, but the black background implies the mysteries of the abyss.

Let Your Photos Do the Talking

Unless hidden under a shortsheet, photos in this annual cover an entire page or spread, allowing the ocean and its inhabitants to sweep the reader away. Running photos large was the easy part; actually obtaining rights for the images was the tricky part. Says designer Mark Brinkman, "Since most of the images we used were taken by *National Geographic* photographers, we literally had to chase them around the world to get clearances and OKs. It was definitely our single biggest challenge."

National Fish and Wildlife Foundation

1996 Annual Report

From the annual: "The National Fish and Wildlife Foundation is a wildlife, and plants and the habitats on which they depend. Among

nonprofit organization dedicated to the conservation of fish, its goals are species habitat protection, environmental education, public policy development, natural resource management, habitat and ecosystem rehabilitation and restoration, and leadership training for conservation professionals."

National Fish and Wildlife Foundation

1996 ANNUAL REPORT

TRIM SIZE is 8 1/2" x 11" (22 cm x 28 cm)

SIXTY-EIGHT PAGE, FOUR-COLOR ANNUAL REPORT

Quantum Opaque 70 lb (105 gsm) Smooth TEXT STOCK

(donated by Georgia-Pacific); Champion International

Corporation's Krome Kote C1S, 10 pt. COVER STOCK

ITC Fenice BODY FONT

CIRCULATION: 10,000

LAYOUT PROGRAM: OuarkXPress

HARDWARE: Macintosh

EDITOR: Jenny Pihonak, Sadhya Hall, the National Fish and

Wildlife Foundation, Washington, D.C. DESIGN:

Annemarie Feld, Feld Design, Alexandria, Virginia.

PHOTO EDITOR: Susan P. Bournique.

Lots of Sections?

Better Get Visually Organized

"There are so many sections in this book," says designer Annemarie Feld, "that I needed an original way to distinguish them." Beginning with the cover itself (left), Feld based her organizational system on illustrations. Traditionally the NFWF uses original work for its covers, and the 1996 annual was no exception. The editorial staff provided Feld with a photo of "Granite Passage" from the William Farley collection (Chicago). Feld noted the strong colors and inherent design elements of the painting and used them to her advantage.

"Granite Passage" is used as the central cover image over a woodcut background, while various sections of the painting serve as table of contents icons and headers for the four chapters covering NFWF operation. Within these chapters, Feld reuses elements from the cover art on a large scale to create pleasing compositions.

In keeping with the wild, natural feel of former publications, Feld used woodcut clip-art icons to fill out the remainder of the table of contents and chapter illustrations.

Don't Box Me In

Instead of separating copy with boxes, Feld keeps the design open—and ultimately, more readable—by using dotted rules to separate copy elements. Note the use of a black dot at the end of each rule (opposite page, middle right), helping to further define the beginning and ending of a particular concept.

The Art of Charts

Charts in the NFWF annual are as colorful and inviting as the rest of the report. Says Feld, "I wanted them to look a little bit painterly, to go with the cover. They even have uneven edges. I guess I could have made them more complicated, but there's so much going on in this report already, I thought anything more would be distracting."

More Copy? More Columns!

Says Feld, "I had a lot of copy to fit so I needed something really flexible. I tried several different layouts before I decided to go with five columns." In practice, she often used the fifth column for graphics or pull quotes. This approach helps draw readers into an otherwise dense page. Note the fun use of paw prints in the fifth column of the right hand page in the spread for the "Save the Tiger Fund" (opposite page, top right).

Spice It Up

Feld creates interesting frames for images that bleed off the page. Because these geometrical shapes are based on the column grid, they retain the internal sense of the document. They also add additional interest without taking up too much valuable copy space.

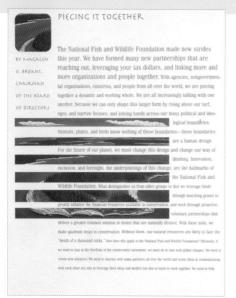

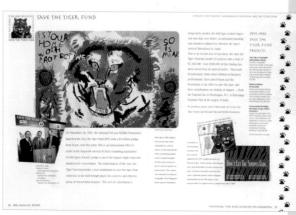

NEOTROPICAL MIGRATORY BIRD CONSERVATION INITIATIO

WILDLIFE AND HABITAT AVANAGEMENT INITIATIVE TO THE GRANTS

\$3,000, outside houds: \$2,000.

Answering the Call-III insplement plane raw of a onop-ranke present between Quest contained, 2000. Present Services forward of Land Menagement, and other to be greated enableated holds: a present of Land Menagement, and other to be greated enabled holds and planet, and the contained and planet, sevels and active granten and by developing water sizes Quad Universities. Services and active granten and by developing water sizes Quad Universities. Services and Servic

GRANTS

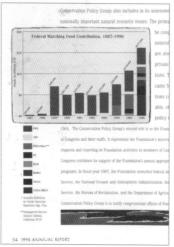

Conservation International:

The First Decade 1987-1997

From the annual: "Conservation International believes that the Earth's natural heritage must be maintained if future generations are to thrive spiritually, culturally, and economically. Our mission is to conserve the Earth's living heritage, our global biodiversity, and to demonstrate that human societies are able to live harmoniously with nature."

TRIM SIZE is 9" x 13" (23 cm x 33 cm)

SEVENTY-SIX PAGE, FOUR-COLOR-AND-SPOT-COLOR

ANNUAL REPORT

Warren Strobe Dull Text Stock

BODY FONTS INCLUDE Today, Baskerville

LAYOUT PROGRAM: QuarkXPress

HARDWARE: Macintosh

DESIGN: Jeffrey S. Fabian, Scott Rier, and Samuel G. Shelton

DESIGN: Jeffrey S. Fabian, Scott Rier, and Samuel G. Shelton of Kinetik Communication Graphics Inc., based in Washington D.C. Publications Director/Project Manager: Robin Bell of Conservation International, also headquartered in Washington D.C.

You Can Judge a Book By Its Cover

The cover of *The First Decade* (left) embodies the goals of the organization itself—to protect, enhance, and enlighten. A tree frog is pictured in green duotone. One eye is revealed in stunning color through a die-cut window. When the gate-fold cover is opened, the reader finds two red-eyed tree frogs atop a heliconia flower. In a sense, the gate-fold cover protects the image inside. Since the main cover is created in green only, the reader's perception of "frog" is enhanced upon opening. (In other words, frogs aren't just green.) And, since frog populations are a major indicator of the health of a particular environment, the use of a frog as a symbol for the organization as a whole is approps and, of course . . . enlightening.

The Setup

"The board wanted *The First Decade* to be a piece that people could hold onto," explains Sam Shelton. "They didn't want it to be a textbook, but they did want to include a series of essays that would serve as a heavy-duty resource guide for members and potential donors."

Worried that the long essays might appear, "overwhelming" to readers, Kinetik opted to go with an unusual template. "The idea to create an oversized book was based on the fact we were going to have a great deal of body copy. Even in 8 1/2" x 11" (22 cm x 28 cm), that much text would make the book seem squatty. The longer page allows for a thinner copy column with open leading." Kinetik used outside columns for sidebar information, maps, graphs, and longer-than-average photo captions. This addition provides flip-through readers with ample information concerning the organization, its goals, and its many accomplishments. To make the book even more reader-friendly, the design and client team broke the copy into four categories—science, economics, policy, and awareness. A glance at the graphic on the bottom of each page tells readers which section he or she is in. On a sophisticated design note, check out the use of thin rules dividing body copy and sidebars and framing the outside edge of photos (opposite page, bottom).

Digital Dollars

The cost to print an extraordinary annual report can be astronomical—in both hard dollars and cost to the environment. To cut down on both, this publication went "direct-to-plate," a digital process that eliminates the need for film and the paper and chemicals involved in producing matchprints.

areas and the specific activities (science, economics, policy, communications, protected area management) needed to achieve our conservation objectives.

In the past few years, the hotspots approach has gained currency at a global level, and has received attention from other international organizations. This renewed emphasis on hotspots stimulated us to review the hotspots concept. which we did in a workshop held at the CI offices in March 1996. The purpose of this workshop was to reassess the hotspots concept, reaffirm its validi ty, add or subtract areas as appropriate, and come up with a series of defensible criteria for what constitutes a hotspot. The results were very exciting. Our new analysis indicated that there are some 19 top priority hotspots, occupying less than 2 percent of the land surface of the planet (see map, pp. 65-67) but harboring 30-40 percent of all known terrestrial species as endemics (found in one area and nowhere else), more than 50 percent of total terrestrial species diversity and roughly two-thirds to three-quarters of the most endangered species of plants and animals. We also identified a second tier of ten slightly less diverse but critically important areas that highlight still further the importance of these hotspots. Included in the second tier are the California Floristic Province (covering most of the state of California). Indochina, the Eastern Arc Mountains of Tauzania, and New Zealand. In any case, the original message echoed load and clear. A very large percentage [50+percent] of global terrestrial biodiversity can be protected in a very small percentage: about 2 percent

on hotspots and reaffirming its validity as our positioning strategy for our second decade and the next millennium.

It is important to note that the CI hotspore emphasize terrestrial ecosystems with some systems and, in some cases, associated coastal marine systems. However, similar hotspots analyses are needed for the freshwater and marine realms so that they are not underemphasized. In fact, our new marine program plans such an analysis for next year. and a freshwater hotspots analysis is under discussion with experts.

It is also important to mention our other priority-setting strategy - major tropical wilderness areas, a concept that we developed in 1988 and 1989 to complement the hotspots approach. The major tropical wilderness areas approach (referred to in Myers' 1988 paper as "good news"

areas) again emphasizes high-biodiversity tropical systems, but focuses on the

Conservation International

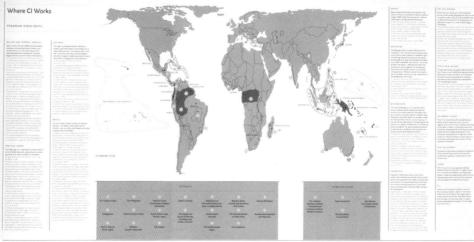

World • Watch

Published by the Worldwatch Institute, World•Watch "tracks key indicators of the Earth's well-being" and is dedicated to providing "policymakers, educators, researchers, reporters, and concerned individuals with the information they need to make decisions that will lead to a sustainable economy."

TRIM SIZE is 8 1/2" x 11" (22 cm x 28 cm)

FORTY-FOUR-PAGE BIMONTHLY

Galliard BODY FONT

CIRCULATION: 80,000

EDITOR: Ed Ayres. DESIGN: Elizabeth Doherty. Both are staff members of the Worldwatch Institute based in Washington, D.C.

It is important that the design of a publication reflect the mission it professes. The World • Watch template certainly does, but not through the use of color photos as one might expect. There are no horrifying shots of starving youths or slaughtered animals here. Breathtaking illustrations of the world's beauty play a much stronger role. Pen-and-ink drawings laid out with clean sans serif headlines pull the reader into feature spreads, gently reminding them of the real color that will be lost if the world is not properly nurtured.

The HomeFront

The newsletter for the San Diego Housing Commission details work of the board and volunteers to provide an "affordable home for every San Diegan."

TRIM SIZE is 8 1/2" x 11" (22 cm x 28 cm)

TWELVE-PAGE QUARTERLY

Galliard BODY FONT

EDITOR: Deborah Miller, Community Relations Officer of the San Diego Housing Commission. DESIGN: Roxanne Barnes, Roxanne Barnes Creative Services, based in San Diego, California.

This two-color, budget-friendly publication looks sophisticated and official due to the use of small, clean images and a layout that alternates between one wide column and three narrow ones. For a newsletter dealing with such a serious subject, this is very appropriate. However, designer Roxanne Barnes achieves a warm feel through her choice of graphics. Notice how the cover flag illustration—a stylized neighborhood—is used as a motif throughout and how pictures of new homes are screened back behind copy.

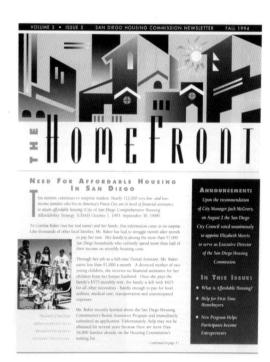

HOUSING TOPIC OF CITY HEIGHTS SUMMIT

by Jim Varnadore

early 200 residents, business and community leaders and government officials set aside a weekend last spring to meet at Wilson Academy to discuss and write a plan that could help reduce crime and improve the economic conditions in City Heights. Housing was a very hot topic.

I was a member of the Housing Issues Team which was comprised of City Heights residents, housing advocates, planners, San Diego Housing Commission and City staff. This team was formed to ackle very important housing issues. In all, the Team discussed ownership, management, the actual condition of buildings in City Heights, area zoning and code compliance regulations, financing, and other issues which were believed to in some way affect the City Heights housing stock.

The Team wrote several suggestions which we believed would help to improve housing in the City Heights area. Among those recommendations was the advocating of more owner-occupied homes in City Heights, more rehabilitation of existing homes, and a moratorium on new multi-unit construction. We strongly believe that this would improve stability and the series of community in the area.

The Team also recommended improvements in the availability of support services like clinics, dentists, banking, insurance, postal, library, parks, etc... for the comminity. These will enhance the quality of like and attract good residents. Firnally, the Team suggested setting up courses in good management for owners and managers, and other courses for residents to help them understand their role in improving like in City Heights. Using both courses would help managers select and retain

Jim Varnadore is a linearing advision who is currouth serving as a member of dia Housing Truss Faha Board of Directors

A one-day follow-up meeting of the larger group was held in July. Recommendations from all teams, including Housing, are being presented to the wider City Heights community and to the City Council for their minput and review. Then a detailed plan will be written and used as the basis for a City Heights improvement program.

good residents and expand the pool of good renters. The Team sees this as a win-win approach

I was pleased to be a part of thisprocess, and strongly feel that if implemented, these recommendations could help restore City Heights to the beautiful, community oriented neighborhood it once was.

Sharing News

Sharing News is published by Earth Share, a federation of nonprofit organizations dedicated to saving the environment through education and employee giving campaigns.

ENVIRONMENTAL FUTURE LOOKS BRIGHT

BUT OBSTACLES REMAIN

We could a good magina que ser auxor conserva presun o la como de 2 das Conserva (de ne de conserva de la presun de la publicación — but sunyi falla repara transit se cue sus por la de finanpalicipación — but sunyi falla repara transit se cue sus por la definiente haman que the sinte excrusaging signe has entre de agricultar defencie en Compress of long-monting, instrumar lasquit françoises con universe and montine travastices. As one configentariose in Par-Radiologiam Para deserved, "restricionemental grangicios nous logicipies a susinges plece a Amendatio proficie. Si in econgarioral su inventidenting titulación de displación por en of the governmenta for computation deservadors para con capitalistic deservadors a meter entre por entarrecessariomental proficiente susinges a camera entre por el para con capitalistic deservadors a meter entre por entarrecessario-

uny want to open agreement.

Since 1970, while disease emissions have been reclaimed 40-percent, carbon instrumed has decopied 50 percent, and labours lead than been very by percent, according to the U.S. Devictor-mental Protection, agreen White travels, the U.S. Devictorial Systems and the percentage of the U.S. Devictorial Systems and the percentage of the U.S. Devictorial Systems are all the percentage of the U.S. Devictorial Systems are all the percentage of the U.S. Devictorial Systems are all the percentage of the U.S. Devictorial Systems are all the U.S. Devictorial Systems and the U.S. Devictorial Systems are all the U.S. Devictorial Systems and the U.S. Devictorial Systems are all the U.S. Devictorial Systems and the U.S. Devictorial Systems are all the U.S. Devictorial Systems and the U.S. Devictorial Systems are all the U.S. Devictorial Systems and the U.S. Devictorial Systems are all the U.S. Devictorial Systems and the U.S. Devictorial Systems are all the U.S. Devictorial Systems and the U.S. Devictorial Systems are all the U.S. Devictorial Systems and the U.S. Devictorial Systems are all the U.S. Devictorial Systems and the U.S. Devictorial Systems are all the U.S. Devictorial Systems and the U.S. Devictorial Systems are all the U.S. Devictorial Systems are all the U.S. Devictorial Systems and the U.S. Devictorial Systems are all the U.S. Devictorial Systems and the U.S. Devictorial Systems are all the U.S. Devictorial Systems and the U.S. Devictorial Systems are all the U.S. Devictorial Systems are all the U.S. Devictorial Systems and the U.S. Devictorial Systems are all the U.S. Devictorial Systems and the U.S. Devictorial Systems are all the U.S. Devictorial Systems a

Del in Antonia's Paria Curaçion-Vermilliono CER Wilderness, wildle biokajosis ristensiol eti songar Galifarriata conduci inso die wild, makkoig ma, teram of Plath Ampirica's largest bird for the ideam viacetiese siste ma albassos of pione tima. "O years, Less thair a decade say, and 27 California condoss weith vall alive. Exilia diacrisis si y più enterne gi captive fibraciano projessio. 121 of these imaginitares si summa di servere, with LT of them lated in the

We have also seen alleagues is serve, one publish queries contrologies, also are, artismi passiquestice the linguise was dismost factory, with plant nativeness conversable this or Nebel production of Europe, with plant nativeness conversable this or Nebel production and production of the conversable that or Nebel production conversable to the conversable that or new production hauteness to provide use as one of 40 percent annual Theo U.S. Operationess of Bernit providing partial good and annual Theo U.S. Department of Bernit providing partial good and annual production and the providence of the production of the production of the providence of the production of the production of the providence of the production of the production of Seydement Caddown, souther production of processing and observations of the production of processing and control production of the production of the production of the production of the production of development of the production of the pr the world's largest solar rooftop, providing power for the \$6 million, 10,000-test aquatic arena.

This past year also sun the diamatic creation of the 1.7 millionone Grand Starcasie-Bealance National Motionnent in southern Libris imperited Bedorck Wildlands, expansion of diacens of paths and creations of new automa heritage areas; historic mais and scenar creas in 14 states, and diaministration action that ended the throat of potentially devastating guids, silver and copper mines not outside Millionne Million.

Not only were congressional strenges at well-energy our baseenstremental times threatered, but anyour Printenstream and Printenstream and Printenstream 20 to 50 person, instead saturations of 10 15 person for reduction in funds, That means the EPW will be able to intensify its pollution in Speciation, continue "Superfund" to the water cleaning, provide sofficient money to the states for safe clinicity water programs and return injournity personned. Buffarrian congressional action and return injournity personned. Buffarrian congressional action to the printensis of the printensis of the printensis or the printensis of the printensis or the printensis or the printensis of the printensis or the printensis of the printensis or the printensis or the printensis of the printensis or the printensis of the printensis or the printensis of the printensis of the printensis or the printensis of the printensis or the printensis or the printensis of the printensis or the printensis of the printensis or the printensis of the printensis or the print

It is formation that environmentalism appears so powerful, for the challenges we have ensured industries, Despite the immerced encouraging advances just described, many performations to affect our fast, air and water, and artic environmentalism are nearly so review their assualts on our public lands, natural:

For example, concerted efforts are under way to open Afaka's Artick National Waldide Rehight to destructive of and gip exploration. I agging interests safe yant to suspend environmenta protections permanently or our national forces so they can continue clear estimate the production of the continue of continue clear estimate the continue of the continue of the temporary "descrict refer that expired to Develotion.

Surf's Un

Vjer Karth Share's World Wide We homepage for helpful, everyday environmental advice, updates or ear many projects, and more afformation on our member char

www.earthshare.org

TRIM SIZE is 8 1/2" x 11" (22 cm x 28 cm) SIX-PANEL GATEFOLD

Garamond BODY FONT CIRCULATION: 30,000

EDITOR: Renny Perdue, Earth Share Executive Vice President, based at the headquarters in Washington, D.C. WRITERS: Vanguard Communications, freelance to Earth Share. DESIGN: Hirshorn-Zuckerman Design Group, also freelance.

Never knock a design that is straightforward, easy to read, clean, and inexpensive. This publication opens up to a three-page, six-column spread packed with information, but the use of small clip art, icons, and bullet points make the short paragraphs easy to see and in fact, inviting. This layout, along with a few well-chosen, diverse photos, makes it fun to glance around the page, quickly checking areas of interest.

ENVIRONMENTAL FUTURE LOOKS BRIGHT

BUT OBSTACLES REMAIN

We heard a great deal this past year about building a bridge to the 21st Century. On the environmental approach to that bridge, many promising developments this year have served as the world's largest solar rooftop, providing power for the \$6

This past year also saw the dramatic creation of the 1.7 million

Environmental Law Institute 1996 Annual Report

From the annual: "The Environmental Law Institute advances environmental protection by improving law, policy, and management. ELI researches pressing problems, educates professionals and citizens about the nature of these issues, and convenes all sectors in forging effective solutions."

Trim Size is $8\ 1/2" \times 11"$ (22 cm x 28 cm) Forty-four-page, black-and-white annual report Bembo Body Font Circulation: 5,000

EDITOR AND PROJECT MANAGER: Stephen R. Dujack, director of communications for the Environmental Law Institute, based in Washington D.C. DESIGN: CartaGraphics Inc. of Sarasota, Florida.

This clean, economical report has a three-column template. The two outside columns often combine to create framed sidebar information. The outside column is also used for sans serif headlines and statistics.

Continuity is further implemented through the use of black and white images by the same photographer, artist Bruce Barnbaum, a protégé of Ansel Adams. This spread, featuring a live oak forest on Sapelo Island in Georgia, is complemented by Gill Sans in a justified block of type. Note the use of dingbats to separate paragraphs.

ENVIRONMENTAL LAW INSTITUTE ANNUAL REPORT 1996

Live Oak Forest, Sapelo Island, Georgi

THE ENVIRONMENTAL PROFESSION is the key to making environmental law work. Since its founding a quarter century ago, the ferriemmental Law lastitute has seen improving the professionalism of this corps of attorneys, managers, and policy makers as critical to achieving society's goals for improving the health of the bisophere and its inhabitants. At The challenge in environmental protection is as much in evolving effective means of reaching goals as in the setting of them. Both the formulation of policy and its execution require an environmental profession that is capable of advancing a field that in a complex in its interrelationships as the ecosystem it addresses. At ELI builds professional expertise through its educational programs and its publications. ELI fosters professional expertise through its educational programs and its publications. ELI fosters professional expertise through its educational programs and its publications. ELI fosters professional expertise through its ductational programs and its publications. ELI fosters professional expertise through its ductational programs and its publications. ELI fosters professional expertise through its ductational programs and its publications. ELI fosters professional expertise through its ductational programs and its publications. ELI fosters professional expertise through its ductational programs and its publications. ELI fosters professional expertise through its ductation of the program and its publication.

Environmental Defense Fund 1996-1997 Annual Report

This 300,000-member nonprofit works to build bipartisan support for environmental recovery by enlisting scientists, economists, lawyers, and public activists.

TRIM SIZE is 8 1/2" x 11" (22 cm x 28 cm)
TWENTY-FOUR-PAGE, FOUR-COLOR ANNUAL REPORT
BODY FONTS include Garamond and Gill Sans
CIRCULATION: 37,500

EDITOR: Joel Plagenz, Environmental Defense Fund director of public affairs, located in New York, New York. DESIGN: Lazin & Katalan, also based in New York.

With the exception of a spectacular four-color cover, this annual report was run in three colors throughout. But three colors seem like four because they run on white 100% post-consumer recycled paper with a tan wash. The template is a strict, tight grid that repeats on every page. The advantage here is savings in design time. The uniformity is broken by a variety of black-and-white photos, some smiling people, and interesting shots of nature habitats. Note the use of gradient blends.

Also the capacity of New England's overbuilt fishing fleet will be reduced gradually. The Federal government will support a vessel buy-out and retirement program and, at EDF's urging, will monitor the program to help insure that other vessels do not restact those removed.

Overfishing also imperils salmon in Walshingon, Oregon, and Californs. For the last several years, the Pacific Fatheries Management Council has instituted casts' restrictions recommended by EDF and others for highly depleted salmon stocks. EDF is also working to protect and restore two ecosystems that once harbored spectosciate must off salmon, the San Francisco Bay-Diats and the Columbia River Basin. by negotisting water transfers that off label processing the control of the Columbia River Basin. by negotisting water transfers that off label processing water transfers that off label processing water transfers that off label processing water transfers that will help restore.

and therewaters that are being hooked and drowned when they go after bast on deep-iss fishing liess. EDF and Defenders of Wildfills critical in policy that could eliminate the unnecessary killing of up to 180,000 seabwins a year. It calls for modified fishing techniques such as the use of more heavily weighted lines that quickly such that but out of reach of the brink. The policy was adopted by the International Union for the International Union for the Conservation of Nature, and a U.S. North Pacific fainternew's association has pilegled to use many of the recommended seckings.

With natural fish stocks in trouble, marine agusculture or "fish farming" is growing rapidly here and abroad. EDF helped organize one of the first international meetings on the troubling environmental impacts of shrimp farming. Shrimp farms cause politice nearly waters and controlled to the destruction of coastal manual politice nearly waters and controlled to the destruction of coastal manual politice.

grove forests, which are essentihabitat for many marine species. ED is working to ensure that aquacultur develops in ways that do not have the environment.

CLEARING THE AIR

Too many people breathe unhealthful air, and greenhouse gases tied to global warming continue to build up in the Earth's atmosphere. EDF's Global and Regional Atmosphere program works to reduce emissions, especially from burning fossil fuels, that cause both local and global problems.

in Science first proved that sulfir policition from annohestacks could stratel long distances to some sold raise long distances to some sold raise long distances to source sold raise for emassions. Sciences show view the urban smoog problem as regional, soo, with nitrogen anothers the major precursors of smoog – traversing from sources up to hundred of miles away. Based on this information, EDF has developed as clean in plant to out reinorgen oxide emissions throughout the JU – states region and of the Rookles.

Clean air and visibility in the national parks and wilderness areas of the Colorado Platesia will be protect ed under an agreement adopted the year by Western governors, trible leaders, and Federal officials. The plan, which EDF helped design, we reduce and then permanently carotal emissions from mobile an advanced and the permanently of the permanently

Severe air pollution in the Paso del Norte region around El Paso, Texas, and Ciudad Juarez, Mexico, will be addressed under an EDF proposal adopted this year by U.S. and Mexican officials. Because the two cities share a common airshed, El Paso businesses

Without a doubt. Kerl R. Rhage is the only person at EDF qualified to drive a zank. He immed this and other hattis shift as a carely patient leader in the U.S. Army. As part of its judge adversary program the Army are the years Transic to be cloud. After seath and leave the years Transic to be cloud. After seath to give at West Protect and the University of Housson, Edwage served as a public office convenience in Trans and disputs addition exercity in the U.S. Department of Europy before joining EDF. In this space time to this leak in the convenience energy officers and the disput patients, seeing all bads, and intuiting efficient patients.

EDF is encouraging Treats electric companies to provide more power from clean, renewable energy sources. Treats consumers show a chear preference for renewables such as the wind power that this West Texas facility produces.

Clean Air Act obligations by investing in measures to reduce pollution in Juarez, where many more cost-effective economisting are available.

the opportunities are inablable.

ED in playing a leading role in nearmational policy on global warming. When more than 100 countries gathered this year to sign the General Declaration on Climate Change, EDF, in allance with other groups, helped strengthen the U.S. stand in the negotiation and uncessfully present other rations to follow the U.S. lead. The signers agreed to along, In Opportunities to 1971, legally brinding commitments to

reduce their greenouse gas emission.

Population policies coulplay a key role in meeting targets for
greenhouse gas reductions, accordir
to research by EDF scientists and ThPopulation Council. A joint study th
year quantified the relationshibetween carbon dioxide emission
and population growth.

and population grown.

EDF has also sought to dra matter – for both decision makers are the general public. — the serious problems that could be caused by climat change. A traveling exhibition or global warming, developed by EDI and the American Museum of Naturr Hestory, has been sen by nearly we million people. The exhibition is not at Columba University Biosphere Content near Tucson, Artoon.

CLEAN ENERGY FOR OUR FUTURE

Producing energy for homes, businesses, and industry has major environmental impacts. EDF's Energi program works to reduce pollution from energy use.

ities are being deregulated. Just a

into long distance priories service, comimers may be offered choices. EDFpricipated in polls commissioned by sexas utilities which showed that cusimers strongly prefer energy effiency and renewable energy sources, sich as wind and solar power.

In California, EDF was heavily molved in a three-year negotiation on electric utility deregulation. The resulting law is a victory for the environment, providing \$400 million to promote clean, renewable technolojes in the new competition among slectric power providers.

Abhough air pollution is the most solvious ammost abross ammost a

sould what had been been over.

In China, where demand for oblectivity is growing at ten percent it every more and more coal has been been used to meet the need — in a coun rry that airway has seem of the sem only polluted cities on Earth. The year EDF led an intensive training program for managers from 30 Chinesi electric utilities, sharing the analytic boots that EDF has used elsewhere to cook that EDF has used elsewhere to cook that EDF has used elsewhere to cook that EDF has the discussed to the electric utilities.

African Wildlife Foundation 1996 Annual Report

From the Annual Report: "The African Wildlife Foundation is an international organization that protects natural resources in collaboration with partners in Africa and supporters worldwide." 1996 marked the organization's thirty-fifth anniversary.

TRIM SIZE is 8 1/2" x 11" (22 cm x 28 cm)
TWENTY-FOUR-PAGE ANNUAL REPORT, BLACK-AND-WHITE with ONE SPOT COLOR varying in different signatures
Goudy Old Style Body Font
CIRCULATION: 5,000

EDITORIAL: Rebecca Villarreal and Julie Vermillion of the African Wildlife Foundation and Crowley Communications, also located in Washington DC. DESIGN: The Magazine Group, based in Washington D.C. Selected photographs by Art Wolfe.

The African Wildlife Foundation annual report boasts three natural colors—black, rust, and teal. Photos are tinted in either blue or brown, and borders are made up of both. This opening spread, featuring a herd of gazelle, is particularly appealing. Note how the drop cap and a photo of an elephant combine to make a graphic treatment. This drop cap is used throughout the book as an icon for programs.

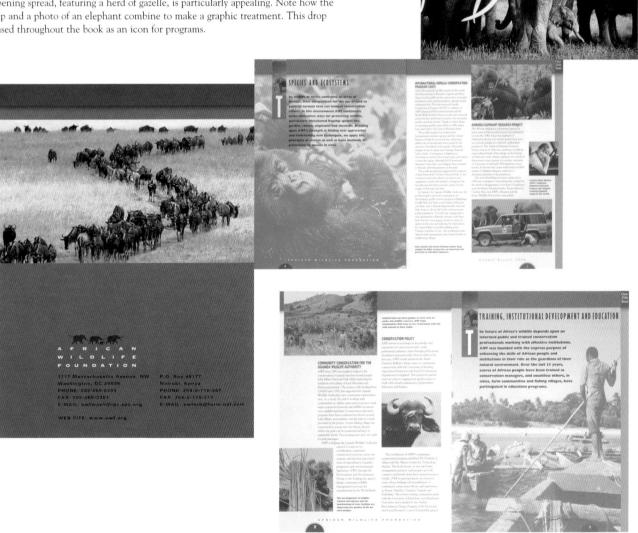

I/ N/ D/ E/ X

A/

A Look Beneath the Surface: Center for Marine Conservation 1996 Annual Report, 128 ABC&D—All About Being Connected to Data: Adaptec Inc. 1996 Annual Report, 62 Acuson Corporation, 60 acuSounder, 60 Adaptec Inc., 62 Adventure 16, 44 African Wildlife Foundation 1996 Annual Report, 140 American Council on Exercise, 108 Anti-Defamation League Pacific Southwest Region 1996 Annual Report, 114 Aono, Carvn, 22 Armour, Tony, 72 The Art of Eating, 44 Ashton, Larry, 116 Ayres, Ed, 135 Azar, Cheryl, 114

B/

Bailey, Craig, 119 Balint & Reinecke, 45 Baran, Joe, 91 Barnes, Roxanne, 78, 136 Beaman, Lindsay, 62 Behr, Edward, 44 Belanger Legault Communications Design Ltd., 47 Belk Mignogna Associates Ltd., 121 Bell, Robin, 132 Benenson, Phyllis, 45 Benson, Julie, 38 Benson, Margaret, 72 Big Blue Box, 89 Big Blue Dot, 89 bLink, 82 Blum, Gary, 60 Bombardier, 87 Bonnell, Anita, 22 Bournique, Susan P., 130 Braen, Beth, 16 Breazeale, Jeff, 30 Brinkman, Mark, 128 Brown, Mike, 82 Bruce, Tim, 72

CI

Butler, Linda, 80

Cahan & Associates, 62, 98, 119
Cahan, Bill, 62, 98, 119
CalArts Current, 22
California Institute of the Arts, 22
California State Parks, 28
Callahan, William, 45
The Callaway GrapeVine, 89
Callaway Vineyard & Winery, 89
CalMat 1996 Annual Report, 100
Camner, Ken, 16
CARN: Corporate Annual Report
Newsletter, 66
CartaGraphics Inc., 138

Center for Marine Conservation, 128 Chamberlin, Keith, 44 Chan, Pak Sing, 78 Chappelle, Jason, 14 Chen Design Associates, 60, 80 Chen, Joshua, 60, 80 Chicago Volunteer Legal Services 1996 Annual Report, 72 Chiquitucto, Edward, 18 Choices, 84 Christie's Art, 20 Christopher, Rick, 55 City of Hope 1996 Annual Report, 104 Clarian Health Partners, 106 Claro, Noel, 14 Cognitive Marketing Inc., 110, 111 Compass, 32 Conservation International: The First Decade 1987-1997, 132 Conservation, 68 Contrails, 87 Corey & Company Inc., 89 Cotton, Richard T., 108 Creative BioMolecules 1996 Annual Report, 120 Crowley Communications, 140 CSU Sacramento, 28

D/

Daniel Hoh and Associates, 110, 111 dateline Nissan, 55
Davis, Priscilla, 28
DeNatale, Josanne, 110, 111
Design, Pentagram Inc., 18
Dienstag, Eleanor Foa, 88
Dietter, Laurie Mansfield, 40
Dinetz, Bob, 98
Dog Ear Design, 16
Doherty, Elizabeth, 135
Douglas Oliver Design Office, 52, 100
Dujack, Stephen R., 138
Duval, Helen, 114

E/

Earth Share, 137
EarthLink Network, 82
Edelman, Sue, 89
Eilperin, Mike, 14
Eleanor Foa Associates, 88
Environmental Defense Fund
1996—1997 Annual Report, 139
Environmental Law Institute
1996 Annual Report, 138
Essex Two, 84, 86, 106
Essex, Joseph Michael, 106
Ethertington-Smith, Meredith, 20
Evans, Mariwyn, 70

F/

Fabian, Jeffrey S., 132 Family, Cheryl J., 14 Feinstein Kean Partners, 120 Feld Design, 130 Feld, Annemarie, 130 The Felt Hat, 76 Fitness Matters, 108 Fitzgerald, Ray, 91 Flynn, Laurie, 46 Footprints, 44 Fox, Ken, 34 Froeter Design Company, 72

G/

Gallagher, Kristin, 55
Geer Design, 46
Geer, Mark, 46
Gericke, Michael, 18
Geron 1996 Annual Report, 98
Getty Conservation Institute, 68
Gibbs, Tony, 42
Glauber, Barbara, 22
Glidden, Clifford R., 28
Green Sticker Vehicle, The, 28
Greteman Group, 87
Greteman, Sonia, 87
GSD&M Advertising, 128
Gunther, Steven A., 22
Gurzenski, Dave, 104

H/

H.J. Heinz Co. 1996 Annual Report, 88
Hall Riney & Partners, 58
Hall, Margie, 116
Hall, Sadhya, 130
Halper, Mark Robert, 104
Harley-Davidson Inc. 1996 Annual Report, 34
Havell, Lynda, 20
HealthWise, 106
Heartport Annual Report, 119
Heavy Meta, 22
Hechinger, Deann, 110, 111
Hirshorn-Zuckerman Design Group, 137
Hoh, Daniel, 110, 111
HomeFront, The, 136
Howell, Anne, 89

I/

Imagine: Jacor Communications Inc. 1996 Annual Report, 47 Ingle Group, 86 Institute of Real Estate Management, 70 Island Escapes, 42 Islands magazine, 42 Islands Publishing Co., 42

J/

Jacor Communications Inc., 47 Janis Olson Design, 32 Jensen, Peter, 40, 44 Journal of Property Management, 70 Juarez, Lisa, 38

K/

Kashi Company, 78 Keating & Associates/Hess Design, 46 Kelley, Patty, 42
Kennedy, Jack, 88
Ketchum PR, 88
Kim Ross Creative, 110
Kim, Somi, 22
Kimberly Baer Design Associates, 104, 114
Kinetik Communication Graphics Inc., 132
Klotnia, John, 126
Krizman, Greg, 86
Kukla, Juanita, 58

L/

Laidlaw, Thomas, 120
Larsen Design Office Inc., 90, 118
Lawrence Ragan Communications Inc., 66
Lazin & Katalan, 139
Lee, Pamela, 91
Lefko, Wendy, 14
Lejeune, Michael, 104
Levi Strauss & Co., 80
Levin, Jeffrey, 68
Living Buddhism, 116
Lux, Steve, 108

M/

Magazine Group, The, 140 Magellan's World, 45 Malofilm Communications 1996 Annual Report, 47 Malofilm Communications, 47 Mānoa: A Pacific Journal of International Writing, 25 Margetts, Tom, 91 Martin, Fletcher, 34 Mason, Dave, 91 Matsueda, Pat, 25 Maurice Printers, 89 McGuire, Karen, 108 McIsaac, Adam, 76 McLeod, William, 119 McQuire, Richard, 62 Meeks, Chris, 22 Melis, Carole, 98 Merkel, Jayne, 18 Mikkelborg, Cheryl, 32 Miller, Deborah, 136 Molina, Jim, 28 Molloy, Joe, 68 Mondo Typo Inc., 68 Montes de Oca, Ivette, 126 Moore, James W., 22 Moyer, Karen, 78 MTV Networks, 14

N/

Murie, Gary, 116

National Audubon Society
1995 Annual Report, 126
National Fish and Wildlife Foundation
1996 Annual Report, 130
NATPE Monthly, The, 16
New Pacific Writing, 25
The Next Level: Ride Inc.
1996 Annual Report, 30
Nickel Advertising Design, 55

Nickel, Randy, 55 Nierenberg, Ona, 121 Nissan Motor Corporation, 55 Northrop Grumman Corporation 1996 Annual Report, 47 Novellus 1996 Annual Report, 90

0/

O'Sullivan, Lucy, 66
Oculus, 18
Oliver, Douglas, 52
Olson, Janis, 32
Operations & Sourcing News, 80
Osato, Teri, 82

P/

Pages, The, 14 Passages, 45 Penner, Victor John, 91 Pentagram Design Inc., 18, 126 Perdue, Renny, 137 Peteet, Rex, 128 Petrick Design, 47 Phillips, Steve, 87 Pihonak, Jenny, 130 Pirtle, Woody, 126 Plagenz, Joel, 139 Pollard, Skip, 20 Portland Brewing Co. 1996 Annual Report, 76 Princess Cruises, 38 Princess News, 38 Puccinelli, Dean, 45

Q/

Quagliarello, Mia, 14

R/

Rancho La Puerta Tidings, 40
Rancho La Puerta, 40
Recreational Equipment Inc., 32
ReVerb, 22
Ride Inc., 30
Rier, Scott, 132
Robbins, Michael, 126
Roberson, Kevin, 62
Robinson Kurtin Communications! Inc., 88
Ross, Kim, 110
Roxanne Barnes Creative Services, 78, 136

S/

Saji, Ken, 14
SamataMason Inc., 91
San Diego Housing Commission, 136
Saturn, 58
Schles, Ken, 119
Schmidt, Ken, 30, 34
Schott, Martin, 20
Schreiber, Curt, 30, 34
Screen Actor, 86
Screen Actors Guild, 86
SGI-USA, 116
Sharing News, 137
Shelton, Samuel G., 132
Shining Star, The, 111

Sibley Peteet Design, 128

Singer, Lili, 45 Siobhan Stofka Design, 45 Slowinski, Rachel, 22 Smith, Mike, 89 Sonnenfeld, Michael, 70 Sorra, Cecile, 66 South Texas College of Law 1996 Annual Report, 46 South Texas College of Law, 46 The Southern California Gardener, 45 Spence, Susan E., 106 St. Jude Medical Inc. 1996 Annual Report, 118 Stant Corporation 1996 Annual Report, 91 Starlight Foundation International 1995-1996 Annual Report, 110 Stewart, Frank, 25 Stofka, Siobhan, 45 Stromberg, Tony, 119 Stureman, Bev, 89 Sydney's Koala Club News, 96

T/

Tabusa, Rowen, 25 Taylor, Marjorie, 44 Thorsby, Mary, 60 Tuschman, Richard, 104

UI

Ultrafem 1996 Annual Report, 121 Urban Shopping Centers Inc. 1996 Annual Report, 85

V/

van Oppen, Maggie, 104 Vanguard Communications, 137 Vermillion, Julie, 140 Villarreal, Rebecca, 140 Visions, 58 VSA Partners, 30, 34

W/

Waldorf, Ross, 16
Warner Design Associates Inc., 96
Weinberg, Flint, 70
Weiss, Jim, 119
Weymouth Design Inc., 120
Wheeler School, 46
Wilcox, Marissa, 20
Window on Wheeler, 46
Witte, M. Lee, 72
Wolfe, Art, 140
The World of Kashi, 78
Worldwatch Institute, 135
World Watch, 135
Worley, Karen E., 96

Z/

Zoological Society of San Diego, 96

THE PAGES

Cheryl J. Family Creative Director, Editorial MTV Networks (A Viacom Company) 1515 Broadway New York, NY 10036-5797 212-258-7690

NATPE MONTHLY

Beth Braen Vice President Creative Services National Association of Television Program Executives 2425 Olympic Blvd., Ste. 550E Santa Monica, CA 90404 310-453-4440

Dog Ear Design 1313 Foothill Blvd., Ste. 6 La Canada, CA 91011 818-790-2268

Oculus

Pentagram Design, Inc. 204 Fifth Avenue New York, NY 10010 (212) 683-7000 info@pentagram.com

CHRISTIE'S ART AUCTION NEWS Christie's Publications 21-24 44th Avenue Long Island City, NY 11101 718-784-1480

CALARTS CURRENT
CALARTS COURSE CATALOG
Office of Public Affairs
Annita Bonnel, Director
Christopher Meeks, Editor
California Institute of the Arts
24700 McBean Parkway

ReVerb 5514 Wilshire Blvd., 9th Fl. Los Angeles, CA 90036 213-954-4370

Valencia, CA 91355-2397

New Pacific Writing Editorial Office University of Hawai'i English Department Honolulu, HI 96822

THE GREEN STICKER VEHICLE
Off-Highway Motor Vehicle
Recreation
P.O. Box 942896
Sacramento, CA 94296-0001
916-324-4442

Jim Molina Senior Graphic Designer, Contract Graphics University Media Services California State University 6000 J. Street Sacramento, CA 95819-6047 RIDE INC. 1996 ANNUAL REPORT

VSA Partners, Inc. 542 South Dearborn, Ste. 202 Chicago, IL 60605 312-427-6413

COMPASS

Cheryl Mikkelborg Corporate Communications Administrator 6750 South 228th St. Kent, WA 98032 253-395-4692

HARLEY-DAVIDSON INC. 1996 ANNUAL REPORT

VSA Partners, Inc. 542 South Dearborn, Ste. 202 Chicago, IL 60605 312-427-6413

PRINCESS CRUISES

Editor: Julie Benson Designer: Lisa Juarez Princess Cruises 10100 Santa Monica Blvd. Los Angeles, CA 90067-4189 310-553-6330

RANCHO LA PUERTA TIDINGS Laurie Mansfield Dietter Graphic Designer 3561 Sydney Place San Diego, CA 92116

Golden Door/Rancho La Puerta P.O. Box 463057 Escondido, CA 92046 760-744-6677

ISLAND ESCAPES

Islands: An International Magazine 3886 State St. Santa Barbara, CA 93105 805-682-7177

FOOTPRINTS

Adventure 16, Incorporated 4620 Alvarado Canyon Rd. San Diego, CA 92120 619-283-2362

Marjorie Taylor Taylor Graphics 12407 Caminito Brioso San Diego, CA 92131 619-530-2440

THE ART OF EATING Edward Behr P.O. Box 242 Peacham, VT 05862 802-592-3491

SOUTHERN CALIFORNIA GARDENER Lili Singer, Editor

Southern California Gardener P.O. Box 8072 Van Nuys, CA 91409-8072 310-396-3083

Siobhan Stofka Siobhan Stofka Design 2041 N. Commonwealth, #106 Los Angeles, CA 90027 213-662-7936 PASSAGES

Magellan's 110 W. Sola St. Santa Barbera, CA 93101 805-568-5400

John Balint Balint & Reinecke 6 St. Francis Way Santa Barbara, CA 93105 805-687-3043

SOUTH TEXAS COLLEGE OF LAW 1996 ANNUAL REPORT

Geer Design, Inc. 2518 Drexel Dr., Ste. 201 Houston, TX 77027 713-960-0808

WINDOW ON WHEELER

Laurie A. Flynn Director Publications & Public Relations The Wheeler School 216 Hope Street Providence, RI 02906-2246 401-421-8100

Hess Design 49 Eliot St. S. Natick, MA 01760 508-650-4063

Keating & Associates 67 Westwood Dr. Shrewsbury, MA 01545 508-842-0543

MALOFILM COMMUNICATIONS
1996 ANNUAL REPORT

Belanger Legault Communications Design 360 St-Jacques, Ste. 510 Montreal, Quebec Canada 514-284-2323

IMAGINE: JACOR INC. 1996 ANNUAL REPORT Petrick Design

Petrick Design 828 North Wolcott Ave. Chicago, IL 60622 773-486-2880

NORTHROP-GRUMMAN CORPORATION 1996 ANNUAL REPORT

Douglas Oliver Design Office 2054 Broadway Santa Monica, CA 90404 310-453-3523

DATELINE NISSAN

Editor, Richard S. Christopher Nissan Motor Corp. U.S.A. 18501 S. Figueroa Gardena, CA 90248 310-771-5662

Randy Nickel Nickel Advertising Design 34071 La Plaza, Ste. 140 Dana Point, CA 92629 714-661-0399 VISIONS

Saturn Corporation 100 Saturn Parkway Sping Hill, TN 37174 615-486-5055

ACUSOUNDER

Chen Design Associates 650 Fifth Street, Ste. 508 San Francisco, CA 94107-1521 415-896-5338

Acuson Corporation P.O. Box 7393 Mountain View, CA 94039 415-969-9112

ADAPTEC INC. 1996 ANNUAL REPORT Cahan & Associates

818 Brannan St., #300 San Francisco, CA 94103 415-621-0915

CARN

Cecile L. Sorra/Editor Lawrence Ragan Communications, Inc. 212 W. Superior, Ste. 200 Chicago, IL 60610 312-867-3369

CONSERVATION

Jeffrey Levin The Getty Conservation Institute 1200 Getty Center Dr., St. 700 Los Angeles, CA 90049-1684 410-440-7325

JOURNAL OF PROPERTY MANAGEMENT Institute of Real Estate Management 430 N. Michigan Ave., 7th Fl. Chicago, IL 60614

312-329-6000

CHICAGO VOLUNTEER LEGAL SERVICES 1996 ANNUAL REPORT

Tim Bruce Froeter Design Co., Inc. 954 West Washington Chicago, IL 60607 312-733-8895

PORTLAND BREWING COMPANY 1996 ANNUAL REPORT

Adam McIsaac The Felt Hat 1231 NW Hoyt, No. 401 Portland, OR 97209 503-226-9170

THE WORLD OF KASHI

Karen Moyer
Kashi Company
P.O. Box 8557
La Jolla, CA 92038-8557
619-274-8870

OPERATIONS & SOURCING NEWS

Chen Design Associates 650 Fifth Street, Ste. 508 San Francisco, CA 94107-1521 415-896-5338

Levi Strauss & Co. 1155 Battery San Francisco, CA 94511 415-501-6070 BLINK

Mike Brown Editor EarthLink Network 3100 New York Dr. Pasadena, CA 91107 (626) 296-5821

CHOICES

Joseph Michael Essex Essex Two 2210 W. North Ave. Chicago, IL 60647 773-489-1400

URBAN SHOPPING CENTERS INC. 1996 ANNUAL REPORT

Joseph Michael Essex Essex Two 2210 W. North Ave. Chicago, IL 60647 773-489-1400

SCREEN ACTOR

Greg Krizman Screen Actors Guild 5757 Wilshire Blvd. Los Angeles, CA 90036 213-549-6652

Ray Ingle The Ingle Group 11661 San Vicente Blvd., #709 Los Angeles, CA 90049 310-207-4410

CONTRAILS

Stephen Phillips Bombardier 400 Cote Verta West Dorval, Quebec H4S 1Y9 Canada 514-855-7412

Sonia Greteman The Greteman Group 142 North Mosley Wishita, KS 67202 The Greteman Group

H.J. HEINZ COMPANY 1996 ANNUAL REPORT

Debora S. Foster H.J. Heinz Company P.O. Box 57 Pittsburgh, PA 15230 412-456-5778

CALLAWAY'S GRAPEVINE

Beverly Stureman Callaway Vineyard & Winery 32720 Rancho California Road Temecula, CA 92589 909-676-4001

BIG BLUE BOX

Susan Edelman Big Blue Dot LLC 63 Pleasant St. Watertown, MA 02172 617-923-2583

Novellus 1996 Annual Report

Tim Larsen Larsen Design + Interactive 7101 York Ave. South Minneapolis, MN 55435 612-835-2271 STANT CORPORATION 1996 ANNUAL REPORT

Stant Corporation 425 Commerce Dr. Richmond, IN 47374 765-962-6655

SAMATAMASON, INC.

101 South First Street West Dundee, IL 60118 847-428-8600

SYDNEY'S KOALA CLUB NEWS

Karen Worley Zoological Society of San Diego P.O. Box 551 San Diego, CA 92112 619-231-1515

Roxanne Barnes Roxanne Barnes Creative Services 2400 Keitner Blvd., #215 San Diego, CA 92101 619-544-1124

GERON

Cahan & Associates 818 Brannan St., #300 San Francisco, CA 94103 415-621-0915

Calmat 1996 Annual Report Douglas Oliver Design Office 2054 Broadway Santa Monica, CA 90404 310-453-3523

CITY OF HOPE 1996 ANNUAL REPORT

Sandra Levy City of Hope 208 W. 8th Street Los Angeles, CA 90014 213-892-7230

HEALTHWISE

Joseph Michael Essex Essex Two 2210 W. North Ave. Chicago, IL 60647 773-489-1400

FITNESS MATTERS

American Council on Exercise 5820 Oberlin Dr., Ste. 102 San Diego, CA 92121-3787 619-535-8227

STARLIGHT FOUNDATION INTERNATIONAL 1995–1996

Annual Report: The Shining Star Deann Hechinger Marketing & Communications Coordinator Starlight Children's, Foundation 12424 Wilshire Blvd., Ste. 1050

Los Angeles, CA 90025 310-207-5558

Daniel Hoh & Associates Temple Building 14 Franklin Street, Ste. 916 Rochester, NY 14604 716-232-2880

Josanne DeNatale Cognitive Marketing, Inc. 46 Prince St. Rochester, NY 14607 716-244-4140 Anti-Defamation League Pacific Southewest Region 1996 Annual Report

Jewish Anti-Defamation League 10495 Santa Monica Blvd. Los Angeles, CA 90025 310-446-8000

LIVING BUDDHISM

Gary Murie, Art Director SGI-USA 525 Wilshire Blvd. Santa Monica, CA 90401

St. Jude Medical Inc. 1996 Annual Report

Tim Larsen Larsen Design + Interactive 7101 York Ave. South Minneapolis, MN 55435 612-835-2271

HEARTPORT

Cahan & Associates 818 Brannan St., #300 San Francisco, CA 94103 415-621-0915

CREATIVE BIOMOLECULES 1996 ANNUAL REPORT

Thomas Laidlaw, Jr. Weymouth Design, Inc. 332 Congress St. Boston, MA 617-542-2647

ULTRAFEM 1996 ANNUAL REPORT

UltraFem, Inc. 805 Third Ave., 17th Fl. New York, NY 10022 212-446-1400

Belk Mignogna Associates 373 Park Ave. South, 7th Fl. New York, NY 10016 212-684-7060

NATIONAL AUDUBON SOCIETY 1995 ANNUAL REPORT

Pentagram Design, Inc. 204 Fifth Avenue New York, NY 10010 (212) 683-7000 info@pentagram.com

CENTER FOR MARINE CONSERVATION 1996 ANNUAL REPORT

Mark Brinkman Sibley Peteet Design 2905 San Gabriel, #300 Austin, TX 78705 512-473-2333

NATIONAL FISH & WILDLIFE
FOUNDATION 1996 ANNUAL REPORT
National Fish & Wildlife Foundation

National Fish & Wildlife Foundation 1120 Connecticut Ave., NW, Ste.900 Washington, DC 20036 202-857-0166

Anne Marie Feld Feld Design 4900 Leesburg Pick, Ste. 413 Alexandria, VA 22302 703-820-1616 CONSERVATION INTERNATIONAL: THE FIRST DECADE 1987–1997 Samuel Shelton Kinetik Communication Graphics, Inc. 1604 17th St. NW, 2nd Fl. Washington, DC 20009 202-797-0605

WORLD • WATCH

WorldWatch Institute 1776 Massachusetts Ave., NW Washington, DC 20036 202-452-1999

THE HOMEFRONT

Roxanne Barnes Roxanne Barnes Creative Services 2400 Keitner Blvd., #215 San Diego, CA 92101 619-544-1124

SHARING NEWS

Earth Share 3400 International Dr., NW, #2K Washington, DC 20008 202-537-7100

Hirshorn Zuckerman Design Group, Inc. 100 Park Ave., Ste. 250 Rockville, MD 20850 301-294-6302

Environmental Law Institute 1996 Annual Report

Environmental Law Institute 1616 P. Street, NW, Ste. 200 Washington, DC 20036 202-939-3800

CartaGraphics, Inc. P.O. Box 15392 Sarasota, FL 34277-1392 941-922-5331

Environmental Defense Fund 1997–1997 Annual Report

Environmental Defense Fund 257 Park Ave., South New York, NY 10010 212-505-2100

Lazin & Katalan 227 W. 17th St. New York, NY 10011 212-242-7611 212-633-6941 (fax)

AFRICAN WILDLIFE FOUNDATION 1996 ANNUAL REPORT

African Wildlife Foundation 1400 16th St., NW #120 Washington, DC 20036 202-939-3337

The Magazine Group 1707 L. Street, NW, Ste. 350 Washington, DC 20036 202-331-7700 202-331-7311 (fax)